Lot's Wife and the Venus of Milo
Conflicting attitudes to the cultural heritage in modern Russia

By way of dedication
'Gifts are not the given's but the giver's.'

Lot's Wife and the Venus of Milo

Conflicting attitudes to the cultural heritage in modern Russia

BORIS THOMSON

CAMBRIDGE UNIVERSITY PRESS

CAMBRIDGE

LONDON · NEW YORK · MELBOURNE

31869

Published by the Syndics of the Cambridge University Press
The Pitt Building, Trumpington Street, Cambridge CB2 1RP
Bentley House, 200 Euston Road, London NW1 2DB
32 East 57th Street, New York, 10022, USA
296 Beaconsfield Parade, Middle Park, Melbourne 3206, Australia

First published 1978

Printed in Great Britain by
The Anchor Press Ltd, Tiptree, Essex

Library of Congress Cataloguing in Publication Data

Thomson, Boris.
Lot's wife and the Venus of Milo.

Bibliography: p. 167
Includes index.
1. Socialist realism in art–Russia. 2. Socialist realism in literature. 3.
Communism and art–Russia. 4. Arts, Modern–20th century–Russia. I. Title.
NX556. A1T48 700′.947 77-77703
ISBN 0 521 21677 X

CONTENTS

31869

INTRODUCTION

This collection of essays is devoted to one of the many problems of creating a socialist culture, namely that of finding a proper place for the culture of the past in the society of the future.

It would seem that strict application of Marxist theory to the culture of the past would require the rejection of it altogether, even if many Marxists have shrunk from this conclusion. The peculiar feature of Russia in the early twentieth century is that artists and intellectuals were also questioning, though for rather different reasons, the validity of the culture of the past. With the Marxist-inspired revolution of November 1917 these different streams suddenly came together: the official proletarian and materialist ideology of the new state seemed to coincide with the disaffection with the past and the Utopian hopes for the future current among the artistic *avant-garde*. For a few years, then, the issue of the culture of the past became a real practical problem which has left its mark on both the theory and the practice of many post-revolutionary writers.

In this debate the word culture is used very broadly: it refers primarily to the arts, but at times it includes the sciences as well; in some cases it can cover morality and even etiquette; and at its broadest it can mean the past as a whole. Since it was in these loose terms that the word was used at the time no attempt will be made here to narrow the definition. Indeed the very elasticity of the concept can help in pointing out the inconsistencies inherent in almost every position adopted in these debates; often enough writers who took up iconoclastic attitudes to one aspect of the cultural heritage proved

willing to make an exception for another. Some examples will be discussed in the fifth chapter.

These essays are concerned with the case against bourgeois and indeed all pre-socialist cultures. Of particular interest for our purposes are such writers as Blok, Khlebnikov, Bagritsky and Leonov who, from their very different positions, saw the full complexities of the problem. The majority of artists, of course (e.g. Akhmatova, Mandel'shtam and Pasternak), and most Soviet writers (e.g. Chukovsky, Erenburg, Fedin, Paustovsky and the majority of the 'fellow-travellers' of the 1920s) saw no problem at all. Their views will hardly appear in these pages because the continuity of the cultural heritage is an unspoken premiss behind their work. In any case the reader's tendency to accept the necessity for this continuity will present the 'conservationist' view effectively enough.

For the astonishing thing about the arts is not that they can be considered as outdated and irrelevant, but that in so many respects and on so many levels there is a natural resistance to treating them in this way. The last chapter will return to these points. Thus, although the issue will be discussed here with special reference to the experience of Russia in the twentieth century, it is hoped that it will prove to be of general interest.

PART ONE

PART ONE

1
The problem of art

Serezha, remembering the lamentable fate of Lot's wife, would never have allowed the young to look back at the old world or to overload themselves with its seductive antiques.
Leonid Leonov, *The Russian Forest*[1]

An important element in the revolt against the culture of the past has of course been the traditional rebellion of the young against their elders; as we shall see, the contrasts of youth versus age and of birth versus death have become stock images in the debate. But in the twentieth century this age-old pattern has been overlaid by other considerations. The habit of instinctive reverence for the culture of the past began to be questioned not just because the culture seemed to have decayed into irrelevance, but out of a new feeling that it was actually suspect.

It is not just that the lessons of art seem all too often to be amoral, if not downright immoral; that can be interpreted as a 'challenge to outdated morality'. More problematic is the fact that art has traditionally been the preserve of a privileged minority; art's willingness to co-operate with the rich and the powerful, and the influence of wealth on artistic taste have become increasingly disturbing in our socialist times. Observing the sinister link between art and commerce throughout history and the apparent prostitution of beauty and creativity to the power of money, many Russian writers of the twentieth century (though, surprisingly, few Marxists among them) have pictured the culture of the past as a brothel.[2] Even supposing that Sodom and Gomorrah had created the odd Venus of Milo, was it really advisable to look back?

Paradoxically, at least for those who take the arts for granted, it was the artists themselves who became the most fearless questioners of the presuppositions on which their work seemed to

rest. It is probable, however, that these ideas would have remained marginal to the history of Russian culture had it not been for the Bolshevik revolution and the re-examination that it entailed of all traditional beliefs about society, morality and art. Almost overnight a few ideas that had hitherto been confined to the artistic and intellectual *avant-garde* suddenly found themselves the property of the uncultured masses.

The confusion that resulted was partly caused by the difficulties of establishing a consistent Marxist position on art, partly by the differing assumptions about the role of art among the various disputants, and partly by a general uncertainty as to its exact significance. For if most people would agree that art is concerned with beauty, and with values that transcend the limitations of time and space, very different conclusions could be drawn from this initial premiss. Some would argue that since there is little beauty in the world as it is, the artist must withdraw or escape from its contagion if he is to create a true work of art. This view would seem to grant the arts an absolute value, and would certainly make them a worthy occupation in Utopia, but meanwhile, it is a rather abstract value, with little relevance for the lives of most non-artists; the pursuit of art becomes a search for the eternal laws of aesthetics. Others, however, would see art as originating out of the imperfections of a particular time and place, and the artist as concerned above all with suffering, either his own or that of society; in this view art becomes social protest or self-therapy, the creation of a pearl out of a piece of irritating grit. This theory gives art more 'relevance', but it is a secondary relevance, dependent on some external issue for its appreciation; the study of art becomes a province of sociology or psychology. And presumably, once Utopia has been attained, art will no longer be required. The artist with his cult of suffering may then seem to be a troublemaker: in the brave new world of Mayakovsky's *The Bedbug* (*Klop*, 1928) he is seen as positively dangerous, and in *Vladimir Mayakovsky. A Tragedy* (*Vladimir Mayakovsky. Tragediya*, 1913) he is actually expelled from the 'city of the future'. The problems of aesthetics arise out of the difficulties of steering a course between the Scylla and Charybdis of these two interpretations: if the claims for art's timelessness tend to trivialize it into irrelevance, emphasis on its particularity in time and place tends to reduce it to mere topicality. On the other hand, if

the former approach can point to the striking fact of the survival of so many works of art from dead civilizations, the latter can at least find some role for art to play.

Of course both sets of ideas seem to co-exist quite happily in some people's minds, and this double vision is particularly marked in the attitudes of Marxists towards art. The aim of this chapter, then, is to trace the main strands in the complex debate about art, and particularly the arts of the past, that was brought to a head by the Bolshevik revolution.

Marxism

In many respects Marxism is a true child of the humanism of the nineteenth century, with its faith in progress and its tendency to replace the Divine Creation by human creativity. Art and science began to usurp the position of religion as ideals of human achievement and potential. In theory Marxism too gives an exalted place to culture. Marx and Trotsky, not to mention lesser figures, envisaged the Communist Utopia as distinguished above all by the liberation of human creativity from the shackles of class ideology. As alienation disappeared so a new all-round, creative, artistic man would arise; then, even the greatest and finest achievements of the past would be seen to be mere foothills beside the heights that were man's natural level. The question that concerns us here is just what value these 'foothills' could have for later generations brought up under different social systems.

For the Marxist the history of art moves in parallel with the history of society and its economic basis: 'social existence determines consciousness'. Art tends to reach its finest flowering in ages when the dominant class reaches the zenith of its power; conversely, periods of social and economic uncertainty are accompanied by new movements in art. An artist, like any other individual, has the choice of co-operating with the movement of history, or trying to turn the clock back; but, whatever he does, something of the truth of the times will inevitably come through in his work. The example Marx gave was Balzac, who 'ideologically' was reactionary to the point of monarchism, but who yet, as an artist, wrote more wisely than he knew in his faithful depiction of the 'progressive' realities of his time.

Like any other field of human activity the arts would seem to be determined by their historical environment, leaving little initia-

tive for human individuality. This was actually stated by one far-from-extreme Soviet Marxist, P. S. Kogan:

> To search for the author in a work of art is to talk about secondary matters. It's the same thing as trying to explain the location of a railway or a bridge in a certain place as due to the inspiration of the engineer, instead of a complex of economic conditions.[3]

The comparison of the artist to a scientist, and particularly to an engineer, is a common one in Marxist and Soviet thinking (it is of course also central in the work of the Formalists). Indeed, the Marxist preference for realism seems to rest primarily on its supposed approximation to scientific method. It implies that the artist has a social function to perform; human will and intellect can analyse and manipulate inert matter, and give it some practical purpose. Art is 'useful' in one way or another, either in organizing collective labour, like the songs of the Volga bargehaulers, or educational, in opening men's eyes to the injustices of their society, or progressive, in offering noble ideals for emulation. These accounts of art may legitimize it as a form of 'praxis', but none of them requires any 'art'. Indeed the very idea of beauty or imagination is suspect, because it implies a softening of the harsh realities that must underlie all pre-socialist art; it seems to be a kind of ornament or distraction that helps to sell the product, like the 'cheese-cake' of the popular press, or at best, the sugarcoating that makes strong medicine palatable. Presumably, once mankind has matured into socialism it will be able to take its ideology undiluted, without any aesthetic sweeteners. One might expect Marxists, therefore, to have provided some drastic revaluations of established works of art, to have unmasked all those which expressed the ideology of an alien class, to have exalted the counter-culture of the down-trodden and under-privileged, and to have given an at best qualified approval to such artists as Balzac, as possessing some historical significance for all their ideological perniciousness; much as they have done in other historical fields, such as economics, politics and sociology. In the cultural sphere, however, they have, for the most part, been content to accept the canon established by non-Marxist critics and societies, and to argue instead that the *real* merit of such works of art can only be properly appreciated from a Marxist standpoint. Meanwhile any

reader knows of authors and books which illustrate Marxist theories far better than any of the complex masterpieces claimed by Marxists for their own, but which are nonetheless spurned by them as of dubious 'aesthetic' value.

The paradox is a strange one. In other fields Marxists are deeply suspicious of all manifestations of the non-socialist spirit; even liberal reforms such as the extension of the franchise and the abolition of slavery have been denounced by them as merely cunning devices by which a threatened ruling class contrived to maintain itself in power a little longer. The achievements of bourgeois culture in law, philosophy and morality have all been scornfully rejected as false and exploitative: the new world must have nothing to do with them:

> The social revolution of the nineteenth century cannot draw its poetry from the past, but only from the future. It cannot begin until all the superstitions of the past have been expunged . . . If it is to find its true content, the revolution of the nineteenth century must leave the dead to bury their dead.[4]

Yet, for some mysterious reason the achievements of non-socialist art are exempted from these condemnations.

It is surprising enough that Marxists should accept so unquestioningly the aesthetic values established by non-socialist critics and societies;[5] but there is a still more fundamental objection. Given the Marxist conception of art as a kind of 'soft' science, of human evolution as 'progressive', and of human activity as determined by historical environment and class interests, it is difficult to see why the arts of the past should ever appeal to later generations at all, let alone socialist ones. Even the finest works of the old culture were surely irremediably tainted by their technical backwardness and their lamentable class origins, and destined to be superseded, if not totally rejected. Thus when Lunacharsky complained to Lenin about the danger posed to Moscow's historic architecture by the street-battles of the winter of 1917–18, Lenin did not blame the opposition for this vandalism (as his successors would have done), but replied quite reasonably:

> How can you attach such significance to this or that old building, however fine it may be, when we are trying to

open the doors to a social system capable of creating a beauty which will immeasurably surpass all that people could even dream of in the past.[6]

There is a problem here, and the two possible solutions to it both raise difficulties. On the one hand one may argue that art is necessarily class-bound ('all art is class-art')[7] and that once a truly classless society has been created the arts of pre-socialist societies will be superseded, retaining nothing more than mere historical interest. Meanwhile human society, even those nations and individuals who fancy themselves to be socialist, is still firmly set in a transitional stage, as is shown, among other things, by the continued prevalence of bourgeois aesthetic values. This would seem at least logically acceptable, and it would provide an explanation both for the postures of the Western New Left and for the cultural policies of today's so-called socialist states. Most Marxists, however, would reject this explanation, partly because of their instinctive desire to retain the arts of the past, but rather more because the implication would be that in that case they are not yet true socialists. The alternative possibility, that art is somehow free, or at least more free, of the limitations of class is much more widely held. But it raises difficult questions for Marxism as a whole. For if aesthetics can exist somewhere outside the Marxist system, then we may suspect that the system is not so water-tight and all-embracing as it claims; having found one exception we may look for others or reject the whole system.

The classic formulation of this problem by Marx is of great importance here, for, with all its confusions and *non sequiturs*, and its Protean adaptability to the most conflicting interpretations, it indicates the crucial difference between Marx and his followers, at least over art. In a well-known fragment of 1857 (the draft of an introduction to *A Contribution to the Critique of Political Economy*) Marx raised the question of the relationship between art and social development. He began by discussing the differences between the Greek poets, Shakespeare and contemporary writers in terms of their economic and technological presuppositions, but then suddenly realized where his argument was leading him, and broke off to ask himself why Greek art should 'still constitute with us a source of aesthetic enjoyment, and in certain respects prevail as the standard and model beyond attainment'.[8]

To this fundamental question he could give only an uncharacteristically tentative answer:

> Why should the social childhood of mankind, where it had obtained its most beautiful development, not exert an eternal charm as an age that will never return? . . . The Greeks were normal children. The charm their art has for us does not conflict with the primitive character of the social order from which it had sprung. It is rather the product of the latter, and it is rather due to the fact that the unripe social conditions under which the art arose, and under which alone it could appear, could never return.[9]

The confusion of later Marxist thinking on the subject of art is all foreshadowed in this passage. There is no connection established between the socio-economic origins of Greek art and its artistic achievement; the 'eternal charm of an age that will never return' is not an aesthetic category but sheer sentimentality, and it is easy to imagine the scorn that Marx would have poured upon such reactionary arguments, had he not happened to agree with them on this occasion. His uncertainty over whether art should be treated strictly as a product of its time and place, or as a happy exception to this rule (and there are many more examples in this fragment) springs, however, from his readiness to let his genuine love of art and his reverence for human creativity undermine theoretical rigour. We need not doubt Mehring's claim that 'he would have scourged from the temple of art those contemptible souls who would prevent the workers from appreciating the culture of the classical world'.[10]

In criticizing Marx we must, then, respect him for recognizing the peculiar problem posed by art and for his honesty in facing the difficulty. Since then, his followers have accepted the 'necessity of art', but without the artistic sensitivity that makes his position sympathetic despite its inconsistency. They have used Marx's words simply as canonical texts; they are capable of declaring with Trotsky that 'every ruling class creates its own culture, and, consequently its own art',[11] while going on in the next breath to explain that it is 'vulgar Marxism' actually to apply this principle to art. In practice this has meant that they have applied strict Marxist criteria to works of which they disapprove,

while bringing in vague aesthetic terminology to justify those works which they do not dare to attack.

There are thus two strains in the usual Marxist attitude to art: one, that it is the finest creation of humanity, and that therefore the new society should acquire a knowledge and appreciation of it; the other, that, for all that, art is not quite reliable, partly because of its questionable origins in an alien environment, both socially and historically, and the consequent difficulties of its interpretation, and partly because of the disturbing fact that, with the passing of time, art is often happy enough to switch her favours from one side to the other;[12] art is suspect because in a materialist and utilitarian world it deals in imagination, beauty and even frivolity.

So it is no coincidence that one of the catchphrases in the Soviet debate over the culture of the past is the call to 'conquer' or 'master' it. The Russian words for this concept, *zavoyevat'*, *preodolet'*, *ovladet'*, like their English equivalents, have strong overtones of power and superiority, and can be used in both military and sexual contexts; as we shall see in later Soviet treatments of the theme. The arts are desirable, but somehow not quite respectable; if beauties of such dubious virtue are to be tolerated, then they should be kept under strict control as a regrettable but inevitable concession to human frailty, rather like state brothels.

This mixture of reverence and distrust for art is marvellously caught in Lenin's reported words to the effect that art alone (specifically the theatre) could take the place of religion in a socialist society.[13] It would be interesting to know whether Lenin meant by this that art could take its place as a source of higher values, both moral and aesthetic; or did he mean that art too was an opiate, albeit a comparatively harmless one, useful for distracting men from the unpleasant realities of their lives? Probably he meant both; in any case the ambiguity of his remark is an indication of the uncertainty that Marxists have always felt about art.

And so despite their reiterated claims, Communists have found it difficult in practice to give art any secure or consistent valuation, at least in the imperfect and transitional world in which we live. When Lenin was told that one of the first actions of the revolutionary government in Hungary had been to nationalize the theatres, he expressed surprise that it had 'no more important business to attend to'.[14] While Lunacharsky, the humane and

sensitive commissar for education and the arts felt that the arts were not, at any rate just yet, a suitable profession for a Party-member:

> Notwithstanding all my immense respect for art I can say that at the present time a Communist should still have to prove that he has nothing better than art to occupy himself with; art is of course a necessary and important business, but it is something to which non-Communists too can devote themselves.[15]

On the one hand we have the supreme value set on art in Marxist theory; on the other the horrifying story of the arts in all countries that have been ruled by the Communists for any length of time. The paradox is not simply an aberration of the Bolsheviks. The Menshevik Valentinov in his book *Two Years with the Symbolists* (*Dva goda s simvolistami*, Stanford, 1969) revealed the same intolerance of any art that he could not understand, so that one has no reason for believing that the history of Soviet art would have been significantly different under any other Marxist group. The contradictions seem to be inherent in Marxism.

Many Marxists would justify this weakness of Marxism by claiming that Marx did not have time to work out a fully comprehensive theory of art, with the implication that, of course, he had 'more important business' to think about. But if art is the finest achievement of man, what could be more important? Although Marxists protest that they take the arts seriously, in fact they do not. Like other adherents of all-embracing systems, they assume that everything does fit the system and that it's simply a matter of finding an acceptable form of words for the problem to be resolved. Art is dealt with as a troublesome but minor difficulty. But minor difficulties have a way of undermining the most plausible scientific theories, and a good scientist recognizes them as such. It could be that the main function of the arts is to serve as a living disproof of all systems.

The contradictions in the Marxist concept of culture would probably not have mattered much, if it had not been for the fact that artists too were questioning its meaning and value at just the same time. The coincidental outbreak of the Bolshevik revolution in November 1917 brought these different attacks on art into explosive confrontation.

The Symbolists

If the Marxists had mixed feelings about art, the Symbolists, though for different reasons, were even more acutely aware of its paradoxes and ambiguities. They recognized that Western culture seemed to have reached a dead end in the misery and squalor of the modern city, but they proclaimed that art had the power to redeem it yet. They were fascinated by the fragility of art as much as by its enduring vitality, but in their pursuit of this elusive combination they were constantly falling into the traps of excessive refinement or, at the other extreme, of contamination by the gross and temporal realities of this world. At times their awareness of their failures and betrayals, in both life and art, led them to feel that they and the rest of their compromised culture could expect nothing better than total destruction, so that a fresh start could be made.

This theme was given its classic formulation in Bryusov's poem 'The Coming Huns' ('Gryadushchiye gunny', July 1905), where the poet seems to welcome and even encourage the barbarians:

> Сложите книги кострами,
> Пляшите в их радостном свете,
> Творите мерзость в храме, –
> Вы во всем неповинны, как дети.
>
> А мы, мудрецы и поэты,
> Хранители тайны и веры,
> Унесем зажженные светы
> В катакомбы, в пустыни, в пещеры.
>
> И что, под бурей летучей,
> Под этой грозой разрушений,
> Сохранит играющий Случай
> Из наших заветных творений?
>
> Бесследно все сгибнет, быть может,
> Что ведомо было одним нам,
> Но вас, кто меня уничтожит,
> Встречаю приветственным гимном.*[16]

*Pile up your books in pyres, dance in their joyous light, commit your abominations in the temple – you are as innocent as children in all that you do, And we, sages and poets, guardians of the mystery and the faith, we will bear our lighted torches away into

Not just the theme, but many of the details, the opposition of childlike innocence and a senescent culture, the imagery of the 'barbarians' and of 'culture in the catacombs', with its suggestion of the collapse of the Roman Empire, were to recur time and again in the literature of succeeding decades.

But when we look at it more closely, this notorious and influential poem becomes strangely evasive. The poet invites the barbarians to destroy existing culture, while holding out a hope that perhaps 'we' will be able to save something from the wreckage, but then in the next stanza, we are told that if anything does survive it will be due to chance. The clumsy versification of the final stanza adds further to the semantic confusion. If Bryusov's 'hymn of welcome' to the barbarians makes little sense beside his avowed intentions of saving culture from destruction, the over-emphatic accent of 'without trace' at the beginning of the line, and the inept rhyme of 'Perhaps' (*byt' mozhet*) with 'annihilate' (*unichtozhit*) produce an impression of superficiality and affectation. The supple *dol'nik* rhythm of the poem yields in the final stanza to fluent, regular amphibracs, which reinforce the sense of glibness. Bryusov talks of preparing himself to meet the Huns, but he is obviously confident that he at least will be spared by them.

As has often been pointed out, the poem reflects the mood of shame and catastrophe felt by many Russians at their humiliations by the 'barbarians' in the Russo-Japanese war of 1904–5, and their panic at the revolutionary events of 1905. But the significance of this should not be exaggerated. In other poems written at exactly the same time Bryusov faithfully reflects other moods too; the cycle 'Modernity' ('Sovremennost'') in which 'The Coming Huns' is included, contains also conventionally patriotic and even jingoistic verse. In context 'The Coming Huns' is an opportunistic poem, one which presents an idea, but is not really committed to it. However events had turned out, one could have found a poem in this collection to match the situation.

the catacombs, the deserts, the caves. And what, beneath this flying tempest, this storm of destruction, what of our treasured creations will be spared by the caprice of Chance? Perhaps everything that was known to us alone will perish without a trace, but you, who come to destroy us, I greet with a hymn of welcome.

Bryusov's flirtation with fire and brimstone takes a slightly different direction in his story 'The Last Martyrs' ('Poslednie mucheniki', 1906). Here he depicts a group of artists and intellectuals who have taken refuge in a church from an anarchic uprising. The revolutionaries surround the building and tell those inside of the fate awaiting them:

> The experience of thousands of years has taught us that there is no place for old spirits in the new life . . . We shall sever from our body all the dead, all those incapable of resurrection, with the same anguish, and the same ruthlessness with which one amputates a sick limb. Why do you pride yourselves on being poets and thinkers? We are strong enough to create a new line of sages and artists, such as the world has not yet seen, such as you are incapable of envisaging. Only he who is too weak to create is afraid of losing something. We are a creative force. We do not need anything of the old world. We renounce any sort of inheritance, because we shall hammer out our own treasures. We are the future, and you the past, and the present is the sword which you see in our hands.[17]

To this the hero retorts:

> Yes, you are barbarians with no ancestors. You despise the culture of the ages because you cannot understand it. You boast of the future, because, spiritually, you are paupers. You are a cannon-ball, which unashamedly smashes the marbles of antiquity.[18]

The speech is rhetorically effective, but as an argument it does not rise above name-calling. The hero offers no defence of his doomed culture other than its age and continuity, and the intellectuals can find no better way to illustrate their cultural superiority over the barbarians than by abandoning themselves to an orgy of drink and debauchery while they wait for the enemy to break in and destroy them. However, we are not to take this destruction too seriously, because the hero is called Athanatos (Immortal), and it is his narrative, miraculously rescued from the flames, that provides the story and demonstrates the indestructibility of cultural values. Perhaps culture will survive after all,

though Bryusov gives no reason why it should. He is still not really thinking about the unthinkable, only flirting with it.

The defence of culture in 'The Last Martyrs', unconvincing though it may seem, does, however, mark a change in Bryusov's attitude, and, perhaps, a more sincere feeling too. The reason for this probably lies in Bryusov's rejection of the political demands made of art by Lenin in his famous article of 1905, 'On Party Organisation and Party Literature' ('O partiynoy organizatsii i partiynoy literature'). Bryusov wrote a long and cogent attack on it in his 'Freedom of the Word' ('Svoboda slova')[19] immediately after its appearance. And so Bryusov's new barbarians are no longer mysterious foreigners but revolutionaries within the camp.[20] He could not have known of course that the leader of his revolutionaries would anticipate Lenin's contemptuous phrase about 'this or that old building'.

But the idea of the end of culture is implicit in many Symbolist pronouncements in a much deeper sense. The 'art for art's sake' period in Russian Symbolism was shortlived, as the conviction of the superiority of art over life and nature led paradoxically to a moralistic or even missionary sense that if life was so inferior then the artist had a duty to do something about it. The elaborate theoretical superstructure of Russian Symbolism from 1900 onwards was designed to demonstrate the artist's social function and necessity. Either, like Blok, he served as an intermediary between the cosmic powers and this world, decoding, interpreting and even preaching the divine message to humanity; or, like Vyacheslav Ivanov, he saw Symbolism as a potential universal myth which would reunite humanity through a revelation of its common heritage. Both poets could accept only an art that was 'more than art'; 'mere' art was, after all, not enough.

The trouble with this view – a very infectious one, to which almost every critic has succumbed at one time or another – is that if there is something even higher, to which art is only ancillary, then what will happen to art once that higher stage has been reached? Will art still be necessary? At times the Symbolists felt that once it had fulfilled its mission, it would indeed be redundant. Thus Andrey Bely held that:

> Art as it exists in the present world is only a temporary
> measure . . . a tactical device in humanity's struggle with

fate. . . . Thus art will only achieve its true aim when it ceases to exist.[21]

Thus by a strange paradox the art that is 'more than art' is doomed to do away with art. And it was not just their own work that faced such extinction. The apocalyptic hopes which most of the Symbolists placed in an imminent revolution in human culture and the appearance of a new consciousness assumed the comparative worthlessness of even the best in the culture of the past. What appeal could the fumblings and gropings of their predecessors have for those who had arrived?

By none of the Symbolists were these paradoxes more acutely felt than by Aleksandr Blok.

The Futurists

The Symbolists' sense of themselves as the culmination of Western culture could not but make them apprehensive of the future. What did it hold in store for them? a new dawn? or a new dark age? Either prospect seemed to threaten them with oblivion. Meanwhile all the indications appalled them; the apocalyptic hopes of the early Symbolists turned into apocalyptic nightmares. The sense of a new chaos threatening civilization is conveyed incomparably in Andrey Bely's *St Petersburg*; Merezhkovsky entitled his essay on Gor′ky and Chekhov 'The Coming Lout' ('Gryadushchiy Kham', 1906; the title probably deliberately recalls the title of Bryusov's poem) and proceeded to argue that even in art the barbarians with no cultural traditions or spiritual values were taking over. The enemy was already within the gates.

Some of the fears of the Symbolists materialized in the Russian Futurist movement. The Futurists answered Merezhkovsky with the insolent rhyming riposte 'Arrived in Person' ('Prishedshiy sam')[22] and they happily accepted the title of 'huns'.[23] Their manifesto 'A Slap in the Face for Public Taste' ('Poshchechina obshchestvennomu vkusu', 1912) called for the dumping of the classics of Russian literature, from Pushkin to their contemporaries, from the 'steamship of modernity'.[24]

It has often been pointed out that this notorious gesture merely reflects the unthinking subservience of the early Russian Futurists to the Italian Futurists even in their *épatage,* for if the Italians might seem to have a case with their cultural traditions stretching

back over two thousand years, it was absurd for the Russians, who could not quite manage a single century. But the point at issue is not so much the length of the cultural heritage; for, in that case where would one draw the line? A deeper reason lies in the natural instinct of the creative artist, whose relationship to the past contains often enough elements of both reverence and rivalry. He takes what he needs, ideas, images, techniques, from other artists and uses them for his own purposes; what is alien he rejects.

This idea is forcefully expressed in Vyacheslav Ivanov's poem 'The Nomads of Beauty' ('Kochevniki krasoty'), where the creative artist is compared, probably for the first time in Russian literature, to the Huns; he is rootless, a nomad in time, and he ruthlessly plunders and destroys the culture of the past in order that a new beauty may rise from the ruins.

> Вам – пращуров деревья
> И кладбищ теснота!
> Нам вольные кочевья
> Судила красота.
>
> . . .
>
> И с вашего раздолья
> Низриньтесь вихрем орд
> На нивы подневолья,
> Где раб упрягом горд.
>
> Топчи их рай, Аттила, –
> И новью пустоты
> Взойдут твои светила,
> Твоих степей цветы!*[25]

The significance of the poem lies not only in the fact that Ivanov was a Symbolist, but that he was a classical scholar steeped in the culture of ancient Greece and Rome; even so, as an artist he was prepared to jettison this heritage. His attitude is startlingly close to that of the revolutionaries in Bryusov's 'The

*For them the orchards of their ancestors and the confines of their graveyards; to you Beauty has allotted the freedom of the nomads. . . . From your expanses cast yourselves down in a storm of hordes on to the fields of slavery, where the slave rejoices in his harness. Trample their paradise, Attila, and let new suns, the flowers of your steppes, spring up in the virgin soil of the wilderness.

Last Martyrs', and, seen in this light, Athanatos's denunciation of the 'barbarians with no ancestors' looks even less effective. As Zamyatin was to write only a few years later:

> The glory of a feudal aristocrat may consist in being a link in the longest possible chain of ancestors; but the glory of an aristocrat of the spirit consists in having no ancestors, or in having as few as possible. If an artist is his own ancestor, if he has only descendants, he enters history as a genius; if he has few ancestors, or only a distant relationship to them, he enters history as a talent.[26]

The resemblances between artists and barbarians can indeed be disconcerting.

The Futurist rejection of the cultural past, then, for all its apparent barbarism, is not so different from the practice of other artists, or societies for that matter. Each generation has its preferences and its blind spots. Every age selects and distorts, rejecting as much in the cultural heritage as it accepts. The Futurists differed only in being not selective in their rejections but total, and in being more outspoken about it.

Besides the excuse of 'the burden of the cultural heritage' there was another reason too why the Futurists rejected the art of the past. The industrialization and urbanization of the twentieth century had brought unparalleled changes to Western life, and as a result man's perceptions and psychological needs had changed too. If the Symbolists had responded to the crisis of their times by appealing to the timeless and spiritual sides of man, the Futurists seized on the physical and temporal aspects, as if to say that, if any progress towards a better humanity were to be made, these realities too would have to be recognized.

Accordingly the Futurists set their aesthetics firmly in their time and place: they were poets of the city not of the countryside; their textures were characterized by harshness and angularity rather than smoothness; they rejected such traditional 'timeless' themes as nature and love in favour of the specifics of one's immediate predicament: 'I know that a nail in my shoe is more nightmarish than Goethe's fantasy', wrote Mayakovsky in *A Cloud in Trousers*.[27] For the same reasons they were keenly interested in the implications of technology for the arts, – in

photography, the gramophone, and, above all, the cinema; and they argued their case in deliberately anti-aesthetic terminology: for example, they rejected realism because a camera was more 'economical' of time and labour than a paint-brush. The germs of the post-revolutionary LEF movement (to be discussed in chapter 3) can be discerned even at this early stage in the theory of the Russian Futurists.

It was the Great War that finally convinced the Futurists of the rightness of their cause. For here their experiments with language and colour had been justified by the fantastic reality of life itself. The Futurists argued that thus they were not only more artistic in their approach, but also truer to life. Addressing the academic artists of his time, Mayakovsky wrote in 1914:

> It was you who walked past the screaming colours of our canvasses and muttered: 'What crazy colours, you can't find anything like them in nature. There everything is calmer. So choose your colours closer to nature.' And now take your grey mouldering palettes, good only for painting the portraits of woodlice and snails, and try to paint the red-faced beauty of war, whose eyes are the suns of searchlights, in her clothes as bloodred as our determination to thrash the Germans.
> . . . You will reply: 'But why should we paint it? We're not fighters at all, we acccept war as a necessary evil, it can last at most a year, it's irrelevant, and anyway there are lots of other things to paint.'
> No; today everything is the war . . . If you cannot see the victims of Kalish in a bright shiny apple, positioned for a still-life, then you are no artist.
> It is not obligatory to write *about* the war, but you must write *of* it.[28]

The art of the Futurists may be grotesque and even fantastic, but it was still arguably a more faithful representation of an extraordinary reality than any conventional techniques could achieve. Modernity of form was always more important than topicality of content.

Thus their programme at this stage was still primarily aesthetic, not political or social. In another article of this period Mayakovsky begins by lamenting (somewhat perfunctorily) the bombing

of Rheims cathedral; but, he goes on to say, the real reason for
the destruction of art was not German bombs, but the stick-in-
the-mud attitudes of the artists themselves. He then effectively
exposed the facelessness and conventionality of even the best
writers of the time, when it came to treating a contemporary
subject, by combining stanzas from different poets to create a
spoof but plausible war-poem. And the article ended:

> As a Russian I revere every effort by our soldiers to seize
> a piece of enemy territory, but as a man of art, I cannot
> but feel that possibly the whole war was only thought up
> so that someone could write one decent poem.[29]

The Symbolists' attitude to the Futurists is worth a study on its
own. They looked with alarm at these barbarians, but they also
had a sneaking suspicion that the barbaric menace they had so
often invoked had at last arrived before the gates. In the critical
writings of Bryusov and the diaries and notebooks of Blok, the
Futurists appear as a fearsome and incomprehensible force, the
potential harbingers of a revolution in human consciousness. In
this as in so many other of their apocalyptic hopes the Symbolists
were, however, mistaken.

'Correspondence from Two Corners'

The various issues raised in the pre-revolutionary debates over
the culture of the past are best summed up in a small booklet,
Correspondence from Two Corners, (*Perepiska iz dvukh uglov*),
containing twelve letters exchanged during the summer of 1920
by Vyacheslav Ivanov and Mikhail Gershenzon, two of the most
learned and cultured men of their generation. The two men were
sharing a room at the time in one of the sanatoria established by
the Soviet government for the relief of needy intellectuals. The
situation is ironic, but also symbolic, in that the Bolsheviks, who
were dedicated to the building of an entire new culture, should
show such concern for the well-being of representatives of the
culture they had come to displace. It was an irony that was not
lost, at least, on Gershenzon.

Gershenzon's arguments against the culture of the past can
be reduced to the three main charges so far discussed in this
chapter: that the sheer historical accumulation of culture had
become intolerable for both the intellectual and the artist; that

culture had become a means of oppression, both social and psychological; and that it was morally suspect and even dangerous. For these reasons a new and utterly different type of culture was desperately needed. For the Christian it is original sin, for the Marxist the division of labour, for Gershenzon it is the cultural heritage that lies at the root of modern man's disaffection.

Yet these ideas are presented with such wit and subtlety that they are worth summarizing in some detail. For, as Gershenzon is well aware, even this wit and subtlety are the products of the culture that he is decrying, and he fully realizes the frustration of criticizing it by means of a consciousness that has been conditioned by it. For all his hostility to it, he remains, as he readily admits, deeply committed to Western culture and its values, and even his fiercest denunciations are punctuated by avowals of his love and reverence for it. Indeed we may feel that at crucial points in his argument he sometimes pulls his punches. For all that, his case is a powerful one.

> What happiness it would be to dive into Lethe and wash away the memory of all religious and philosophical systems, of all knowledge, art, and poetry, and emerge on the shore again naked, like the first man, unencumbered and happy, and to stretch out one's bare arms freely to the skies, remembering only one thing from the past – how oppressive and stuffy it had been in those old garments, and how delightful it was without them . . . Perhaps we had not really found that glorious raiment so oppressive, so long as it was intact and beautiful and hugged our bodies comfortably; but now that in these last years it has been torn and dangles off us in rags, one wants to tear it off and throw it far away.[30]

The seductive lure of culture has encouraged an indiscriminate acquisitiveness at the expense of man's own individuality. An example is the fascination exercised by the discoveries of the physical sciences. Because they come to us second-hand, and not of our own experience, they have no value, practical or spiritual, to us in our daily lives. We simply know too much; what we have lost is the priceless ability to discover matters of importance for ourselves by ourselves:

I would sacrifice all the knowledge and ideas that I have
gained from books, and, in addition, all the ideas that I
have managed to add to them, for the pleasure of coming
to know personally, from my own experience, just one
original, fundamental piece of knowledge.[31]

But this is just what we cannot do, because we have been too
deeply infected by culture. If this is true of intellectuals and
thinkers, how infinitely more difficult it must be for the creative
artist to 'preserve the power and freshness of his innate inspira-
tion in our enlightened times'.[32]

In art this devitalization takes two forms; first, the denaturing
of the artist's original vision in his actual realization of it, the
result of his compromises with the tyranny of established tech-
niques and traditions; and second, the gulf that yawns between
his unique inspiration and the crude, generalized interpretation
put upon it by the outside world; thus the true Hamlet exists only
in Shakespeare's mind. All great works of art have begun as
libertarian, and have ended as despots crushing the free creativity
of other artists. The world is only interested in institutionalizing
and exploiting the power of art for its own repressive purposes.
For Napoleon's mother, no doubt, Napoleon always remained a
baby, but the rest of the world is allowed to see only the Emperor.
So with art.

Even so, despite this exploitation a divine spark still smoulders
in true works of art, and each man can still recognize something
personal and individual in them, for which he continues to respect
and cherish them. Sooner or later, however, this ambiguous rela-
tionship must collapse, as the feeling of submission gives way to
true creativity. So far, however, all revolutions against culture
have stopped halfway, and have ended by recanonizing it. Only
when we have taken it away from the State and returned it to
the individual, will culture rediscover its purpose.

Naturally Gershenzon can offer no blueprint for the new
culture that will arise 'beyond the perimeter of our present
prison',[33] for any such attempt would necessarily be coloured and
distorted by our present limitations. The only ray of hope that he
can offer is the gloomy one that some historical purpose is work-
ing itself out in these perversions of culture:

Perhaps it was necessary for man to abandon his original freedom for a long period of laws, dogmas and discipline, so as to enter upon freedom again completely transformed. Perhaps. But woe to those generations whose lot is this transitional stage – the stage of culture. It is collapsing from within, as we clearly see today, and it dangles in rags from the exhausted spirit. Is this the way that liberation will come, or will it explode in a catastrophe, as it did two thousand years ago? I do not know, and, of course, I shall never enter that Promised Land.[34]

Ivanov had begun by objecting that art is essentially a liberating force; so long as it is not imposed dogmatically, but is freely assented to, it is not felt as an oppressive burden. But Gershenzon's attacks have made this defence sound like the self-justification of a contented 'slave', and so Ivanov temporarily shifts his ground, seriously weakening his position in the process.

He now argues that culture is only one aspect, though an important one, of religious values; by itself it is valueless. What is important is the launching-pad that it provides for the take-off of the free human spirit. Culture is not just a valley of dry bones: it is a vital supra-temporal link between the generations. He points to the fact that deluges and conflagrations have destroyed culture in the past, only for a new, no less transient, culture to appear in its place. But it is not the transience that is important, so much as the obstinate human determination to rebuild according to the traditions of the past. Memory for Ivanov, as for the Greeks, is the mother of the Muses, and he declares that culture can only be sustained and extended on the basis of the past:

> Not a single step up the staircase of spiritual resurrection is possible without a step downwards into the underground treasurehouse: the higher the branches the deeper the roots.[35]

The fact that culture is rebuilt on the same lines as before does not mean that culture is irremediably evil; rather, that, like all human activities, it is tainted by original sin. Original sin can never be rooted out by the mere destruction of its external signs and manifestations. To destroy culture and the arts is only to resurrect them in the same old limited and imperfect forms. Only faith in God's absolutes can restore true culture and true values.

Gershenzon, of course, cannot accept this argument, because
he regards even the transcendental values and spiritual freedoms,
of which Ivanov speaks, as irremediably compromised by the
culture which they claim to transcend. But there are other weak-
nesses in Ivanov's position too. For if culture is only a relative
value, and if it is necessarily rebuilt according to the same tradi-
tions after each round of destruction, it is difficult to see why he
should be so concerned to preserve this particular culture. After
all, *sub specie aeternitatis*, nothing is going to be lost. Surely, it
is better to be one of Gershenzon's new creators out of personal
experience and initiative than one of Ivanov's inheritors and
rememberers?

The crucial point in Ivanov's argument, which emerges only
gradually from his letters, is that he does not envisage culture as
a static accumulation of knowledge, as Gershenzon seems to do.
As he says, it is not just the memory of the relics of previous
generations, but the memory of the processes by which they
achieved their works. And it is this memory which is of such
value and inspiration to later generations. If we see culture as
'old' then we are allowing ourselves to forget that each of its
achievements was once new. This is the truly liberating inspiration
of the past: that art is not static or dead, but a perpetual chal-
lenge to become creative ourselves. If we feel ourselves trapped
by the culture of the past, it is we who have become weak and
weary, and unable to recognize the new.

At this point the balance of the argument seems to have shifted
back in Ivanov's favour. At any rate Gershenzon is unable to do
more than concede that he did not really advocate total destruc-
tion and repeat that it is just the highest achievement of human
culture which seems to him to be poisoning the life of man today.
It would be very nice if the masterpieces of the past were still
living inspirations, but in fact they have turned into mummies
and fetishes, that tyrannize our minds and souls.

Finally Ivanov quotes the example of contemporary revolu-
tionary Russia: surely here was an example of the return to the
cultural traditions that seemed to have been superseded?

> What is happening at the present moment? The abolition
> of all cultural values? Or their decomposition, proving
> their total or partial decease? Or even a revaluation of

previous values? Undeniably the values of yesterday have
been deeply shaken . . ., but these anarchic tendencies
are not the dominant ones . . . What is called the think-
ing proletariat stands firmly on the ground of the cultural
succession. The struggle is not over the abolition of these
values, but for the restoration of everything in them
which is of objective and eternal significance.[36]

This new generation, even in its destruction, still remains within
the cultural tradition. And so Ivanov offers in place of the image
of Napoleon's mother, contemplating his power, the image of the
Mother of God, seeing Christ crucified, dead and buried, and
risen again on the third day.

For Gershenzon, however, this optimism is quite unfounded.
How can one speak of cultural rebirth after the horrors of the
Great War and the Revolution? Don't they rather show the
bestiality latent within so-called civilized man? Can one still main-
tain any belief in the beneficent progress of history? Stags have
evolved antlers, reasonably enough, but in some types they have
overgrown so monstrously as to bring the threat of self-extinction.
May not the same thing have happened with human culture too?

As for the Revolution's new-found tolerance for the culture of
the past, it is impossible to predict what the proletariat will even-
tually make of this alien culture. They may see it simply as an
instrument of oppression which must be torn out of the oppres-
sor's hands. Even assuming that they can make any use of it, it is
unlikely to be our kind of use, or indeed any that we or the
proletariat can as yet envisage. But it is more probable that sooner
or later they will react violently against it, and create a new
culture of their own, bearing no resemblance to the old.

The argument ends unresolved. In logical terms, at least,
Gershenzon's arguments are irrefutable (it seems to me that
Poggioli underestimated their cogency in his essay on the corre-
spondence).[37] They simply raise the possibility (which must have
occurred to most intellectuals at one time or another) that all our
values are only relative and self-perpetuating, at least until they
are shaken or destroyed by some historical catastrophe.

In the following chapters, however, we shall see some attempts
to apply Gershenzon's principles to the problem of the new
culture, and in the process Ivanov's arguments will come to

acquire more and more power. Many of the arguments and images used by the two men have by now themselves become part of the cultural heritage. Gershenzon may not have been adequately answered in the pages of *Correspondence from Two Corners*, but he has been, to a large extent, by history.

2
The necessity of art:
the last years of Aleksandr Blok

Those who look into the future have no regrets for the past.
Aleksandr Blok[1]

Who will shed tears for the wife in the Book?
For isn't she one of the least of the dead?
But I know that my heart will never forget
That she gave up her life for a single look.
Anna Akhmatova, 'Lot's Wife'[2]

If the Symbolists often thought of themselves as intermediaries between different levels of existence, each of which had to be experienced to the full, then in their ceaseless shuttling between the extremes of human nature they ran the usual risk of all double agents, that of losing their sense of direction and identity, and finally of being 'turned'. Poison and devilry became such familiar attributes of art in their work that they gradually lost the ability to distinguish between the inspirations of divine beauty and goodness and the venomous exhalations of Hell, as did Blok for example, in his famous poem 'To the Muse' ('K Muze', 1908). But whereas for some of the Symbolists such paradoxes were little more than an intellectual game, for Blok they expressed in eschatological terms, the central dilemma behind all his work.

Like others before him Blok realized that the Western orientation of the Russian intelligentsia had alienated them from the vast majority of their fellow-countrymen; but he saw this not just as a regrettable fact of life, but as a moral challenge. The artist's primary duty, he believed, lay with his people, even if this meant opposing those very values of the intelligentsia which had made him what he was. In this chapter I shall discuss Blok's evolution in his last years, from the extreme positions that he adopted in 1917 and early 1918 to his final recognition of the virtues of the classical concept of art.

The awareness of this dilemma was first aroused in Blok by the 1905 revolution, and it comes to the surface in a group of three

works of 1908, all devoted to the same theme: the play *The Song of Fate* (*Pesnya sud'by*), the cycle of five poems *On the Field of Kulikovo* (*Na pole Kulikovom*) and the article 'The People and the Intelligentsia' ('Narod i intelligentsia'). In each Blok contrasts the tiny handful of Russian intellectuals with the masses of the people. They provided only a thin veneer of Western civilization over the elemental realities that would sooner or later reassert themselves. Blok foresaw a second battle of Kulikovo, in which the Russians would once again throw off a hated foreign yoke; indeed, his later writings often suggest that he found the tyranny of Western culture even more intolerable than that of the Tartar barbarians. Russia must be allowed to discover herself. And so in the play *The Song of Fate*, an intellectual (The Man in Spectacles), in a moment of revelation, says of Faina, the allegorical incarnation of the Russian people:

> She has brought us a part of the soul of the people. And for this we must prostrate ourselves before her, and not laugh. We writers live the life of intellectuals, while Russia, essentially unchanged, laughs in our faces. These millions are shrouded in darkness; their powers are still dormant, but even now they hate and despise us. They will come, and, I know, they will bring new constructive principles with them. Will any trace then remain of us? I do not know. An abyss opens within me as I listen to the songs of Faina. These songs burn out our barren and flabby intellectual souls. As I listen to her voice, I feel how weak and puny my voice is. Perhaps, people with new souls have already arrived, and are hiding somewhere in our midst, only awaiting the signal. They look straight into the face of Faina, when she sings the Song of Fate. Do not listen to the words of her song; listen only to her voice; it sings of our weariness and of the new people, who will succeed us. This is the free song of Russia, gentlemen . . .[3]

The antitheses of strength versus weakness, of the collective and spontaneous versus the individual and self-conscious, and the sense of an imminent revelation, or perhaps revolution, reflect in Blokian terms the problems raised in the first chapter. How much of the art created by the alienated Westernized intelligentsia, to

which Blok himself belonged, was meaningful to the vast masses of the people? How much, if any, would outlast its time?

Throughout Blok's writings on this subject there runs a deep feeling of guilt at the thought of living as an artist at the expense of the people who provided his inspiration. This parasitism could only lead to Nemesis, but the fearful welcome that he extended to this prospect is far removed from the paradox-mongering of Bryusov's 'The Coming Huns'. For central to all Blok's thinking is his conviction of the supreme value of art, or at least of artistic inspiration. The value did not lie in the actual 'message' or moral; the visible, paraphrasable content of a work of art provided only, as it were, the staves, over which hovered the 'music', mysterious, irresistible, and unanalysable ('Don't listen to the words of the song; listen only to the voice'). 'Music' remained for Blok a symbol of the source of inspiration, an elemental power, the rhythm of history, an image of divine creativity: 'In the beginning was music. Music is the essence of the world.'[4] It followed from this that the artist was powerless in the grip of his inspiration; he could take no part in directing it and could bear no responsibility for the consequences. His justification consisted simply in blindly obeying the promptings of a higher power, working its will through him as merely one of many possible channels. It followed too that the efforts of the individual artist to do justice to the overwhelming power of his inspiration were pitifully inadequate:

> 'In the light of this knowledge the actual works of artists become secondary, since to date they are all imperfect creations, mere fragments of much greater conceptions, reservoirs of music that have managed to incorporate only a tiny part of what was glimpsed in the delirium of the creative consciousness.'[5]

Even the greatest artist was therefore doomed to fail the power that had chosen him.

Thus the conflict between Blok's view of art as a cosmic force of universal concern, and his simultaneous awareness of the inadequacy and pretentiousness of much of the poetry that he and his fellow-Symbolists were composing led him to veer between hope and despair at ever achieving anything in so compromised a medium:

But I am an intellectual, a writer, and my weapon is the word. I distrust words, but I have to pronounce them. Distrusting all 'literariness', I, nevertheless, look for a literary answer; all of us share a secret hope that the gulf between words and deeds may not last for ever, that there is a word, which can pass into action.[6]

In the years 1908–16 Blok wrestled despairingly with these dilemmas. The changes in society that he had dreamed of seemed remoter than ever. The Great War had shown the essential barbarism of Western culture, and Russia was yet again following its lead. This sense of guilt and helplessness is reflected in Blok's own work; from 1914 onwards he wrote less and less poetry (thirty-seven poems in 1914, ten in 1915, six in 1916, one in 1917). For this reason the revolutions of 1917 brought him renewed hope. At first he co-operated willingly with the Provisional Government and worked on the commission charged with investigating the crimes of the former Tsarist ministers; but with time he came to be dissatisfied with the slowness of the legal procedures. He began to doubt whether anything had really changed, and to fear that he too, both as man and as artist, was still incurably contaminated by the old order. As in 1908 he began to look for another revolution which would transform the whole of life: 'We (the whole world) are trapped in our own lies. We need something totally new.'[7]

On 14 April 1917, Blok summed up his dilemma: the Revolution had given him the freedom to return to art; but was his art required any longer?

I must get on with *my own business*, establish my own inner freedom, make time and resources available for being an artist . . . I have no clear idea of what is going on, and yet by the will of fate I have been made a witness of a great epoch. By the will of fate (not my own *puny powers*) I am an artist, i.e. a witness. Does democracy need the artist?[8]

In the summer of 1917 Blok's diaries demonstrate his total identification with the common people and his eagerness to anticipate and rebut the sneers and jibes of the bourgeoisie. The death of a tree prompted the following reflections:

The tree in front of my window has withered. A bourgeois especially one with an aesthete's snout would simply say: the workers at work again. But first of all you need to know; well, perhaps something heavy had been dumped here, or perhaps there was no way of avoiding it, or perhaps it was simply a very clumsy worker (many of them have not yet acquired the art [*kul'tura*] of precise movements).[9]

In 1908 Blok had contrasted the culture of the people with the culture of the intellectual élite, but now he was extolling even their lack of culture, their inability to perform simple tasks competently. On several occasions he compares the workers to children, ignorant but innocent.[10] It was no longer a question of replacing a false culture by a true one, but increasingly of rejecting all culture as bourgeois.

Blok was acutely conscious of such 'bourgeois' impulses still latent within himself, for example, in his instinctive indignation at the decision of Finland and the Ukraine to secede from Russia. By a characteristic and revealing process of thought he passes from guilt at these reflexes to the thought that perhaps even the noblest ideals had been so compromised by their bourgeois origins that they too were endangered:

> Yesterday I had to tell Ol'denburg that, to be frank, nationalism and even cadetism run in my blood, and that it is shaming for me to love my own, and that a bourgeois is anyone who has accumulated valuables of whatever description, even spiritual ones (this is the psychology of '*la lanterne*' and of all extremist 'senseless' protests); Kuprianovich agreed with me, with the proviso that all this has an economic basis; but my feeling is that it happens of its own accord that intelligence, morality and especially art – become the object of hatred. This is one of the most terrible tongues of the fires of revolution, but it's a fact, and more characteristic of Russians than anyone else.[11]

The revolution, then, had to tread a narrow path between the extremes of anarchy and stagnation, until it had brought Russia and the world safely to their new destination. But what was the role of art in all this? At times Blok felt that the

established culture of Russia had a mission to control and direct the destructive power of the revolution and prevent it from totally annihilating the past:

> And this is the task of Russian culture – to direct the fire on to what needs to be burnt; to transform the energies of Razin and Pugachev into a conscious musical rhythm; to set up obstacles which will not weaken the force of the fire, but organize it, organize these chaotic impulses; the slow smouldering fire, in which there also lurks the possibility of a chaotic flare-up, must be steered into the Rasputin corners of the soul and be fanned into a pyre reaching to the sky to burn out every trace of our sly, servile, lazy lust. One of the means of organization is industrialization.[12]

But on other occasions Blok would reject this view of the revolution as a potentially purifying force, which only needed to be directed by the right hands, as unacceptably paternalistic. History had its own logic, and its own morality. Commenting on the breakdown of rehearsals in the Moscow Arts Theatre for *The Rose and the Cross* (Blok's favourite among his plays, which he was destined never to see on the stage) he wrote:

> If history is going to continue its outrageous tricks, then, perhaps, everybody will be distracted from his proper job and then culture will be finally destroyed, which will be a retribution, probably well-deserved, for the 'humanism' of the nineteenth century. For its monstrous passion for 'gradualism', history will take its revenge in the form of a hysterical accumulation of events and facts, and a shapeless quantity of facts is always deafening, always anti-musical, i.e. meaningless.[13]

And at times his hatred for bourgeois Western-based culture was so intense that he was happy to contemplate the prospect of the revolution flooding Western Europe in an orgy of destruction. During the Tartar invasions Russia had borne the brunt of the attack; in so doing she had saved Western culture but at the cost of delaying and distorting the development of her own. Now it was Russia that was the vehicle of history, and there was no

reason why she should protect European culture from annihilation:

> We are fed up, this is what Europe will never understand, because all this is so *simple,* and in their muddled brains it's so confused. But though they despise us more than ever, they are mortally afraid of us, I think; because, if it really came to it, we would happily let the yellow races through Russia and flood not just the cathedral at Rheims, but all their other holy department-stores. We are a dam, but there is a sluice in the dam, and from now on nothing can stop anyone from opening that sluice 'in full awareness of his revolutionary power'.[14]

Indeed this kind of blanket destruction sometimes seemed to Blok to be the only way forward. In his best known formulation of the idea, the poem 'The Scythians' ('Skify', 1918), the phrase 'the savage Huns' is used to recall the imagery of Ivanov and Bryusov.

Throughout the summer and autumn of 1917 Blok's sympathies oscillated between the Bolsheviks and the other parties. At times he felt that history was working through the Bolsheviks:

> The Bolsheviks are just a group acting on the surface, and behind them there lurks something that has not yet manifested itself.[15]

But in the elections of July 1917 he voted for the S.R.s. We do not know Blok's immediate reactions to the Bolshevik coup because he later destroyed his diaries and notebooks relating to this period, but the next surviving lines and above all the poem *The Twelve (Dvenadtsat'*, 1918) reveal his total identification with the new revolution. He was not worried by the Bolsheviks' disregard for the legal and democratic niceties; such concerns seemed trivial by the side of the cosmic events that were unfolding. On 15 January he wrote in his notebook the phrase: 'The end of the historical process.'[16]

The chaos and destruction of the first days of the revolution therefore seemed to him to be only temporary and insignificant side-effects of the colossal process of building a new culture. In his notes on a conversation with Yesenin at the beginning of 1918 he wrote:

The destruction (of churches and the Kremlin which doesn't worry Yesenin) is only for the hell of it. I asked him if there weren't any who destroyed in the name of higher values. He said 'No' (are my thoughts ahead of their time?)[17]

Despite Yesenin's categorical answer Blok remained confident that the destruction brought by the revolution was primarily creative (he had quoted Bakunin's words to this effect as long ago as 1906).[18] In the article 'The Intelligentsia and the Revolution' (Intelligentsiya i revolyutsiva', January 1918) he wrote:

Don't be afraid. Do you think that a single grain of what is truly valuable can be lost? Our love is too small if we tremble for what we love. 'Perfect love casteth out fear'. Don't be afraid of the destruction of Kremlins, palaces, pictures, books. We must preserve them for the people; but if they are lost the people will not lose everything. A palace destroyed is no longer a palace. A Kremlin wiped off the face of the earth is no longer a Kremlin. A Tsar who has fallen off his throne is no longer a Tsar. The true Kremlins are within our hearts, the true Tsars within our heads. The eternal forms that have been revealed to us can be taken away only with our heads and our hearts. Did you think that the revolution would be an idyll? That creation need not destroy anything in its path?[19]

Here again we meet the old paradoxes of placing a supreme valuation on culture. Just because it possesses eternal values that are not of this world, its temporal visible manifestations can be sacrificed almost without a qualm. But how long can such values survive without any material form? Surely hardly beyond the memories of the last generation to see them. Even more dangerously, Blok's ecstatic confidence in a new Golden Age to come made him feel that anyway a few lost works of art here and there would not be too serious. What was fit to survive into the new age would mostly survive. A rough sort of justice would be done, but it would still be justice.

Woe to those who think to find in the revolution merely the fulfilment of their dreams, however lofty and noble

they may be. The revolution, like a whirlwind, like a snowstorm, always brings something new and unpredictable; many are cruelly deceived 'by it; much of value is mutilated in the maelstrom; frequently the undeserving are washed up ashore unharmed. But these are only the details; it doesn't alter the general direction of the current, nor the fearful and deafening roar of the torrent. This roar is always and inevitably – *about something great.*[20]

It can be seen that the emphasis is placed rather more on the roughness than on the justice. Undoubtedly, Blok did succumb at times to the fascination of violence and destruction. In mitigation it may be said that he was later to discover that these hopes and sacrifices were delusions, and he was to pay for this recognition with his life. Values, even when threatened by corruption, are still better than no values at all. In our time the romantic cult of violence is more fashionable and widespread than it was in 1917. Blok at least had the saving grace of being an unfashionable minority – he knew what he was destroying, even before he had destroyed it.

It must be remembered too that Blok did not spare himself from his indictment of the Russian bourgeoisie and intelligentsia. In his article 'Russian Dandies' ('Russkiye dendi', 1918) he wrote up a conversation he had had with a young intellectual, Stenich. Stenich had declared:

We are all worthless, we are flesh of the flesh, bone of the bone of the bourgeoisie . . . I am intelligent enough to understand that it can't go on like this, and that the bourgeoisie will be destroyed. But if socialism does materialize, nothing remains for us but to die; we still have no conception of money; we are all well off and utterly incapable of earning anything by our labour. We are all on drugs and opium; our women are nymphomaniacs. We are a minority, but we are influential among the young; we pour scorn on those who are interested in socialism, work and the revolution. We live only for poetry; I have not missed a single collection in the last five years . . . Nothing interests us but poetry. We are empty, utterly empty.[21]

This revelation of the bankruptcy of the aestheticism of the intelligentsia ends with the young man turning on Blok:

> You are to blame that we are like this. You and all you contemporary poets . . . We asked for bread and you gave us a stone.

Blok ends with the comment: 'I didn't know how to defend myself; and I didn't want to; and anyway I couldn't.'[22]

The article raises the dilemma of the artist in its most agonizing form. Is art simply escapism and, in times of crisis, a dangerous luxury? Is the artist responsible for the interpretations of his work and the uses to which it is put? Is art quite inseparable from the society which has produced it, a class with leisure to read and cultivate its good taste, and the comfortable assurance that cultural superiority justifies a superiority in material terms as well? During 1917 and the early part of 1918 Blok was ready to answer 'yes' to all these questions, and one can only admire him for the courage with which he faced them.

They form the background to his great poem, *The Twelve*. The immediate inspiration came from the dispersal of the Constituent Assembly by the Bolsheviks on 6 January 1918, and, as Anatoliy Yakobson has pointed out, the murder of Shingarev and Kokoshkin in their hospital beds later the same night.[23] The poem celebrates the destruction and desecration of the hopes and ideals of the Russian intelligentsia over the previous century, and, finally, on top of everything else, introduces the figure of Christ at the head of the Red Guards. In the last nine lines the violence and cacophony of all that has gone before suddenly yield to more conventionally 'beautiful' imagery and mellifluous rhymes and rhythms. The image seems to be alarmingly like that of 'Gentle Jesus, meek and mild', but the context is now the Day of Judgement.

In the reunion of these two seemingly contradictory images lies much of the power of the poem, but it also raises unanswerable questions. Who is this Christ? He is 'ahead' of the Red Guards, but how far is He identified with them here and now, and how far does He stand for the new age, as yet out of sight? Do the Red Guards recognize or accept Him as their leader? – after all they shoot at Him. Is He the old Christ or a new one?[24]

The questions are unanswerable because Blok himself did not know the answers (the poem was written in a state bordering on

ecstasy) and his own complex and changing attitudes to the poem would make a study in themselves.

In the usual interpretation of the poem the figure of Christ stands for the new culture that will spring out of the ruins of the old – indeed the suddenness of His appearance suggests that it has already arrived – as Christianity had emerged from the collapse of the Roman Empire (Blok himself seemed to sanction this interpretation in a group of articles beginning with 'Catiline', 'Katilina', 1918). But it is disturbing that the only image Blok can find for the new age is the central image of the culture that he saw and heard crashing in ruins around him.

Evidently there were times when Blok rebelled against this image as too weak and gentle an ideal to stand at the head of the revolution. As he wrote in his diary for 10 March 1918: 'I myself sometimes hate this effeminate apparition'.[25] Perhaps, even in January 1918, Blok was afraid that the revolution had not gone far enough and was threatened by the few old values that it still seemed to retain. Yet, even as one argues this case, one is aware of the extraordinary blessing that Christ seems to confer on the Bolsheviks – the surface meaning of the poem is undeniable too. The two attitudes combined form the culmination of Blok's conflicting attitudes to the culture of the past.[26] Many of Blok's own later writings are, directly, or indirectly, concerned with understanding his own poem.

These conflicting possibilities in the figure of Christ explain how it was that Blok could be both assured of the irresistible advance of a new historical era, and also alarmed by the dangers of the revolution being sucked back into the evils of the bourgeois past. In his note-book for 24 February 1918 he recorded without comment the prophecy of A. G. Gornfel'd: 'The Bolsheviks are creating a huge class of petty bourgeoisie, with all its typical tendency to rapacity etc.'[27] The article "Fellow-citizens' ('Sograzhdane', April 1918), sums up his horror at the reappearance of bourgeois tastes. What was alarming was not just the reappearance of the old bourgeoisie, but the fact that the workers and the peasants were aping the same contemptible airs. The new age that seemed to have dawned in January 1918, no longer seemed so imminent. Without retracting a single word of *The Twelve*, Blok now began to look at it rather differently.

In his article 'Catiline', written in May 1918, Blok recounts

the history of the famous Catiline conspiracy and then moves on to the theory that Catullus in his ode 'Attis' was somehow referring to this failure. The interrelation of poetic inspiration and social revolution deliberately recalls the creation of *The Twelve*, but the real significance of the article lies in Blok's reinterpretation of its central symbol. In *The Twelve* Christ had placed Himself at the head of the twelve Red soldiers, but the Catiline conspiracy is not directly linked to the coming of Christ; it is merely symptomatic of the greater revolution already imminent. Even though as a revolutionary Catiline might have failed, he had hammered the first nail into the coffin of

> the 'great culture' which had given birth to and was still to give birth to so many treasures, but which in a few decades was to hear a final and everlasting sentence in a different court, a court that was no respecter of persons, the court of Jesus Christ.[28]

Thus the once short distance between the Red Guards and Christ has lengthened to an indeterminate number of years and even decades. This did not alter the significance of the revolution one whit: when Christ was born the final fall of the Roman Empire was still centuries away, but the crucial event by which the new era would date its calendar, had already occurred, hardly noticed or appreciated by the outside world. It meant simply that the Bolshevik revolution was not, after all, the last word; it was just the beginning of the end. The final outcome was as unforeseeable as the triumph of Christianity had been.[29]

A rather more elaborate version of the same argument was to be developed in 'The Collapse of Humanism' ('Krusheniye gumanizma', March–April 1919). Here Blok tried to show that just like the Roman Empire in the fifth century A.D., so European civilization had overreached itself and lost its roots. Western culture since the Renaissance had been built on the 'rediscovery of classical civilization, by which the mass of the people had never been touched, indeed they were the same people as the barbarian masses that had finally swamped that civilization and wiped the Roman Empire off the face of the earth.'[30] It followed that the same fate now awaited the West.

Russia's role, then, as in the days of the Scythians and the Huns, was to revivify the world with a new, even if seemingly

barbaric, culture. Just because she was so backward (as in the old Slavophil argument) and had been spared the corruption and decay of the West, she was closer to the elemental essence of culture, and so better placed to set the world straight again:

> In Russia was raised the (for a European) indiscreet question: 'which was better, boots or Shakespeare?'; and in Russia discussions long forgotten in Europe often raged over the function of art, discussions, which I would call truly cultured, even though in their primitive naiveté they were all too alien to the spirit of 'civilization'.[31]

Because the elements were now expressing themselves through the masses the old bourgeois intelligentsia was incapable of recognizing or protecting the new face of culture. It was no paradox then to call the barbarian masses its true guardians:

> If we are to talk of bringing the masses to culture then it is by no means certain who has the greater right to bring whom: the civilized – the barbarians, or *vice versa,* since the civilized are now exhausted, and have lost their cultural value; at such a time the unconscious guardians of culture are the young and fresh barbarian masses.'[32]

This culture is not to be mocked; it is alarming and possibly even fatal for those who have been nourished by the old world:

> This music is a wild chorus, a formless howl to the civilized ear. It is almost unbearable for many of us, and today it will not seem funny if I say that for many of us it will be fatal. It is ruinous for those achievements of civilization which had seemed unassailable; it is totally opposed to our familiar melodies of 'the true, the good and the beautiful'; it is utterly hostile to much that has been instilled in us by our upbringing and education in the Europe of the last century.[33]

The Russian intelligentsia was therefore caught in a terrible dilemma: as humanists they could never accept this new culture; but if they could not accept it they would find themselves cut off from all culture, both of the past and the future. The clock could not be put back, and if Europe would not recognize these truths then she would have to be forced to recognize them.

In fact, by the time that Blok came to write 'The Collapse of Humanism' his thoughts had already begun to take a new turn. His earlier fascination with violence 'in the name of higher values' was wearing off in the face of the nihilism that he saw around him: 'Life is becoming monstrous, hideous, senseless, Robberies everywhere. The Mendeleyev flat with its *peredvizhnik* archive is in danger of being lost.'[34] The touchstone for judging the new order was still art, and he was coming increasingly to realize that his own poetry and inspiration were of no interest or use to it. He recorded laconically in his diary the verdict of a publisher's reader: 'My verse is of no use to the workers.'[35]

On 6 January 1919 Ionov, the notoriously insensitive[36] chief editor of the State Publishing House (Gosizdat) rang up Blok to discuss the possibility of bringing out a new edition of *The Twelve*. Blok asked him ironically if he didn't think the poem was a bit out-of-date by now. Ionov willingly agreed:

> Absolutely true. One comrade has already made this point, but we have decided to publish the best works of Russian literature, even if they have only a historical significance.[37]

Reflecting on this barbarism from a cultural representative of the new government, Blok went on to raise profound moral (and indeed prophetic) questions about the future of art under such circumstances. Again the guilt that he felt as a privileged intellectual is in evidence, but it is no longer allowed to dictate a total rejection of culture. This long passage deserves to be quoted in full, because its range of reference, from general questions about the practical needs of culture to its unassailable value, from the guilt, both social and moral, of the individual artist to the understandable but empty distrust and hatred felt for him by the masses, shows clearly that for Blok art stood in the centre; all questions come from and ultimately return to the problem of art. Although his conclusions are pessimistic and still overshadowed by his sense of guilt and his acceptance of contempt and hatred as just retribution, this is now seen as a historical tragedy, which will eventually be righted. The value of art still remains whatever the crimes of individual artists.

> Besides all this is *horrifying*. Who will triumph this time? Total anarchy (the provinces are deluging the ministry

with complaints at their publishing the classics instead of
political pamphlets) or a 'new cultural order'?

I don't know.

Is it justifiable, for example, to utter the admirable
sentiment: 'there is more revolutionary ardor in a single
line of a great writer than in a dozen rubbishy pam-
phlets'? (that's how the ministry could answer these
complaints).

No, it's not really justifiable, because it's only partly
true, it's an evasion; of course, the pamphlet is rubbish,
but people read into it more than is written there, just
because it is so worthless and rubbishy, and this inspires
more confidence in a poor reader than a long and flawless
book. And in a great work of genius the poor and
embittered may find only what will sow yet further
bitterness in his crushed, broken and already embittered
soul.

All culture, scientific and artistic, is demonic. Indeed
the more scientific or the more artistic, so the more
demonic it is . . . But this demonism is a force. And force
means the defeat, the humiliation of the weak. The
wretched Fedot [a peasant who had joined in the plunder-
ing of Blok's former country-home Shakhmatovo] has
violated and desecrated *my* spiritual values, over which
I still weep *demonically* in my dreams. But who is
stronger? I, who weep and have suffered so much, or
Fedot, even assuming that he had managed to acquire
what he is incapable of using (and of course he didn't
acquire it, none of them did, because no doubt, they all
took what they could, and in Shakhmatovo there was
little worth taking). For Fedot, a twenty-kopeck piece
and a pre-revolutionary rouble are equivalent to what
for me is a source of priceless inspiration, ecstasy, tears.
So, then, I am the stronger and will remain so, and this
power I have acquired by one of my ancestors having
sufficient leisure, money and initiative, by the fact of
his proud, independent children (though in some respects
also degenerate), the fact that they were educated and
taught (taught by their blood, taught by their being
spared the need to earn their bread in the sweat of their

brows) how to create lasting values out of nothing, 'how to turn nettles into diamonds', and then to write books, and then to live by these books at a time when those who have not learnt to write them, are dying of starvation.

I remember when I experienced the flame of a deep love, based on the same old basic elements, but with a new content, a new meaning, from the fact that Lyubov' Mendeleyeva and I were 'special people'; when I experienced this love, of which people will read in my books after my death, I used to love galloping through a wretched village on my fine horse; I loved asking the way, which I knew perfectly well, either to show off in front of a poor yokel or a pretty girl, so that we could flash our white teeth at one another and our hearts flutter in our breasts, for no particular reason, except youth, the damp mist, her swarthy glance, and my own tapered waist. All this didn't in the least undermine my real love (or did it? What if my later falls and corruption began here?), but rather intensified my youth, and with it my great 'otherworldly' passion.

They *knew* all this. Knew it far better than I did, for all my self-awareness. They knew that the master was young, his horse handsome, his smile attractive, that his bride to be was a beauty and that both were 'masters'. And whether the masters are decent or not, just wait, one day we'll show them.

And they did show us.

And they're still showing us. And so even if with hands dirtier than mine (and I'm not sure of that, and, O God, I don't mean to condemn them for it) they throw out of the printing-house the books of the comparatively deserving (in the eyes of the revolution) writer A. Blok, *even then I cannot complain.* It is not their hands that throw out my books, or not only theirs, but those distant unknown millions of poverty-stricken hands; and it is watched by millions of the same uncomprehending, but starving, agonized eyes, which have seen a handsome well-fed 'master' prancing down the road. And there are other things too that various other eyes – effectively the same eyes – have seen. And now those eyes twinkle –

how's that, the prancing, ogling master, and now the master's on our side, is he? On our side, is he just?

The master's a demon.

The master will wriggle out of it, and he'll always remain a master. But we just think 'the time may be short, but while it's ours, it's ours'.[38]

Of crucial importance in the evolution of Blok's outlook was his appointment to the Repertory Section of the Theatre Department of the Ministry for Enlightenment, and later to the directorship of the Grand Dramatic Theatre. Unable to write more than a handful of poems during these last years, he found his main purpose in life in recreating on stage the great dramatic masterpieces of the world.

It was not just a personal satisfaction that he drew from this work; he felt that he was playing a vital role in preparing the masses to create their own culture. It is revealing, then, that, despite all the theoretical reservations he had recently been expressing about the moral ambiguity of art, he turned instinctively to the established classics of the Western theatre. He deliberately avoided topicality of subject-matter and modernistic productions, arguing that his chief obligation was to keep the old culture alive so that the future could see it as it was, and make its choice accordingly. It was typical of him not to make any utilitarian or educative claims for his work; art for Blok was an absolute value, in whose light other values should be judged. But, aware of the possible distortions and limitations imposed by their common bourgeois upbringing, he warned his actors and producers against any 'interpretation' with its risks of oversimplification and didacticism:

> We must not impose anything of our own; we must not preach; we must not take the stage with any feeling of superiority or condescension; we must lovingly put into the workers' hands everything – without any exception – that we know, love and understand. Ours is not to select, but to indicate. We are not shepherds and the people are not sheep. We are only better informed, and the final choice does not remain with us.[39]

Blok was confident that, freely entrusted with this task, the people would, admittedly, probably only after many generations, rise to the challenge, and that:

> even the most complex of the thoughts uttered by culture would sooner or later be taken up by the whole world, the whole people, and would bring an unexpectedly rich harvest; even the tenderest flower of art would not wilt as it passed from the hands of a thousand into the hands of tens of thousands.[40]

Accordingly he was not prepared to compromise on artistic standards in the hope of making things easier for his audience. The power of art must not be diluted – such dilution had indeed been one of the crimes of the bourgeoisie – for only so could art be recognized for what it was. In time the discredited bourgeoisie would have their places taken by a new class of people, spiritually starved, but attentive and sensitive.

Events seemed to justify Blok's optimism. After only a few productions, on 21 March 1919, he told his company proudly:

> Just how directly and powerfully art can act when it is unshackled we can see even today, for example, in some works of the Proletkul't or at theatre productions, where a mass of new people with unprecedented eagerness and profound attention listen to torrents of speeches (for example, those of the Marquis of Posa) that are totally imbued with sheer art and create a truly aesthetic impulse.[41]

And the following year he was able to declare:

> There was something that attracted a new kind of spectator into our theatre, there was something that he liked. And that this was a new kind of spectator, we have all seen with our own eyes.[42]

Encouraged by this success he advocated publishing the classics of world literature in cheap mass editions, and he opposed the move to supply them with ideologically slanted introductions. He felt that there was a vast unsatisfied demand that was not being met, and that people were being fobbed off with junk from the private printing-houses or crude propaganda from the official

ones. Blok had of course already raised this problem in his reflections on Ionov, but he now answered his doubts with a new confidence:

> I have heard various weighty opinions from Communists to the effect that ultimately the classics cannot create the intensity of life which is required at the present exceptional moment of history. My reply is: agreed, possibly, they can't, but firstly, you can't just assume this *a priori,* you can't just bury the art of twenty-five centuries in the ground at a time when only a tiny handful of people have experienced the effect of its poisons, both medicinal and harmful . . . Secondly, our moment in history is genuinely exceptional and there will indeed be a re-examination of the art of these twenty-five centuries, but it will not be carried out by our Communist comrades alone. Thirdly, there just is no art, other than the art of these twenty-five centuries, 'classical' art in the broad sense, and so inevitably it alone, in all its innumerable ramifications will have to face the judgement of history . . . The theatre will either flourish again or choke; but the deciding voice in the struggle between the iron forms of the old art and the spring shoots of the new, as yet unborn – does not and cannot belong to us.[43]

But with the deepening of social chaos all around Blok began to lose his confidence in the unaided triumph of culture. He was appalled by the continuing illiteracy of new prose and poetry; there seemed to be no sign of the cultural rebirth of which he had dreamed: 'One begins to be terrified for culture – is it really irreparable, is it really buried under the ruins of civilization?'[44] Everywhere he seemed to see not the creation of a culture, but its extinction:

> Everything is even filthier than it was last year. Everywhere there are signs of filth, deliberate or otherwise . . . Nobody is willing to do anything. In the old days millions of them had worked for a few thousand. That's the explanation. Why should these millions want to work? And how are they ever going to understand Communism as anything but robbery and gambling?'[45]

If Blok still seems to be finding excuses for the proletariat here, they are not comforting ones; there is no prospect now of culture, new or old, ever coming to the masses. And at the end of 1919 Blok wrote: 'A symbolic act; on the Soviet New Year's Eve I broke up Mendeleyev's old desk.'[46]

In the struggle to protect culture against the onslaught of barbarism Blok now felt that his theatre stood in the front line. He no longer argued that his role went no further than presenting plays for the proletariat to take its pick of; instead, he declared that his theatre should be a 'leader'[47] (the Russian word *povodyr'* has the sense of a 'leader of the blind'). He was no longer so sure that the masses could be trusted to recognize true art, and so he began to adopt utilitarian arguments and to emphasize the 'relevance' of a particular play to the present:

> we need to present these plays in such a way that the public should recognize something familiar, the grandeur of the age, of which, for better or for worse, we are fated to be witnesses; so that the audience should realize that the people of the sixteenth and eighteenth centuries play their part in the events of 1919, and that this is not a mechanical repetition of history, but a new attempt to grasp and make sense of our own time.[48]

In introducing a new series of plays, 'Historical Tableaux', Blok explained that its primary function was educative. His earlier uncertainty (in 'The Collapse of Humanism') as to who had the greater right to bring whom to culture, the civilized the barbarians, or *vice versa,* was now resolved once and for all. It was clearly the educated classes who were able to give a lead, and the illiterates, who, for all their distrust of any kind of education imposed from above, would have to be brought to culture; the advantage of the theatre was that it offered a comparatively painless way of achieving it. By a drastic shift in his thinking culture and the 'elements' were no longer identified, but seen actually as hostile to one another:

> . . . the whole series must illustrate the struggle of two principles: culture and the elements in all their possible manifestations. The 'elements' are to be understood both in the sense of nature and in the sense of unbridled human nature. The concept of the 'elements' includes

similarly backward, unyielding matter, earthquake, revolution, and possibly too the backwardness and indifference of man.'[49]

This new position represents a complete break with the romantic assumptions that had governed Blok's thinking at least since 1908, and opens the way for his final rediscovery of classical values. The earlier Apocalyptic interpretation of the revolution as 'the end of the historical process' is abandoned once and for all. At first Blok tried to replace it with a cyclic conception of history, as in the prose foreword of July 1919 to *Retribution (Vozmezdiye)*, which 'arose under the pressure of my constantly growing hatred for the various theories of progress'.[50] At the end of September in a speech to his theatre company he said:

> You know that the decline of the initial impulse, the ebbing of spiritual and physical power is our earthly lot, the most painful of the evils which we have to bear. So too the tide of the elements ebbs and the movement of the revolution exhausts itself . . . The cultural impulse declines too . . . But a decline will be followed by a new rebirth. The great French revolution will be followed by 1830, 1848, 1870, 1917. This new element will awaken again in Europe.[51]

It was not easy for him to accept the idea of cyclicism; one of his most desperate poems, 'Night, a street, a lamp, a chemist's' (Noch', ulitsa, fonar', apteka') had been devoted to a nightmarish vision of just such a universe. By temperament he was one of those who looked for a direction and purpose to history. So he tried to believe that a way out of this cycle would eventually appear: 'One day man will learn, and the crowd will learn too.'[52] But until that happy day the example of classical art provided a lifeline; art was no longer for Blok a breath of the elemental powers of the cosmos but something quite opposed to them, even a talisman against them. Its medicinal qualities now outweighed its poisons.

> There is in the great works of the past, even the distant past, a characteristic, imperishable intoxication, a joy which is generously spilled over anyone who approaches them with an open heart; the ideas and the situations may be different from ours; but in every great work the

main thing is something which has no name, which defies explanation or analysis . . . It was this creative spirit of Shakespeare and Schiller which helped us all in 1919 because we believed in its absolute and continuing vitality. But it is not easy to believe even in this in such times as ours when the lives of men are broken from top to bottom, when at times it seems that nothing has the right to survive from the old world. In order to believe in the creative spirit of great works one must be infected by this spirit and experience its timeless power on oneself.[53]

Blok had turned his back on his earlier conception of the pitiful inadequacy of actual works of art beside the overwhelming experience of artistic inspiration; it was now the artists and their works who defined for him the nature and the mystery of art.

At the jubilee celebrations for Mikhail Kuzmin on 29 September 1920 Blok said:

In your person we hope to preserve – not civilization, which has never yet existed in Russia, and may never exist – but something of Russia which has existed, still does exist and will continue to exist.

The most miraculous thing is that much which seems to us unassailable will pass, while rhythms will never pass; they are as fluid as time itself, and unchanging in their fluidity . . . We all know how difficult art is, we know how capricious the soul of the artist is. And with all our hearts we pray that eventually a milieu may be created where the artist can be as capricious as he needs, where he can remain himself without becoming a civil servant or a committee-man or an academic. We all know that this is essential if the artist is to leave behind a legacy as essential to men as bread, even though today they naggingly insist on 'utility' from marble, and scratch their ephemeral words on the same marble, only to understand tomorrow that 'this marble is a god.[54]

It is just the individuality and caprice of a work of art that constitute its value. The grandiose claims for the social, revolutionary and cosmic significance of art have dropped away; the elements have disappeared; only art remains. The cult of the

'wild and formless howl' of the barbarians has been replaced by the classical virtues of restraint, balance and harmony. Fittingly enough Blok's last public speech was devoted to the one figure in Russian culture who embodies just these virtues, Pushkin:

> [The poet] writes in verse, that is, he brings words and sounds into harmony, because he is a child of harmony, a poet. What is harmony? Harmony is the agreement of universal forces, the order of the life of the universe. Order is cosmos, in contrast to disorder – chaos . . . Chaos is the primordial, elemental, formless; cosmos is ordered harmony, culture; harmony is created out of chaos.[55]

In his last poem 'To the Pushkin House' ('Pushkinskomu domu', February 1921), Blok himself managed to demonstrate just these virtues. It is a marvellous, apparently totally unBlokian poem, light and dancing with a wry but not ironic smile. It is the only one of Blok's poems which evokes the classical past (the rhythms pay homage to Pushkin's triumphant 'Feast of Peter the First', 'Pir Petra Pervogo'). It is the exemplification of his belated discovery of the culture of the past.

Thus to reprove Blok, as Mayakovsky did in his 'Alexander Blok is dead' ('Umer Aleksandr Blok', 1921) and later in his *Good!* (*Khorosho!*, 1927), for accepting the revolution only with a large 'Yes, but . . .' is to oversimplify the tragedy of Blok's last years. He began by welcoming the destruction of the past almost as wholeheartedly as Mayakovsky, and only gradually withdrew from this position under the pressure of events and the inspiration of his work in the theatre. Marxists may well regard Blok as an example of the kind of liberal intellectual who loses his nerve when the going gets rough. I think that a reading of Blok's works shows that he did not lose his nerve; it was far harder for him to abandon his earlier conceptions than to stick with them. As he came to see that the last years of his life had been spent chasing up a blind alley, he had the courage to re-examine all his previous assumptions. It was not easy.

> In order to destroy something on a site which is to be reoccupied, you must have something ready to reoccupy it with. – In order to combine disparate elements together

in one place you must ensure that the place is fit for their combination (capable of combining them). In order to do anything, you must know how. – To force someone to do something which he does not know how to do is useless and even harmful. In order to write in a given language, you must know that language, or at least be literate in it. If you waste the time and energy of a man on trivia, you should not expect him to contrive to expend the same time and energy on more serious matters.[56]

Elementary truths, but the truth of every one of them had been questioned by Blok in 1917, and had been revised in the light of hard experience. They are not to be read so much as criticism of official vandalism, or even of the barbarism of the masses, but as directed primarily at Blok himself. But by the time Blok had come to the recognition of these truths it was too late to go back.

Life has changed (it is changed, but it is not a new life, not a *nuova vita*); the louse has conquered the whole world, that's an accomplished fact, and everything can change now only in a direction contrary to the one which we have loved and lived by.[57]

3

The redundancy of art:
Soviet and Marxist views of art in the 1920s

Comrade Polonsky! We will not allow
The fanciers of the old aristocratic ways
To flaunt their calluses,
Earned over centuries of service to Venuses
In the faces of our builders.
Mayakovsky, 'Vyacheslav Polonsky and the Venus of Milo'[1]

The contradictions inherent in the Marxist attitude to art came into the open soon after the Bolshevik seizure of power.

One of the first decrees issued by the Communists called for the removal of all monuments to the Tsars and other enemies of the working-class. In fact only a few were actually destroyed, for Gor'ky protested energetically in the pages of his newspaper *Novaya zhizn'*, and the policy was quietly dropped. This act of self-righteous revenge on the past proved to be untypical, for the Bolsheviks were acutely sensitive to the charges of vandalism that were levelled at them from all sides, both within and outside Russia (Gumilev even identified them with the long-awaited Huns).[2] The pendulum soon swung the other way: special provisions were made for preserving and protecting works of art, support was given to artists and intellectuals, regardless of their ideological and political persuasions, and even anti-Bolshevik works were tolerated. Indeed, by the standards of Western governments the Bolsheviks' cultural policies of 1917–20 were a model of enlightenment and generosity, all the more amazing in view of the economic chaos of the times, the life-and-death struggle of the Civil War, and, it must be admitted, the brutality that was later to characterize Soviet policies in all cultural matters.

This brave start seemed to support the Bolsheviks' claim that Communism would inaugurate a Golden Age of culture. As Trotsky wrote on the first page of his *Literature and Revolution,*

the arts were 'the highest test of the vitality and significance of each epoch,'[3] and it appeared as though the Communists were willing to be measured against this test. They were untroubled apparently by any thought of possible disagreements between the Party and the artists; after all, culture too was essentially progressive, and it seemed a natural, and indeed a very respectable ally. But even in these comparatively enlightened years, the seeds of future troubles were being sown.

For the Marxist the fundamental principles of economic production and distribution determine the nature of the entire superstructure, culture, political organization and all other forms of social and individual life. Strictly speaking, then, both the culture and the politics have equal status as reflections of the underlying economic realities. In the early post-revolutionary period many artists, whether Communists or not, assumed this equality as a matter of course. It was difficult, however, for the politicians to acccept this. It seemed absurd to put the productions of a few artists beside their own historic achievements. Armed with their mastery of the dialectic and justified by their success in the revolution and Civil War, they felt that they had gained control over the mechanisms of history and so that politics was no longer part of the superstructure, but the basis, even the prime mover of history; 'politics commands all', in the words of Chairman Mao.

There was a further difficulty too. The Bolshevik Party was primarily a movement of middle-class intellectuals who had forsworn their natural class allegiances in order to dedicate themselves to the cause of the proletariat. Now that the revolution had been succcessfully achieved, it might seem that the Party should stand aside and allow the proletariat to come into its inheritance. Despite this, however, most Bolsheviks felt that they still had a duty to ensure that the proletariat, having been put on the right road, should stay on it. The proletariat was ignorant and inexperienced, they themselves well-tried and comparatively cultured: what more natural than that they should feel that they could still lend a guiding hand to the unfledged class? It never occurred to them that in cultural matters their tastes and values could be questioned as limited or old-fashioned, or even plain bourgeois; instinctively, they considered that these were absolutes. Like most relativists, in recognizing the motes obstructing

the vision of even the greatest men, they forgot to apply the same correctives to their own assumptions.

For most people, then as now, culture was primarily a passive concept: it was seen as the acquisition of culture and the ability to appreciate it; these seemed to be prerequisite for the creation of the culture of the future; in such a scheme the problems of the culture of the present came a rather poor third. For others, however, culture was primarily an active term; it meant the creation of culture. For such people the priorities were the exact opposite of those of the first group. For them the culture of the present was all-important, for this was what would determine the nature of the culture of the future. In this view the culture of the past was irrelevant, if not actually harmful.

These fundamental differences were compounded by the peculiar nature of the Bolshevik revolution, and its attempt to take a short cut through the historical process. The Party naturally argued that just because of this historical discontinuity, there was an urgent need to educate people in the culture of the past, and so prepare them for the creation of their own. Their opponents argued that, on the contrary, the revolution had provided a perfect opportunity, further enhanced by the emigration of many leading artists of the previous generation, to set about creating a totally new culture. In their view the reintroduction of alien art-forms and values would inevitably lead to the reinstatement of alien modes of thought and behaviour.

The former approach can be associated with the majority of the Bolshevik leaders, particularly, Lenin, Trotsky and Krupskaya, and with such writers as Gor′ky, the majority of the 'fellow-travellers' (*poputchiki*) and the Party-inspired 'October' group. The most prominent Bolshevik to be identified with the latter school of thought was undoubtedly Bukharin; the artistic movements most concerned were the Proletkul′t (1917–20) and LEF (1923–8).

A vast gulf yawned between these two irreconcilable conceptions of culture, and Lunacharsky, as Commissar for Enlightenment (the term included both education and the arts) was caught in the middle of it. As a practising, though rather conventional, dramatist, he believed in the special nature of art, and the artist's right to experiment; but as a Marxist he believed that it had a social responsibility. However, who was to judge the social

responsibilities of art in the present situation? If, as writer and critic, Lunacharsky was sometimes prepared to tolerate the 'nihilistic' views of the Proletkul't and LEF, as a Communist he could only recommend their subordination to the Party: 'The bearer of proletarian culture can only be the Communist Party, which stands on the position of class war.'[4] The odds were thus stacked in favour of the Party, and increasingly, its views of culture came to dominate the scene. In December 1920 Lenin intervened in order to bring the Proletkul't under Party control, and at the end of the decade LEF was destroyed.

The Proletkul't (acronym for *Proletarskaya kul'tura*, 'proletarian culture') had been established as an autonomous organization within the Commissariat for Enlightenment even before the Bolsheviks took power; but it was only after the October revolution that it really came into its own. It saw itself as the artistic movement corresponding to the historical period of the 'dictatorship of the proletariat', and argued from this that just as the preceding epoch, 'the dictatorship of the bourgeoisie', had produced a culture oriented towards the bourgeoisie, so the new age should at once set about creating a culture of and for the proletariat. This line of thought had two corollaries: first, an intolerance of all culture that was not either created by or concerned with the proletariat; and, second, a total rejection of the cultural heritage as irrelevant or even pernicious – it had been created by an alien class, so what could it say to the proletariat? As early as 1917 some members of the Proletkul't were arguing that 'all the culture of the past might be called bourgeois, and that within it – with the exception of natural science and technical skills (and even these with some reservations) – there was nothing worth preserving, and that the proletariat should begin the work of destroying this culture and creating a new one immediately after the revolution.'[5]

In these iconoclastic attitudes the Proletkul't was strongly supported by several of the former Futurists, notably Mayakovsky. In several poems of 1918–20, notoriously 'Too Soon to Start Rejoicing' ('Radovat'sya rano', 1918), Mayakovsky asked why the revolution was so ruthless with the bourgeois enemy on the battlefield, and so tolerant of it in the cultural sphere; Pushkin and Rastrelli were the cultural equivalents of White officers. In the name of culture the Revolution seemed ready to

accept the whole of the past indiscriminately:

> for the preservation of the Venus of Milo
> You are ready to amnesty the cabal of the past.[6]

But how could a Communist feel any reverence for the past? Like Blok and Yesenin, Mayakovsky was untroubled by the shelling of St Basil's Cathedral: [7] higher values were at stake.

The Proletkul't emulated these sentiments energetically. Kirillov, in his once notorious poem, 'We' ('My', 1918), denounced the culture of the past in the name of the still more glorious future. The task of the new age was to produce a culture as soon as possible:

> Let us set fire to Raphael in the name of our tomorrow,
> Destroy the museums, trample underfoot the flowers of
> art.[8]

In the years 1918–20 these attitudes became dominant among the Proletkul't, and with good reason. They regarded the revolution of November 1917 as the first stage on the road towards smashing the bourgeois system and inaugurating socialism, and they could see no need for acquiring the culture of the bourgeois past. As Bukharin put it:

> I personally think that to master bourgeois culture as a whole, without destroying it, is as impossible as to master the bourgeois state. The same thing happens with culture as with the state. As an ideological system, it is acquired by the proletariat in a different combination of its constituent parts. Practically speaking, the difference is that if you argue from the standpoint of acquiring it *as a whole,* you end up with, for example, the *old* theatres and so on.[9]

Here Bukharin put his finger on the crucial point: how could a Marxist argue that the arts were a special case and that they deserved special treatment? In the climate of the 1920s when the principles, practice and purposes of education were being radically revised, and when even some of the findings of bourgeois science, such as the theory of relativity, the science of genetics and quantum mechanics, were to come under suspicion and attack in the Soviet Union, it really did seem odd that a

majority in the Party-leadership was so committed to continuity
in the arts. At a time when the new society was still fighting a
bloody civil war for its survival, it seemed positively to invite a
relapse into bourgeois habits of thought and behaviour.

Mayakovsky made the same point even more pertinently:

> Lunacharsky is Commissar for Enlightenment; but those
> views which he propagates in the sphere of art are not
> at all the same ones as he applies in the political sphere,
> and if he were to apply such views in any other sphere
> [than art], it would somewhat surprise and shock the
> Central Committee of the Party.[10]

These attitudes were at first tolerated by the Communist
leaders, but they were disturbed by this apparently vandalistic
assault on the cultural heritage, and they found the manifesta-
tions of the 'new art' even more embarrassing. In their attempt
to refute the Proletkul't heresy, they resorted to a series of
counterarguments, which found their most eloquent expression
in Trotsky's *Literature and Revolution*.

Trotsky began, as we have seen, by conceding the supreme
importance of culture. But he went on in the very next breath to
add that this was not the time to think of creating a proletarian
culture; the tasks of satisfying the basic needs of food, shelter and
literacy had to be tackled first in order to prepare an adequate
foundation for it. Since the present was anyway only a transi-
tional period, and the dictatorship of the proletariat merely a
brief interlude before the final emergence of a classless society,
the proletariat should not worry its head about creating a culture,
which would by definition be class-bound and therefore transient.
Instead it should first master the culture of the past before
attempting to create anything of its own. If Marx and Engels, the
finest representatives of bourgeois culture, had been able to work
selflessly for the overthrow of that culture, surely the proletariat
would be prepared to work all the more enthusiastically for the
world revolution and the coming of the classless society. Accord-
ingly, Trotsky rejected the proletarian slogan 'rough and ready
but our own' ('Koryavoye no svoye') on the grounds that prole-
tarian culture should not be content with the second-rate; the
'rough and ready' could not be art. Thus by a strange paradox
the 'highest test of the vitality and significance of the epoch'

seemed to lie precisely in refraining from any attempt to create a culture adequate to its times.

There are many flaws in this argument. As Bukharin pointed out, with the failure of the international revolution, the proletarian dictatorship in Russia might well last longer than Trotsky had anticipated. In that case, the sooner the proletariat began to create its own culture the better. After all, it was, of all types of society the closest to the final classless stage: why should it of all classes be denied the opportunity of achieving its cultural potential? Trotsky's arguments had, of course, been based on different meanings of the word 'culture'. When looking at the past or the future he had used it to signify a whole complex of phenomena, arising out of a given set of historical circumstances: in this sense no age or society can help producing a culture, whether or not it succeeds in creating any works of art. However, in dealing with the present, Trotsky had used the word virtually as a synonym for the arts: like it or not, the proletariat would create its own culture, but at least it might be dissuaded from trying to produce any art. There was certainly something odd about an argument that gave more rights to the cultures of societies which were ideologically alien to Communism than to the proletariat, in whose name the present situation had been brought about.

One of the reasons for this lies in the Marxist tendency to view art as a branch of science. In the early 1920s the acute shortage of qualified Communists had forced the Bolsheviks to recruit staff for Government administration, engineers for industry and even officers for the armed forces, from among the defeated bourgeoisie. Their policies in the arts (clearly a much less sensitive area from the point of view of national security) were based on the same principles. Until the Soviet Union could produce its own experts, whether in the economy, the military or the arts, it was prepared to rely on non-Communists, both past and present.

This came all the more naturally to the Bolshevik leaders, since they had been brought up on the classics of nineteenth-century Russian literature and the socio-political interpretations usually given them. They had read these works during their most impressionable years, and had been profoundly influenced by them in their moral and intellectual development. Lenin saw nothing absurd in equating the methods and achievements of culture with those of Marxism:

L.W.V.M.—C

Marxism has won its universal historical significance as the ideology of the proletariat by the fact that, far from rejecting the most valuable conquests of the bourgeois epoch, it has acquired and reworked everything of value that has been evolved by human thought and culture over more than two thousand years. Only further work on this foundation and along the same lines, inspired by the practical experience of the dictatorship of the proletariat as the final stage of the struggle against all forms of exploitation, can be regarded as the development of a truly proletarian culture.[11]

But this analogy between art and science breaks down on precisely the kind of case on which he relies. For the sciences are subject to obsolescence. Marx's revision of Adam Smith and Ricardo was intended to spare us the necessity of ever reading them again. The question at issue is not whether the culture of the past has been filtered and digested to contribute to a new ideology – obviously in some sense this is a continuous process in all societies – but whether the actual products of that culture, unreworked, still have any part to play.

To *this* question Lenin gave a rather different answer. Far from being a prescription for total conservation of the cultural heritage, the significance of his remark lies rather in the idea of selectivity ('everything of value'), and his conservationism was in fact highly selective; he was responsible for the banning of works by Plato and Tolstoy (and many others) from Soviet libraries. Of course, the whole of the cultural heritage was to some extent suspect and would have required considerable 'reworking' to make it fully satisfactory. So in practice the principle of selectivity was applied to two main categories: certain forms of ideology such as religion, and, in the field of form, modernism.

With these exceptions the cultural heritage was adjudged to be acceptable, at least as a stopgap: ironically, because of their inability to question their own inbred reverence for the classics, the Bolsheviks could not at first go even so far as to revise the artistic canon in favour of works that might seem to be more socially progressive. Instead, to justify the reissue of the classics, flaws and all, Soviet editors usually prefaced them with an apologia, correcting the 'errors' and pointing out the inadequacies, but

finally coming to the formulaic conclusion: 'Despite the limitations of his class and the age in which he lived, such and such an artist gives a true picture, and his work has not lost its relevance even today . . .', sentiments which come oddly from Marxists, concerned as they are with just such limitations above all others.

The logical conclusion of this line of argument was finally spelt out by the Marxist critic, Voronsky, who roundly declared that art was concerned with absolutes, quite independent of the contingencies of time, place and class. In a deliberate echo of Marx's question, though ignoring the socio-economic basis of his formulation, he asked: 'Why does the Venus of Milo continue to set an unattainable standard for us, despite the great differences in taste, way of life, and feeling, between us and the Greeks?', and answered: 'Because there exists an objective beauty in nature and the artist reveals it to us in his work.'[12] Indeed Voronsky's reverence for art, regardless of ideology, was such that he was prepared to concede some merit not only to the modernists, but even to the émigrés.

For Voronsky the value of culture was unquestionable; doubts about the 'poisons', or even the inadequacies, of art seem never to have entered his head. But if art is primarily concerned with such universals and absolutes as beauty, truth, goodness, liberty, etc., then what is so special about it? If these Platonic ideals exist at all then they would hardly seem to need any reinforcement from the arts; to extol them would be merely truistic and our pleasure in reading about their inevitable victories simply the vicarious assurance that all is well with the world (which is hardly a Marxist virtue). And of course, if all true art were so single-minded, it would be dreadfully repetitive, and selectivity an unqualified blessing.

The objections to modernism were less theoretical and more human. The Bolshevik leaders had grown up in the great age of Russian prose, and all literature written since then had seemed only minor by comparison. For one thing it seemed to have less relevance to the immediate social situation; for another, the Party conspirators, with the passing of the years, found less and less time for coming to terms with the subtleties of new types of art. However artificial the conventions with which one grows up, they tend to seem 'natural' and all deviations from them to be unneces-

sary complications or wilful distortions. Hence the Communist leaders' distrust of Symbolism and Futurism, and indeed all other modernist movements, which had emerged after their artistic tastes had been formed.[13]

It was natural, then, for the Bolshevik leaders to hope that the new arts would reinstate the familiar forms and conventions; but this did not alter the fact that these were the preferences of the nineteenth-century bourgeoisie, and it did not necessarily follow that they were shared by the proletariat in the twentieth. Dobrolyubov, in his article 'On the Degree of Participation by the Populace in the Development of Russian Literature' ('O stepeni uchastnosti naroda v razvitii russkoy literatury'), had shown that Russian writers such as Pushkin and Krylov, generally admired for their simple and idiomatic Russian, were in fact incomprehensible to the very people, the peasants, whom they professed to take as their models. But instead of drawing conclusions, as they might have done about the inescapably class nature of art, the Bolsheviks' reaction was to insist that the peasant should be educated until he could appreciate the classics. Not surprisingly, therefore, it began to seem to some sceptics that the Party was determined to prevent the workers from having any say in the creation of their own culture, let alone challenging that of the bourgeois era.

The difficulties that the Communists encountered in their cultural policies spring ultimately from their failure to find any worthwhile place for art within the Marxist system. Marxists may think of art as a branch of science, but they do not claim that it reveals new truths – that is the province of dialectical materialism. Rather art was of value for confirming truths that could be established by other means; thus Russian literature of the nineteenth century could be justified in terms of the Marxist view of historical evolution. But the arts were still a secondary and diluted form of truth; as Trotsky said: 'The arts are generally in the baggage-train of the movement of history.'[14] It was fit for relaxation, even very high-minded relaxation, but of no practical use for the battles and difficulties encountered on the road. As Kogan said to Marina Tsvetayeva:

> We need writers. And not just civic ones either. You'll probably be surprised to hear this from an old and con-

firmed Marxist, but even I, you know, love to flop on a sofa and read Bal'mont – even we need our beauty, and this – both the need and the beauty – will continue to grow, as the economic position improves. We need writers, and we're ready to do anything for them – well, we've given you a ration-card . . .[15]

And the same idea is implicit in Lenin's comments on Beethoven's *Appassionata* (of all pieces of music!):

> I know nothing better than the *Appassionata*, I could listen to it every day. Amazing, superhuman music. I always think with pride, naively perhaps, what miracles man can work . . . But I can't listen to music often, it affects my nerves, makes me want to say silly compliments, stroke people on the head for living in this filthy hell and creating such beauty. But nowadays you mustn't stroke anybody on the head, or they'll bite your hand off; you must beat them over their heads, beat them without any mercy, though in principle we're against using violence on people.[16]

The arts are very nice and all that, but they are enervating and distracting, and rather a waste of time. Presumably when humanity matures, it will have no need for such dilution and sentimentalization of reality. The arts of the future, assuming there would be any, would be confined to ornamenting bridges and palaces of culture, and reassuring the populace, presumably quite unnecessarily, that all was well with the world.

In this scheme of things the arts of the past could still play some useful role. Severely limited though they were by their class origins and their ideological weaknesses they still provided valuable models of craftsmanship and style, which would be of use to the new class struggling to express itself in art. Once these lessons had been mastered, however, there would, presumably be no further need for them; they would simply be superseded and outclassed, for the new society would be able to do the same things only better.

It is a poor justification for preserving the cultural heritage to argue that it can teach us how to dispense with it. But there are good Marxist reasons too for rejecting the use of the classics as

training-manuals. For this approach assumes not only that form and content are totally separable, but that the form is actually of greater value (this is, of course, the heresy of which the Formalists were, wrongly, accused). It would seem more consistent for a Marxist to argue that if the content were unacceptable then the form would be suspect as well; consequently any attempt to acquire the forms on their own would inevitably lead back to the reinstatement of much of their content.

The dangers of this sort of appeal to the past had in fact been foreseen by Karl Marx when he wrote:

> The traditions of all the generations of the dead hang like an incubus over the brains of the living. And just at that very time when men seem to be on the verge of radically transforming themselves and the world around them, of creating something that has never been created before, it is in precisely such periods of revolutionary crisis that they anxiously conjure up the spirits of the past.[17]

It was just this realization of the inseparability of form and content that distinguished the methods of LEF (acronym for LEft Front of the arts). In two classic articles on Fadeyev's novel *The Rout* (*Razgrom*, 1927) the LEF critics Osip Brik and V. Trenin demonstrated that outdated forms could sabotage even the most revolutionary content. Fadeyev had modelled his style and technique on Tolstoy's *War and Peace*, but had tried to reverse the message. Thus instead of Tolstoy's belief in the forces of history working out their designs regardless of the hopes and ambitions of men, Fadeyev had tried to exemplify the Marxist-Leninist idea that human will-power could impose a meaning and direction upon history. But the forms of Tolstoy (and still more of Chekhov), devised originally to evoke the helplessness and insignificance of human powers, consistently undermined the new content that Fadeyev intended to express through them. As a result, the critics argued, his book came closer to expressing the pessimistic outlook of a threatened and bewildered bourgeois than the optimistic and constructive vision of a Communist.[18]

The LEF movement traced its origin back to the pre-revolutionary Futurists, and the leading figures in it had at first been sympathetic to the Proletkul't. The alliance had been further

strengthened by their common iconoclasm and distrust of the Bolsheviks' policies in the arts. But by 1920 they themselves were becoming disillusioned with the Proletkul't, as they came to realize that it too interpreted 'proletarian art' primarily in terms of content. The Proletkul't artists might seem *avant-garde* and their forms unpleasantly modernistic to official tastes, but they still remained essentially imitative; it was simply that the forms they imitated came from a later period than the Party-leaders had yet learnt to appreciate.

For the Futurists form and content had always been inseparable: 'the most revolutionary of contents cannot be revolutionary without a revolutionary treatment of the word',[19] and in LEF they made the most serious attempt yet to apply Marxist principles to the task of creating a socialist culture. Art was not a special case; it had no 'eternal charm'; it was just as much a product of its time and place as any other aspect of human behaviour and it should be practised and judged accordingly.

LEF's rejection of the past was as uncompromising as the Proletkul't's had been; to the Futurist contention that the twentieth century was different in kind from all previous epochs they now added the argument that Soviet society too was qualitatively different from all others. If before 1917 to be a traditional artist had been merely anachronistic, it was now seen to be counterrevolutionary. In 1918 Osip Brik argued that to defend works of antiquity was tantamount to defending landowners, while the artist, Lev Bruni, even suggested that instead of trying to protect and rescue works of art from the chaos of the times, the Bolsheviks should set up a 'commission for the planned destruction of works of art and antiquity'.[20] Mayakovsky declared: 'We call anyone who treats old art with hatred a Lefist',[21] and although he later denied that he seriously advocated its destruction he could find no better use for it than as reading-primers for the illiterate;[22] neither in form nor in content did it have anything to contribute to contemporary culture. 'We Lefs see in the revolution not an interruption of the old traditions, but a force that utterly destroys these traditions, along with all the other systems of the old world.'[23] The classics were admissible only when they had been adapted to new purposes: parodied, as Mayakovsky did with Pushkin and Lermontov in *Good!* (*Khorosho!*, 1927); drastically updated, as in Meyerkhol'd's production of Gogol's *The*

Inspector-General; or turned inside out as in Shostakovich's operatic version of Leskov's story, 'Lady Macbeth of Mtsensk'.

Instead LEF campaigned on behalf of the new technological arts, such as photography, film and radio, not simply because of their propaganda potential (though of course that was not to be despised), but because they extended the old ways of perceiving the world. Nor was this just a matter of the so-called 'fine arts'. LEF made no distinction between them, provided they could play a part in changing people's consciousness and behaviour. Its members were equally interested in questions of industrial design, functional architecture and domestic furniture (in this respect they were akin to the Bauhaus); instead of literary criticism they recommended connoisseurs of the arts to apply themselves to criticizing and improving the standards of consumer goods (here they anticipated *Which?*). The ultimate goal of LEF was the realization of the Utopian dream, expressed by Trotsky in the closing pages of his *Literature and Revolution*, of a new type of man, the *homo-creator*, and of a high culture, whose every manifestation would reveal the harmony of the society that had produced it.

Thus culture was for LEF one of the most vital areas of the battle for socialism; indeed its members tended to see themselves as the Bolsheviks of the cultural sphere. Far from conceding the primacy of politics, they were inclined to suggest rather that it was the arts which led the way, and they considered their *avant-garde* works of the pre-revolutionary period as just as contributory to the eventual Bolshevik triumph as the activities of the professional revolutionaries themselves. Like the Party too LEF had little confidence in the ability of the proletariat to build its own culture unaided; it would have to be helped by experts who had already proved their credentials in the field.

So, when Trotsky complained that LEF was forcing the development of culture unnaturally the LEF writers were amazed: wasn't this just what the Bolsheviks had done in 1917? Why should it be correct in one sphere and wrong in the other? How could any Marxist regard culture as separable from the rest of the development of society? When Lunacharsky complained that Left art had been rejected by the proletariat, Mayakovsky reminded him that the proletariat had once welcomed Kerensky; it had taken Communist propaganda to show them where their true interests lay. If there were more propaganda for the new art

then the misunderstandings would soon pass. Mayakovsky's reading tours were, among other things, missionary expeditions to the culturally heathen.

In fact Mayakovsky argued that, given a chance, his works had proved perfectly comprehensible to the real proletariat, and indeed to anyone who was prepared to try; it was the relics of the bourgeois past, accountants, croupiers, librarians and academics who could not or would not understand what he was saying, and who made all the fuss. If the 'uncultured' proletariat could understand, then to fail to do so was to confess one's alienation from the proletariat.

Thus LEF saw itself as fighting a battle on two fronts against the old traditional art of the schools and academies, 'those who with the sinister intent of ideological restoration ascribe a vital role to the old academic junk for today';[24] and second, against the Philistines in the Party from Trotsky and Lunacharsky downwards, 'who, through ignorance, caused by a narrow specialization in politics, serve up the traditions inherited from their great-grandmothers as the will of the people'.[25] Trotsky had placed the arts in the 'baggage-train' of history, but from LEF's point of view it was the Party that was trying to keep it there, threatening to destroy not just art in the process, but the revolution too. In *The Bedbug*, two survivors from the past are enough to corrupt the whole of society fifty years on.

LEF's objections to established forms and genres centred on just this backward-looking orientation, typical and expressive of reactionary societies. The task of the artist, as of every self-respecting Marxist, was not just to contemplate the world, but to help change it. And so LEF wanted an art that was ahead of its time, and could play its part in bringing about the future, and even in hastening that happy day:

> The greater an object or an event, the greater the distance which you have to go [in order to appreciate it]. The weak run on the spot, waiting for the event to pass, so as to reflect it, the strong ones run so far ahead that they can pull in the time they have grasped.[26]

The artist could achieve this both through content – many Futurist and LEF works purport to depict the future – and by means of style, stretching the potentialities of existing forms and

techniques, so as to stimulate readers in the present and, as a mark of success, provide continuing stimulation in the future. In place of the old class-bound genres of the theatre, the opera and the ballet, and the museums of painting and sculpture, LEF offered the new dynamic and participatory forms of the public reading, the political slogan and the factory wall-newspaper.

The same attitude dictated their contempt for conventional aesthetic standards, and their implied 'eternal and absolute' values. Trotsky had rejected the Proletkul't slogan 'rough and ready but our own' on the grounds that the 'rough and ready' was synonymous with artistic inferiority. As practising artists LEF knew very well that this was not necessarily the case:

> It's not worth it for beginners to produce absolutely smooth, flawless verse; you can and you should make it as 'rough and ready' as possible. This will fix the reader's attention on every line; words must be presented in such combinations and treatments that they come alive and appear in a new light before him.[27]

The object of LEF's particular scorn was the classical realistic novel, a form that was clearly designed for a class of readers with unlimited time for a long story. One LEF theorist estimated that it would take a modern proletarian seventy-two hours out of his hard-earned leisure to make his way through *War and Peace*.[28] Even assuming that the proletariat found the time to produce anything of its own, how could its art ever hope to be original or socialist, given this kind of preparation?

But, significantly, it was realism itself that was the main target for LEF's attacks. The realistic novel may well have represented the highest form of art in the nineteenth century, but even the finest realism still remained fiction, and, as Chernyshevsky and Pisarev had pointed out, no match for reality. There was inevitably a time-lag involved in the processes of artistic composition and the mechanics of publication, which would diminish the impact of the facts on which realism was supposedly based. What was worse was that realism fostered the illusion that it was identical with reality, and that the reader was participating in real life, while in reality he was actually withdrawing from it. This dangerous tendency was naturally encouraged by bourgeois society, because of its fear of reality, and its resulting cult of art

as an anaesthetic. 'Fiction is the opium of the people' said LEF,[29] taking up Lenin's suggestion that art might take the place of the church under socialism.

But art was not a sedative, a mere part-time relaxation, however high-minded. Art was an integral part of life, with its own contribution to make to human and social development. If art was to serve socialism it would have to be brought into closer contact with reality. In the superb but chilling lines of Mayakovsky's 'Home!' ('Domoy!', 1925):

> Не хочу,
>> чтоб меня, как цветочек с полян,
> рвали
>> после служебных тягот.
> Я хочу,
>> чтоб в дебатах
>>> потел Госплан,
> мне давая
>> задания нá год.
> ...
> Я хочу,
>> чтоб в конце работы
>>> завком
> запирал мои губы
>> замком.
> Я хочу,
>> чтоб к штыку
>>> приравняли перо.
> С чугуном чтоб
>> и с выделкой стали
> о работе стихов,
>> от Политбюро,
> чтобы делал
>> доклады Сталин.*[30]

*I do not want to be plucked like a flower of the fields after a hard day's work. I want Gosplan to sweat as it debates my assignments for the year . . . I want the shop-stewards to lock up my lips at the end of the day, I want the pen to be equated with the bayonet. I want Stalin to read out the reports of the Politbyuro on the efficacy of poetry alongside those on the production of pig-iron and steel.

It was in fact difficult to see any justification for feeding the citizens of a materialist society with fictions at all. Surely they were mature enough by now to face the truth undiluted by the imagination. The LEF theorists moved accordingly towards the idea of the newspaper as the ideal vehicle of art in the present situation; not in the sense of 'artistic documentary' as favoured by orthodox Soviet writers, where 'creative writing' tended once again to obscure the real facts at issue. No, the observations of untutored contributors from industry and the countryside, uncluttered by any attempts at 'style' were of far more value.[31]

True, the problem of the time-lag still remained, even though it had been drastically reduced. One way of overcoming this was the demand that writers should not confine themselves to a photographic description of the present; instead they should 'draw their poetry from the future'. One implication of this was frankly propagandist; writers were encouraged to describe not what actually was, but what would assuredly be in the not so distant future. This idea was later taken up by socialist realism, with the difference that in the 1930s and after the Party told the writers what the future was going to be; under LEF this prospect was still left to individual initiative and imagination, qualities with which most Lefists felt themselves to be better endowed than any mere Party-members.[32]

The importance of this distinction became clear early on. One of the chief theorists of LEF, Sergey Tret'yakov, had written boldly:

> For us factographers there can be no facts 'as such'. There is a 'fact-effect' and a 'fact-defect', a fact that strengthens our socialist position and a fact that weakens it.[33]

But who decides which is which? Here LEF and the Party with their different criteria were bound, sooner or later, to come into collision. Tret'yakov himself was one of the first to find this out, as Shklovsky relates:

> In Tiflis I was present at a conference between Tret'yakov and the editorial board of *Zarya vostoka*, which was refusing to print Tret'yakov's article on Fyn-yuy-san (who had not then yet betrayed the revolutionary cause). The

board considered that Tret'yakov was compromising a revolutionary general by the facts that he had adduced.

Unfortunately, in the event, the general proved to be not so revolutionary after all. It would have been better if the reader had been prepared for this by some such article. Of facts you can only say, as Karl Marx used to say, quoting a well-known English proverb, that facts are obstinate things.[34]

The anecdote is a revealing one. In political matters LEF had always been a wholehearted supporter of the Party-line; their differences, as they freely admitted, were confined to the questions of artistic form.[35] But in accepting 'factography' as a principle, they had surrendered their last claim to any special expertise in the field of art, and were now wholly at the mercy of inconsistencies and changes in the Party-line.

But one may still question whether even factography is a tenable position. For how can one justify merely writing about a situation instead of participating in it? However engaged the artist might be he still seemed to be at one remove from reality. For example Chuzhak attacked Bezymensky (always a *bête noire* of LEF for his watered down imitations of Mayakovsky) for his topical poem 'The War of the Storeys ('Voyna etazhey') on just these grounds:

> If Bezymensky had been personally involved in the war waged in our homes, he would very soon have discovered that it wasn't just a matter of fine words, which were of no use to anyone just then (the fight was going quite well enough without any need for musical accompaniment) but of direct and stubborn struggle against sordid and depressing obstacles.[36]

If the artist's job was not to contemplate the world but to change it, then direct action must necessarily take precedence over artistic treatment.

By a paradoxical logic, worthy of Shigalev, Marxism begins with absolute reverence for art, and ends by finding no place for it. The more conservative Bolsheviks were unable to conceive of any use for the arts of the past except as teaching-manuals, or spare-time relaxation, or as evidence of the cultural acquisitions of the new society. In rejecting these answers, understandably

enough, and trying to find a more positive function for art, LEF seemed to be driven by its own logic to deny it altogether.

Naturally the Party, with its passive view of culture, did not see things in quite this light; it was axiomatic that culture was highly desirable, and so the iconoclasm of the Proletkul't and LEF only confirmed it in the belief that artists, even though they might have created masterpieces, always had been and still were unreliable: art was too important to be left to the artists. Thus, although Trotsky was prepared to admit in theory that

> one can never judge whether to reject or accept a work of art on Marxist principles alone. Works of art must be judged first of all by their own special laws, that is, the laws of art[37]

and to accept that 'the new art . . . can be created only by those who are at one with their epoch',[38] in practice he reserved to himself and the Party the right to decide which tendencies were 'at one with their epoch'. His argument, which might seem to have provided a perfect justification of the new art of the Proletkul't and LEF, abruptly changed course to reject their claims. It was for the Party to say when and how its culture would be produced.

Thus the debate over culture turned eventually into a struggle for power. Both the Proletkul't and LEF had infringed on the Party monopoly of Marxist doctrine, and were therefore destroyed. It is true that, as Lunacharsky charged, the Proletkul't were not really a spontaneous proletarian movement; LEF too was unashamedly an élitist organization, claiming to lead rather than to represent the masses. But such charges came strangely from the Communists who were even more vulnerable to them and even more distrustful of proletarian spontaneity.

The new Communist policies that came in at the end of the 1920s emphasized the primacy of ideological content; the question of form was reduced to 'What was good enough for our grandfathers is good enough for us'; increasingly the traditional three-decker novel was canonized as the central genre of socialist realism. At the Congress of Soviet Writers in 1934 several speakers were to call for the appearance of Soviet Homers and Shakespeares; the word 'Huns', once the war-cry of revolutionary artists, was by now reserved only for the Nazis.

Mayakovsky was able to accept the prescriptions for the primacy of content over form after some verbal juggling. In 1929 he introduced a new movement REF (acronym for REvolutionary Front of the arts) to succeed LEF, claiming that the time had come to move on from the earlier 'how?' of art, through the 'what?' now required, to the new stage of 'what for?', in other words to the primacy of aim over both form and content.[39] In fact the distinction between aim and content was minimal, and Mayakovsky admitted as much when he put the same idea a different way: '. . . if a bourgeois beats a proletarian, that means it's a bad work, but if, on the contrary, the proletarian beats the bourgeois, then it's a good work'.[40]

But the rehabilitation of the past was more than he could stomach. On one of his last public appearances, only a few days before his suicide, he bitterly conceded the total defeat of everything that he and his colleagues in Futurism and LEF had stood for:

> . . . twenty years ago we Futurists raised the subject of a new beauty. We said that the marble beauty of museums, all those Venuses of Milo with their lopped-off arms, all that Greek classical beauty, could never satisfy the millions who were entering into a new life in our noisy cities, and who would soon be treading the path of revolution. Just now . . . our chairwoman offered me a sweet with Mossel'prom on it; and above that there was the same old Venus. So, the thing you've been fighting against for twenty years has now won. And now this lopsided old beauty is being circulated among the masses, even on sweetpapers, poisoning our brains and our whole idea of beauty all over again.[41]

The contradictions in Soviet thinking about art are reflected in the two faces that Soviet culture today presents to the world. If culture is conservation and preservation then the Soviet Union is the most cultured country in the world. Its theatre, ballet, museums, and its scholarship in art and literature are all justly admired. But you cannot create a culture in museums, and if culture is defined in terms of vitality and development, then the picture is very different. If Lot's wife was prepared to abandon her own children for nothing more than the curatorship of some-

one else's ancestral archives we may well begin to feel that perhaps she deserved her fate after all.

The Communist Party itself has never been very happy to be judged by the culture it has so far produced; somehow, it feels, its artists have failed to do it justice. But art is not mocked: societies get the culture, both official and unofficial, that they deserve.

PART TWO

PART TWO

4

The secret of art:
two Soviet myths

Yes, all in all, this busybody with her curiosity about the void behind her, has caused quite a lot of trouble for humanity in the past.
Leonid Leonov, *The Russian Forest*[1]

The dual attitude of reverence and hostility towards the culture of the past, discussed in the first part of this book, is usually veiled in Soviet discussions of art. It is, however, an ideal subject for artistic treatment, for the ambiguities and paradoxes of the theme, not least the fact that it is the artists and not the Philistines who have dared to raise it, are endless. It is this aspect which will be discussed in the second part.

In this chapter I shall examine two works, Khlebnikov's *Night Search* (*Nochnoy obysk*, 1921) and Bagritsky's *February* (*Fevral'*, 1933–4) in which this dualism has been raised to the status of myth; as in a true myth several features of the treatment and the imagery have in turn become inseparable from the theme itself.

Velimir Khlebnikov and 'Night Search'[2]

Khlebnikov's first approach to the theme of the past occurs in his poem *The End of Atlantis* (*Gibel' Atlantidy*, 1912). The work is set in a future rationalist Utopia, which has discovered the secret of immortality, and is dedicated to continual progress; in this world the past seems to have no place. As the High Priest says, rather smugly:

> Наукой гордые потомки
> Забыли кладбищей обломки.
> И пусть нам поступь четверенек
> Давно забыта и чужда.*[3]

*The descendants, proud of their science, had forgotten the ruined cemeteries. What if we had forgotten and lost touch with the gait of four legs!

However, his assurance is challenged by a slave-girl who presents irrationality as the necessary complement to his crude scientism ('I am your consonance', she tells him). Driven by her logic to an act of irrationality the High Priest kills her and thus prepares the way for a new outbreak of chaos. A flood ensues, which destroys Atlantis, while the head of the slave-girl appears over the waters as a vengeful Medusa:

> И вот плывет между созвездий,
> Волнуясь черными ужами,
> Лицо отмщенья и возмездий,
> Глава отрублена ножами.*[4]

In the immediate context of the poem this apparition may seem to represent the triumph of the irrational, and the same unusual (for Khlebnikov) rebellion against science, and even numerology, can be found in other works of 1912, such as 'Hearts more transparent than a vessel' ('Serdtsa, prozrachney, chem sosud') and the 'Titanic' section of *Otter's Children* (*Deti vydry*);[5] but, as we shall see, the image can also be taken as referring to the past.

The most remarkable and influential instance, however, of Khlebnikov's complex attitude to the past is to be found at the end of his revolutionary trilogy of November 1921. This consists of three narrative poems, *Night before the Soviets* (*Noch' pered Sovetami*), *The Present* (*Nastoyashcheye*) and *Night Search* (*Nochnoy obysk*). As their titles suggest, they are all set at night, and there is an implied temporal progression within them, 'before, during, after'. Each part of the trilogy contains a clash between representatives of the old order and the forces of the revolution.

In the first of the three poems, a 'Lady' is being prepared for bed by her old nurse, who relates the story of her family's humiliations at the hands of their masters. In the central episode an old peasant-woman, the grandmother of the nurse, is forced to put her own son from her breast in order to suckle one of her owner's puppies. When her son grows older he kills the dog and is flogged almost to death for it. The complaints and recriminations of the old woman break out finally into open threats to her mistress: 'They will hang you tomorrow'. In the second poem the reflections of an elderly Grand Prince are contrasted with the

*And lo, among the constellations, undulating with/like black grass-snakes, a face of vengeance and retributions, a head severed with knives.

violence of the first days of the revolution, and at the end the insurgents burst in to murder him and rape his daughter.

In each poem the past, its aristocracy (they are old and the revolution is young), its culture, its religion, its values, are swamped under the tide of retribution, and the development of the imagery emphasizes its historical logic. Humiliated even by the hounds of their masters, the people have become hunting-dogs themselves; the blue eyes of the oppressed peasants evolve into the blue of the sea which has spawned the revolutionary sailors.

In the final poem, however, the events and the imagery take a different direction. *Night Search* is prefaced by a mysterious epigraph, '$3^6 + 3^6$'. In his *The Boards of Fate* (*Doski sud'by*) Khlebnikov explained that the powers of three are associated with the reversal of historical trends and events, and he gave as an example the following: 'Tsarist debts acknowledged by Soviet Russia 6/xi 1921, $3^6 + 3^6 = 1458$ days after the beginning of Soviet power 10/xi 1917, when they were reduced to nil';[6] the poem *Night Search* is dated 7 November–11 November 1921. In other words the poem is concerned with the reversal of the original revolutionary impulse, celebrated in the first two poems of the trilogy, and brought about by the Soviet government's decision to accept liability for the debts incurred by its Tsarist predecessors. So much may be clear; the actual working out of this theme, however, is not so simple.

At the beginning of *Night Search* a band of Red sailors enters a middle-class apartment in search of loot and class-enemies. The son of the house, a White, fires a shot at the sailors but misses; in the search he is soon caught; he is stripped naked and then shot before the eyes of his mother and sister. The sailors pun grimly on his name, Vladimir:

> Согнутый на полу
> Владеет миром.
> И не дышит.*[7]

The pun at first seems ornamental, but as the poem unfolds, it reveals a functional significance.

The White boy accepts his fate with schoolboyish heroism. He

*Curled up on the floor he possesses peace [*Vlad*eet *Mir*om; the phrase could also be translated 'he possesses the world']. And doesn't breathe.

laughs at the sailors and asks to be shot without a blindfold and facing his executioners:

Даешь в лоб, что-ли?*[8]

His request is granted and his last words are:

Прощай, дурак! Спасибо
За твой выстрел.†[9]

His acceptance of death and his insolent courage make a deep impression on the sailors, and one of them continues to reflect on it:

Подлец! смеется после смерти!‡[10]

In a long monologue, he three times goes over the events leading up to the execution; he becomes increasingly aware of the wanton destructiveness of his actions, and of the reproach in the eyes of the ikon. But he too refuses to submit: he challenges God as the White boy had challenged him:

– Даешь в лоб что-ли?
Даешь мне в лоб, Бог девичий,
Ведь те же семь зарядов у тебя.
С большими синими глазами?
И я скажу спасибо
За письма и привет.

 . . .

Хочу убитым пасть на месте,
Чтоб пал огонь смертельный
Из красного угла. –
Оттуда бы темнело дуло
Чтобы сказать ему – дурак!
Перед лицом конца.
Как этот мальчик крикнул мне,
Смеясь беспечно
В упор обойме смерти.
Я в жизнь его ворвался и убил,
Как темное ночное божество.

*Will you shoot me in the forehead then?
†Farewell, fool! Thanks for your shot.
‡The swine! He laughs even after death.

Но побежден его был звонким смехом,
Где стекла юности звенели.
Теперь я Бога победить хочу
Веселым смехом той же силы,
Хоть мрачно мне
Сейчас и тяжко. И трудно мне.*[11]

In the final lines he seems to have achieved his ambition. He sees
the fire break out, and coolly strikes the pose he has sought:

Горим! Спасите! Дым!
А я доволен и спокоен,
Стою, кручу усы и все как надо.
Спаситель! Ты дурак!†[12]

but somehow the gesture seems of 'dubious value' as Vladimir
Markov has suggested.[13] It is partly that the atmosphere of the
two passages is quite different. In the first case the tone is fool-
hardily heroic, in the second it is grim and fatalistic. What had
been instinctive and natural for the White boy is achieved by the
Red sailor through will-power and deliberate emulation, and the
contrast between the sudden heroism of the boy and the obsessive
ambition of the old sailor serves still further to weaken the impact
of the second death. Thus the verbal repetitions serve to suggest
the differences rather than the similarities between them.

This strange and unexpected ending is paralleled by some
equally strange changes in the imagery: the blue eyes that had
been associated with the peasants and the revolutionaries are now
given to the Christ in the ikon. The ikon is desecrated, but it is

*Will you shoot me in the forehead then? You shoot me in the
forehead, you virginal god. You have seven shots, you with your
great blue eyes. And I shall say thank-you for your letters and
your love . . .
 I want to fall dead on the spot, and the fatal fire to fall on me
from the ikon corner. I want the black muzzle to appear from
there so that I can say to Him 'Fool' in the face of death, as that
boy shouted it at me, laughing easily into the twin barrels of
death. I burst into his life and killed him like a dark god of the
night, but I was overcome by his clear laughter, ringing with the
crystal of youth. Now I want to overcome God with the same
laughter and the same strength, though I feel gloomy and
oppressed. And confused.
†We're on fire! Help! Smoke! But I am calm and unruffled. I stand
and twirl my moustache, just as I should. Saviour! you're a fool!

no longer helpless; it is allowed to answer back, as it does with the final fire. The 'sinister old woman' of the opening lines of *Night before the Soviets* seems to reappear in the final lines of *Night Search* as the immediate agent of the fire.[14] Finally even the dog image is reinterpreted in the piano-smashing episode.

> Кто играет из братвы?
> – А это можем...
> Как бахнем ложем...
> Аль прикладом...
> Глянь, братва,
> Топай сюда,
> И рокот будет и гром и пение...
> И жалоба,
> Как будто тихо
> Скулит под забором щенок,
> Щенок забытый всеми.
> И пушек грохот грозный вдруг подымается,
> И чей-то хохот, чей-то смех подводный и русалочий.
> Столпились. Струнный говор,
> Струнный хохот, тихий смех.
> – Прикладом бах!*[15]

The puppy has here lost its earlier associations of power and brutality; it is treated as a victim, and is even linked once again with the culture of the past. Like the dying White boy, even in destruction it laughs at the Red sailors; it is compared to a Lorelei/*rusalka*, and later in the poem the reproachful eyes of Christ in the ikon survive the sailor's bullet and recall the same 'Lorelei with cloudy, powerful eyes'.[16]

The tone too changes dramatically from the coarse speech, violent actions and staccato rhythms of the first half to an impersonal mode of narration, imprecise ('someone's'), almost mystical in its serenity. And even though the elements of destruc-

*Who of the brothers can play? That we can . . . Just belt it with the stock or the rifle butt . . . Watch, brothers, trot along here, there'll be some racket and thunder and singing . . . and a wail, as if a puppy were whimpering in a ditch, a puppy forgotten by everybody. And suddenly the ominous roar of cannons arises, and someone's laughter, someone's underwater, Lorelei laughter. They crowded round. The chatter of the strings, the laughter, the quiet laughter of the strings. Belt it with your rifle butt!

tion soon return as the piano is thrown out of the window ('that box with a puppy moaning in it', as one of the sailors comments scornfully),[17] this vision of a different set of values remains unassailable, and finally, in the closing lines, emerges as the dominant element.

To some extent, of course, the poem is concerned with the self-destructiveness of the revolution; the images that were originally associated with the people finally turn against them. But at a deeper level it is concerned with the problem of the values of the past. It is seen at its crudest in the epigraph, with its reference to the Soviet government's acceptance of the financial obligations of the Tsars, an apparent betrayal, at least in the eyes of Khlebnikov. But in the poem itself, the murdered White youth and the smashed piano come to life again and inspire the revolutionaries, however grudging, to emulation. It is extraordinary to discover that these apparently discredited values can, in spite of everything, still 'provide a standard and model beyond attainment'.

The ironies of the poem deepen the more we read it. In the first two poems of the cycle, the representatives of pre-revolutionary Russia are old, and the revolutionaries are young; in *Night Search* the White is a youth, and his killer an older man, named Starshoy (elder). The old sailor's cry to the dead boy 'possess the world' (or, at first reading, it might be merely, 'possess peace') turns out to be truer than he knew; for the White youth does seem to have spirited away with him a whole world of values in art and human conduct. But why should these values still be desirable and enviable? Can the revolution then never be free of its past?

Khlebnikov's *Night Search* offers no answers, but it captures with the diagrammatic simplicity and moral complexity of true myth the ambivalent attitude of Soviet Russia to its past, a mixture of love and envy, admiration and hatred, a confused impulse to emulate and acquire it, but also to master and destroy it.

Eduard Bagritsky and 'February'

If Khlebnikov may be said to have proceeded from a Futurist rejection of the past to a near-mystical recognition of its values, the evolution of the Soviet poet Eduard Bagritsky (1895–1934) described almost the reverse trajectory. In the early part of his career Bagritsky was known as an ardent advocate of the con-

tinuity of poetic culture, with a reputation for a detailed know-
ledge of even the most recondite and unfashionable poets of the
preceding epoch. In his later years, however, partly as a conse-
quence of his hardening political attitudes, he seems to have
moved towards a total repudiation of the past. His last poem,
February, presents a strange synthesis of these contradictory
impulses.

The first indication of Bagritsky's changing attitude to the past
occurs in his poem 'Cigarette Packet' ('Papirosnyy korobok', 1927).
The poet has been chain-smoking late into the night, and as he
sinks into an uneasy sleep, a picture of the Decembrist poet
Ryleyev on a cigarette-packet catches his eye. Gradually this
casual impression turns into a monstrous nightmare, which spawns
the figures of the other Decembrists. Bagritsky is terrified, and he
tries to drive out the unwelcome visitors, but Ryleyev tells him:

> You are ours for ever! We are with you everywhere . . .
> Our solidarity is assured for all eternity.[18]

As the nightmare continues, Bagritsky is forced to undergo the
flogging which they underwent and to experience all the horrors of
the Tsarist past. As dawn comes, however, the figures of the
nightmare reveal themselves to have been only the trees and
currant-bushes of his garden. Bagritsky calls in his son and tells
him:

> – Вставай же, Всеволод, и всем володай,
> Вставай под осеннее солнце!
> Я знаю: ты с чистою кровью рожден,
> Ты встал на пороге великих времен!
> Прими ж завещанье:
> Когда я уйду
> От песен, от ветра, от родины –
> Ты начисто выруби сосны в саду,
> Ты выкорчуй куст смородины!*[19]

*Rise up then, Vsevolod, and possess everything, rise up under the
autumn sun! I know: you are born with pure blood in your veins,
and you stand on the threshold of great times! Listen to my
bequest: when I am gone from song and the wind and my father-
land, you must cut down the pines in the garden, and leave no
trace behind, and root out the bush of blackcurrant!

And on this uncompromising and problematical note the poem ends. The evils of the past have vanished with the coming of day; nothing but healthy fruits and vegetation remain in their place. But this is not the conventional image of the beneficent and progressive workings of history; for here the fruits are seen as contaminated by the roots. Where almost all other Soviet writers would proudly place themselves in the Decembrist tradition, Bagritsky sees only the horror and the demoralization; Russian history is a long nightmare that must be obliterated if a new and healthier race is ever to inherit the world.

Where Khlebnikov had punned on the name Vladimir – 'vladey mirom' (possess the world), Bagritsky echoes him on the name Vsevolod – 'vsem voloday' (possess everything), but gives it precisely the opposite meaning. Khlebnikov's words were addressed to the past – the dead can keep their culture; Bagritsky's are addressed to the future, which will contain everything but the past. Khlebnikov places the words near the beginning of his poem, and then proceeds to question them, before finally showing that the words contain an ironic truth: the past has taken with it something that the future wishes too late that it had acquired; in Bagritsky the episode occurs at the end of the poem as its climax and moral.

The poem is a startling one, but in the following poems, 'My Origins' ('Proiskhozhdeniye', 1930), 'The Last Night, ('Poslednyaya noch'', 1932), 'A Man of the Outskirts' ('Chelovek predmest'ya', 1932) Bagritsky returns to this vision of the past as a loathsome nightmare which has no place in the future. It is in this context that the poem 'February' makes its extraordinary bid to settle accounts once and for all with the past.

The poem is, strictly speaking, unfinished (the poet died of tuberculosis early in 1934) and it appears that he had intended to insert some 'lyrical interludes' into the work. It is hard to believe that these would have enriched the poem any further; if anything they would have diluted it. As it stands it is already a self-contained and unified work of art.

The poem is set in Odessa, where the unnamed narrator-hero has returned on leave in the middle of the Great War. The ensuing action falls into three distinct episodes. In the first the hero tries to gain the attention of a girl he has always dreamt of hopelessly, and is contemptuously rejected. The scene then shifts

to the immediate aftermath of the February revolution; the hero takes part in the storming of a police-station, and soon becomes a military policeman himself under the new regime. In the final episode he leads a raid on a private house suspected of harbouring some bandits; it proves to be not only that but a brothel as well, where the hero discovers the girl of his dreams in bed with an unknown officer. He arrests him, sends his men out of the room, and then rapes the girl himself. The poem ends with the hero's attempts to explain his actions.

This final episode is an extraordinarily powerful one, and it is not altogether surprising that it was based on an event from Bagritsky's own life, that took place soon after the November revolution:

> All this actually happened to me, just as I describe it. Yes, the schoolgirl and the search. I hardly added anything at all, but what was essential for the idea. First, the bandits we were looking for, turned out not to be in the house.
>
> Second, when I saw this schoolgirl, with whom I had once been in love, and who had now become an officers' prostitute, well, in the poem I send everyone out, and jump on the bed on top of her. It was, so to say, a break with the past, a settling of accounts with it. In actual fact I was completely bewildered and couldn't get out of the room fast enough. That's all there was . . .[20]

For all Bagritsky's disclaimers these changes are not minor ones. It is worth looking at the poem in some detail to see why they were 'essential'.

The poem combines two distinct themes, the hopeless and envious love of an adolescent boy, and his identification with the revolutions that will destroy the society that has frustrated his love; in the final episode these two motives are brought together as the two sides of a single coin. The connection between them is the compromised reputation of the culture of the past: apparently infinitely beautiful and desirable, the girl finally turns out to be only a prostitute in an officers' brothel, a Venus of the cities of the plain. The hero's attempt to 'possess' and 'master' her is an allegory of the revolution's attitudes to this dubious heritage.

From the start the narrator feels an outsider, desperately in-

secure and unsure of himself. He is a Jew, like Bagritsky, who changed his real name Dzyubin to something more suggestive of the Red revolution (the root 'bagr-' means 'crimson'). His childhood too, as so often in Bagritsky's autobiographical writings, is depicted as a time of deprivation without any happiness or freedom or love:

Я никогда не любил, как надо,
Маленький иудейский мальчик.*[21]

But, as the self-pitying tone suggests, and as the narrator himself is uneasily aware, it is not just a matter of deprivation, but an inner flaw, a lack of any confidence and *savoir-faire*, both social and sexual, that cripples him. As he explains in a sour mixture of self-disgust and envy:

Я не подглядывал, как другие,
В щели купален.
 Я не старался
Сверстницу ущипнуть случайно...
Застенчивость и головокруженье
Томили меня.†[22]

Shy and friendless as a boy he becomes a passionate ornithologist (again like Bagritsky himself), with an extensive library and a collection of singing-birds, and throughout the poem ornithological imagery stands for an easier, rosier existence where the difficulties of this life will no longer alarm or threaten. But, typically, when he tries to describe his ideal future, he can picture it only in terms of specific childhood details that are not imagined, but remembered:

Я должен найти в этом мире угол,
Где на гвоздике чистое полотенце
Пахнет матерью, подле крана – мыло,
И солнце, бегущее сквозь окошко,
Не обжигает лицо, как уголь...‡[23]

*I never loved as I should have done, a poor little Jewish boy.
†I never spied like the others through the chinks of the bathing huts. I never tried to accidentally pinch the girls . . . Shyness and vertigo sapped my strength.
‡I must find a corner in this world, where a clean towel hangs on its nail and smells of mother, where the soap lies ready by the tap, and the sun streaming through the window does not scorch the face like a hot coal . . .

This atmosphere of homely comfort (and particularly the dislike
of bright lights) recurs again and again as a criterion by which to
evaluate the hero's state throughout the poem. One might have
expected such values to be condemned as nostalgic or bourgeois
or at least un-Communist; but no! this is what will one day be
restored, with the difference that today's outsiders will then be
the insiders, with all that that implies in the way of self-possession,
power and authority.

Now returned from the front the hero sits on the Odessa
boulevard in his military uniform, hoping that at last he will be
admitted to the magic circle from which he has been excluded:

И я теперь среди них как равный,
Захочу – сижу, захочу – гуляю,
Захочу (если нет вблизи офицера) –
Закурю...*24

His service at the front has earned him (at least in his own eyes)
the right apparently to equality with these more fortunate citizens.
But he is still not their 'equal', only 'like an equal'; and his back-
ward glance for an officer casts doubt even on that.

So too his knowing appraisal of the girl's escorts serves only to
emphasize his own isolation:

Я знал в лицо всех ее знакомых,
Я знал их повадки, улыбки, жесты,
Замедленный шаг их, когда нарочно
Стараешься грудью, бедром, ладонью
Почувствовать через покров непрочный
Тревожную нежность девичьей кожи...
Я все это знал...†25

For he knows this only with the knowledgeability of jealousy. The
use of the impersonal second person singular ('when you try') may
seem for a moment to come from direct experience, but it is con-
tradicted by '*their* steps'; and so the final 'I knew it all' creates

*And now I am like an equal among them. If I want I can sit, if
I want I can stroll, if I want – and there isn't an officer close by –
I can smoke . . .

†I knew all her acquaintances by sight; I knew their mannerisms,
smiles, gestures, the way they slowed their steps when, with your
chest, your hips or your hands, you deliberately try to feel the
disturbing softness of girls' skin through its fragile covering. I
knew it all . . .

instead the impression of second-hand knowledge, the knowledge of an observer, an outsider, not a participant.

All the frustrations of his adolescence, his unhappy childhood and his poor background, his sense of exclusion from the 'world in which people play tennis, drink orangeade and kiss women'[26] seem to crystallize in the figure of this girl. Alien and hateful though this world is, the narrator still wants to become part of it. Finally he screws up the courage to address her:

Я козыряю ей, как начальству.
Что ей сказать? Мой язык бормочет
Какую-то дребедень:
 — Позвольте...
Не убегайте...Скажите, можно
Вас проводить? Я сидел в окопах!...*[27]

In these lines Bagritsky conveys the insecurity of the speaker; even his mention of his time in the trenches is not a boast, but a pathetic plea for consideration: 'Surely I deserve a reward?' Not surprisingly she dismisses him:

'Уходите немедленно', – и рукою
Показывает на перекресток...
 Вот он –
Поставленный для охраны покоя –
Он встал на перепутье, как царство
Шнуров, начищенных блях, медалей,
Задвинутый в сапоги, а сверху –
Прикрытый полицейской фуражкой,
Вокруг которой кружат в сияньи,
Желтом и нестерпимом до пытки,
Голуби из Святого Писанья
И тучи, закрученные как улитки...
Брюхатый, сияющий жирным потом
Городовой.
 С утра до отвала
Накачанный водкой, набитый салом...†[28]

*I salute her, as if she were my commanding officer. What can I say to her? My tongue mutters some drivel: 'Permit me . . . Don't run away . . . Please, may I accompany you? I have served in the trenches . . .'

†'Go away at once', and with her hand she points to the cross-

For a moment the individual frustration of the narrator seems to have passed into a social protest. The unattainable world of beauty and luxury symbolized by the pretty girl is allied to a smug and apparently impregnable ruling caste; words such as 'Empire' and 'Holy Writ' turn the policeman into a symbol of the power and authority of Imperial Russia. The girl that he desires becomes identified with all that he hates. But what these lines contain is not so much social protest as frustration masquerading as social protest; it is the 'I' of the poem who describes the scene, and the last one and a half lines, deliberately set off from the rest, make no pretence at objectivity (the hero does not speak to the policeman or go any nearer to him); they are made to look like an afterthought, an insult hurled from a safe distance and under the breath. Here in a single image is the nub of the situation, the rebel and the culture he loves and hates.

The second episode moves to the historical and political plane. It opens with an enthusiastic political meeting:

> Из февральской ночи
> Входят люди, гримасничая от света,
> Толчутся, отряхая иней
> С полушубков – и вот они уже с нами,
> Говорят, кричат, подымают руки,
> Проклинают, плачут.*[29]

The outsiders seem to have become insiders at last (they have 'come in' from the 'night'); they feel confident, on the winning side, in the majority. The 'I' has become happily absorbed into

roads . . . There he stands at the crossing for the maintenance of order, like a whole empire of ribbons, polished buttons and medals, wedged into his boots, and covered on top with a gendarme's cap, around which doves out of Holy Writ and storm-clouds, whorled like snails, circle in the intolerable radiance, so yellow that it hurts – a potbellied policeman, gleaming with fatty sweat, stuffed full since breakfast of ham-fat and bulging with vodka . . .

*People come in from the February night, grimacing in the light, bumping into one another, shaking the frost off their coats; and now they're all in with us together, talking, shouting, raising their hands, cursing and weeping.

the 'we', and the revolutionaries set off to attack the police-
station. The timid, insecure hero can now feel himself a real man:

> Кровью мужсства наливается тело,
> Ветер мужества обдувает рубашку.
> Юность кончилась...
> > > Начинается зрелость...
> Грянь о камень прикладом! Сорви фуражку!* [30]

The hero's body floods with 'manhood', not in the usual sense of
the Russian word, 'manly stoicism', which is hardly applicable in
this situation of aggression, but in the more basic meaning of
virility. Yet the childish gestures with rifle-butt and cap contrive
to undercut these claims of manhood and maturity. It is as if the
hero were still looking over his shoulder for reassurance: 'Is this
how real insiders behave?'.

The revolutionaries take over the police-station without meet-
ing any resistance, and they demand to see the Inspector. When
they meet him they are taken aback by his effusiveness:

> Улыбаясь, тая, изнемогая
> От радушия, от нежности, от счастья
> Встречи с делегатами комитета...
>
> А мы...стояли, переминаясь
> С ноги на ногу, пачкая каблуками
> Невероятных лошадей и попугаев,
> Вышитых на ковре...
> > > Нам, конечно,
> Было не до улыбок.
> > > Довольно...
> Сдавай ключи – и катись отсюда к черту!
> Нам не о чем толковать.
> > > До свиданья...
> Мы принимали дела.
> > > Мы шлялись
> По всем закоулкам. [...]
> ...Мы добыли арестантский чайник,
> Жестяной, заржавленный, и пили,

*My body floods with the blood of manhood, the wind of manhood
blows around my shirt. Childhood is over. Maturity has begun.
Bang your rifle-butt on the stones! Off with your caps!

Обжигаясь и шлепая губами,
Первый чай победителей, чай свободы. . . *[31]

In the face of the mocking courtesy of the Inspector the assurance
of the new rulers crumples, as is suggested by the broken lines,
the abrupt changes in tone, from the embarrassing sense of being
out of place and dirtying the carpets to the peremptory commands
and the peculiar aimlessness of their activities after the takeover.
Somehow the old regime's secret has escaped them. They are
insiders to all appearances, but the imagery still hints that they
are not masters but captives; the doors are closed behind them,
and they drink their tea from a prisoner's teapot. Society has been
turned upside-down, and the former insiders have been evicted,
but the new masters are depicted as squatters, without any sense
of permanence, and the confident assertion of the last line reads
ironically because of the triviality of the actual gesture – drinking
tea. As at the end of *Night Search* the revolutionaries seem to
have won everything except the one thing they desired most of all.

The new regime is installed, and the narrator becomes assistant
to the local commissar. Surrounded by the visible trappings of
power, he wishes that his down-trodden Jewish forebears could
see him now in his hour of triumph. But this need to justify him-
self by a challenge to the past shatters all his pretensions to
maturity and self-assurance. He has become an insider only to
find himself once again a prisoner, looking out through the
windows at the world continuing without him:

Я просиживал ночи в сырых дежурках,
Глядя на мир, на проходивший мимо,
Чуждый мне, как явленья иной природы. †[32]

*Smiling, melting, swooning with cordiality and graciousness and
the sheer happiness of meeting the delegates from the committee
. . . And we – we just stood there, shifting from one leg to the
other, our heels muddying the fantastic horses and parrots em-
broidered on the carpet. Of course we were in no mood for
smiles. That's enough, hand over the keys, and clear out of here.
There's nothing to negotiate. Good-bye . . . We set about taking
things over. We wandered around all the corridors. [. . .] We
found a prisoner's teapot, tinny and rusty, and drank our first tea
of victory, the tea of freedom, out of it, slurping and burning our
lips.
†Nights on end I sat in damp guard rooms, gazing out at the
passing world, foreign to me like elements of an alien nature.

In the final and culminating episode the hero and his men raid a house which is suspected of harbouring bandits. The scene in which they burst into the house is in many ways parallel to their takeover of the police-station, a similar mixture of timidity, self-consciousness, bewildered admiration and brutal violence:

<div align="center">

К двери

Подошел я один.

Ребята,

Зажав меж колен карабины,

Вплотную прижались к стенке.

Все – как в тихом приличном доме...

Лампа с темно-синим абажуром

Над столом семейным. [...]

...на шкафе бюст Толстого.

Доброта домашнего уюта

В теплом воздухе [...]

Все в порядке...

Мы вошли как буря, как дыханье

Черных улиц, ног не вытирая,

И не сняв бушлатов... *33

</div>

One night have expected the hero and his revolutionary sailors to be enraged and extra-suspicious rather than impressed by this picture of bourgeois culture. Do they recognize it perhaps as an incarnation of the ideal culture towards which they too aspire?

<div align="center">

Я вошел и стал в изумленьи...

Черт возьми! Какая ошибка!

Какой это чайный домик!

Друзья собрались за чаем.

Почему же я им мешаю?...

Мне бы тоже сидеть в уюте,

Разговаривать о Гумилеве,

</div>

*I went up to the door on my own. The lads, gripping their carbines between their knees, squeezed themselves flat against the wall. Everything was just as in a nice decent house – a lamp with a deep blue shade over the family table [. . .] a bust of Tolstoy on the cupboard. All the solidity of domestic comfort in the warm air [. . .] everything was quite in order. We burst in like a tempest, like the breath of the black streets, not wiping our feet or taking off our coats . . .

А не шляться по ночам, как сыщик,
Не врываться в тихие семейства
В поисках неведомых бандитов...*³⁴

Because of the reference to Gumilev this passage might seem to be ironic (as it would be in most Soviet writers), but it is difficult to see any irony here. There is none in the narrator's tone: he is still fascinated by these bourgeois ideals, and quite willing to accept their right to exist like this, provided they break no laws. He even feels guilty at interrupting this cultural idyll.

But at this point one of the sailors recognizes the officers as the bandits they were looking for and tells them to put their hands up. The revolutionaries then proceed to search the house, and discover that it is a brothel. In one room they find the supposedly inaccessible girl naked in bed, and a man in his underclothes beside her. For a moment he brandishes a gun, and then he winks: 'Oh, the whole fleet's come! This little cannon's not much good against them. I surrender.'³⁵

The two faces of the bourgeois world fuse into one: the glamorous and unattainable culture of the bourgeoisie proves to be no more than a den of bandits and prostitutes, yet it still retains all its glamour and superiority. There is a striking stylistic contrast between the easy capitulation of the winking officer and the clumsy and embarrassed manner of the victorious revolutionaries. As in *Night Search*, even in defeat and humiliation, the old class still possesses its secret intact. And as in *Night Search* the secret is in the eyes.

What is this secret? And how can it be acquired? And what is the justification for acquiring it? These questions are raised in the final lines of the poem. The hero challenges the girl:

(1) 'Ну что, узнали?'
 Тишина.
 Тогда со зла я брякнул:
 'Сколько дать вам за сеанс?'

*I entered and stopped in amazement. The devil take it! What a blunder! What sort of thieves' kitchen was this – just some friends sitting over a cup of tea. What was I doing interrupting them? I too would like to sit in comfort, converse about Gumilev, and not wander through the nights like a spy, bursting into respectable families in search of non-existent bandits.

И тихо,
Не раздвинув губ, она сказала:
'Пожалей меня! Не надо денег...'

Я швырнул ей деньги.

Я ввалился,
Не стянув сапог, не сняв кобуры,
Не расстегивая гимнастерки.
Прямо в омут пуха, в одеяло,
Под которым бились и вздыхали
Все мои предшественники, – в темный
Неразборчивый поток видений,
Выкриков, развязанных движений,
Мрака и неистового света...

(2) Я беру тебя за то, что робок
Был мой век, за то, что я застенчив,
За позор моих бездомных предков,
За случайной птицы щебетанье!

Я беру тебя, как мщенье миру,
Из которого не мог я выйти!

(3) Принимай меня в пустые недра,
Где трава не может завязаться, –
Может быть, мое ночное семя
Оплодотворит твою пустыню.

Будут ливни, будет ветер с юга,
Лебедей влюбленное ячанье.*[36]

*(1) 'Well, do you recognize me?' Silence. Then in anger I blurted
out: 'How much do I pay you for a session?' Quietly, not moving
her lips, she said: 'Take pity on me! I don't want any money . . .'
I threw some money at her. I plunged in, without pulling off my
boots or taking off my holster, or unbuttoning my tunic. Straight
into that abyss of down and blanket under which all my pre-
decessors had struggled and panted – into a dark and phantas-
magoric torrent of visions, yelps, shameless movements, darkness
and fierce light.
(2) I am taking you because my generation was timid, because I
was shy, because of the shame of my homeless forebears, because
of the twittering of a chance bird. I am taking you as vengeance
on a world from which I couldn't escape.
(3) Receive me into your empty depths, where even grass cannot
take root. Perhaps my nocturnal seed will fructify your desert.
 Spring showers will come, and a wind from the South, and the
love-calls of swans.

The three sections indicate the successive stages in the hero's interpretation of what has happened in the act of 'possession', and they recapitulate the main themes of the poem, and indeed the three main attitudes to the problem of the culture of the past.

In the first stage he is concerned simply to possess and humiliate; all the gestures are violent and brutal. If one's ideal turns out to have been a prostitute all along, one might as well treat her the same way oneself. There is no 'secret' to be sought or redeemed in this 'possession'. But the very crudity of his assault leads him into the same old trap. Far from possessing the past he begins to wonder if he has not been possessed by it; the imagery is of being sucked in and swallowed up by darkness. Is there any significant difference between his actions and those of his predecessors?

In the second stage the tone changes dramatically: from action to introspection, from self-assertion to self-justification, from aggression almost to apology. Even the word 'vengeance' is so modified by the 'shy' and the 'timid' of the first two lines that it sounds impotent. The transition is extraordinary: the unattainable ideal has been caught in the act of collusion with the class-enemy, and the hero finds himself apologizing for his anger. He addresses her for the first time as 'tu', and without any mockery or contempt.

In the final section the situation is reversed, or rather restored. The hero addresses the girl once again in the tones of a diffident lover: 'receive me', 'perhaps'. Hateful though this old world is, the hero still wants to renew its vitality. But why does he call *her* a desert? in that case she wouldn't be worth possessing. Surely throughout the poem this ideal has been depicted as a secret inaccessible garden of elegance and beauty, of self-assurance and good taste, into which the hero time and again brings his muddy boots. Culture, upper-class whore that she is, needs only to throw herself open to the masses, and all will be forgiven. Because, surely, the desert is the uncultured post-revolutionary society. The culture of the past does not need the present to bear its fruit; it is the present which needs the secret of the past.

Of course, Bagritsky did not actually behave like this, or think of these arguments at the time; in some embarrassment he ran straight out of the room. Wasn't this in fact the normal, healthy

and correct response? If the whole episode was, 'so to say, a break with the past, a settling of accounts with it', it is strange that Bagritsky should have felt the need to rewrite it this way: to turn a non-event into a rape, a 'complete break' into a desperate plea for continuity. Why should one have any truck with 'mastering' and 'possessing' such social undesirables? In *Night Search* the revolutionaries had come gradually to a grudging admission of the merits of the class-enemy. In *February* the supposed merits of the girl are stripped away one after another, until nothing remains, but she still remains uniquely desirable.

If in the works of other Soviet writers the intellectual hero often seeks (in vain) for renewal through a union with an illiterate peasant-girl, in Bagritsky the homeless revolutionary tries to establish and legitimize his inheritance by raping a bourgeois girl in an officer's brothel. The successive arguments of the hero to the girl are metaphors for the changing attitudes of the revolutionary generation to the culture of the past: first, a violent and destructive assault, then the envious aspirations and self-justifications of the frustrated and deprived outsider, and finally the half-hearted suggestion that perhaps between them they could improve the genetic stock. Partly because of this the final two lines of the poem with their evocation of a springtime idyll, complete with birds and all, are so unconvincing. These images have throughout been associated with escapism and self-defence, not of a new understanding. The hopes of the final lines, as of the whole poem, remain a pathetic, unattainable vision.

5

The difference of art:
some Soviet writers of the 1920s and 1930s

O salt-stone family of Lot,
Here is your family album.
Tsvetayeva[1]

Early Soviet literature is, not surprisingly, obsessed by the
problem of 'the new and the old'. The Communist victory had
not created a new world overnight; old ways and values con-
tinued to exist and to pose a challenge to those of the new
society. For this reason the apparently simple imagery of birth
and death that permeates this literature often proves to be more
complex than might seem at first glance. Indeed, even in rejecting
the values of the past, writers often tacitly took them as their
starting-point.

In Fedin's *Cities and Years* (*Goroda i gody*, 1924), for example,
the clash takes the form of a Russian intellectual (Andrey
Startsov) being forced to choose between his traditional moral
duty to repay his benefactor, Count von Schönau, who had helped
him to escape from internment during the Great War, and his
new duty to imprison him as an enemy of the revolution.
Startsov finally decides to let him go, and for this he is himself
executed by the one who was formerly his closest friend, the
Communist Kurt Wahn. It is plain that Fedin means us to con-
demn Startsov and to approve Kurt Wahn; he intervenes in the
narrative to spell out the logic of the new morality:

> And now we come to the end of the story of a man who
> had yearned hopelessly that life would accept him. We
> look back at the road along which he had travelled hard
> on the heels of cruelty and love, a road, covered in blood
> and flowers. He had travelled its entire length, and not a

single drop of blood had sullied him, not a single blossom
had been trampled by him.

O, if only he had taken upon himself a single drop of
blood or trampled a single blossom! Then perhaps our
pity for him would have grown into love, and we would
not have allowed him to perish so ignominiously and
painfully.[2]

Fedin clearly felt that his demonstration of the new morality
was not completely self-explanatory: was it simply the bourgeois
indoctrination of his contemporaries that was to blame? After
all if the moral had followed more naturally out of the narrative,
the author would not have needed to intervene so crudely. And
the fact that of the two central characters the model of Com-
munist righteousness, Kurt Wahn, is a German, while the old-
fashioned moral scruples are given to a Russian, further con-
fuses the sympathies of the reader. Doesn't this suggest a certain
dilemma within the mind of the author too? The issue should be
plain enough by itself, but in practice it proves to be not so easy.

An exhaustive study of this feature of Soviet literature would
require a much larger book than this one. In this chapter I shall
look at five writers whose works raise these questions particularly
acutely.

Zamyatin

Zamyatin provides a good starting-point, because being both a
Marxist and an artist he symbolizes the problem of art in the
post-revolutionary period. He saw the history of art in terms of
the Marxist dialectic of progress, and so his account of it is
oriented entirely towards the future; there would seem to be no
place in it for the arts of the past.

> Today is doomed to die; because yesterday has died, and
> because tomorrow is being born. Such is the cruel and
> wise law. Cruel, because by it those who today glimpse
> the distant heights of tomorrow are doomed to eternal
> dissatisfaction. Wise, because only this eternal dissatis-
> faction can guarantee our eternal progress and eternal
> creativity. The man who has found his ideal today is like
> Lot's wife; he has been turned into a pillar of salt, has

settled into the ground and moves no further. The world is kept alive only by its heretics: Christ was a heretic, Copernicus was a heretic, Tolstoy was a heretic. The symbol of our faith is heresy.[3]

For Zamyatin art, and especially literature, was the spearhead of this movement; the artist was the heretic *par excellence*, the very image of evolution. The artist does not wait for the world to catch up with him; his task is to be constantly ahead, questioning and challenging even the truths that he had himself propounded only the day before. The artist knows that yesterday's heresies become tomorrow's dogmas.

If in many of his views Zamyatin comes close to those of LEF, he could never accept its political loyalism. The function of art was to act as a constant gadfly, to continue to oppose the natural conservatism of the powers that be, whatever their ideological colouring, and to correct the excesses caused by the latest swing of the historical pendulum in order to prepare the ground for the next revolution. And so he was horrified by the willingness of many young artists to serve the new regime unquestioningly, and no less horrified by the willingness of the former revolutionaries to accept such quick-change converts as Averbakh and Gorodetsky. A government could be judged by the extent to which it was alive and receptive to the new, the strange, and the heretical; and, conversely, by the degree of its attachment to the well-tried and familiar;

> I am afraid that we are preserving too lovingly too much of what has come down to us from the palaces. These gilded chairs – of course they must be preserved: how elegant they are, and how comfortably they caress the buttocks. And isn't it true that the court poets resembled these charming gilt chairs in their elegance and comfort. But isn't it a mistake to preserve the institution of court poets as carefully as the gilt chairs. The palaces may have remained, but not the court.
> . . . The French Revolution was more ruthless in its destruction of everything connected with the court . . . The French Revolution guillotined the court poets even though they'd changed their clothes. But our 'nimble authors, who know when to put on the red cap and when

to take it off' . . . are held up to the people as a literature worthy of revolution.[4]

The same ideas are found in Zamyatin's fiction too. Life and history are depicted as a continuous onward progression. Death is the seeming antithesis necessary for the creation of new life. And so many of his stories end with a scene that combines both death and birth. In Bryusov's 'The Last Martyrs' the final orgy before destruction by the barbarians had been simply self-indulgent (for the author as for the heroes); in Zamyatin such juxtapositions are always significant. Thus in the 'Story about the Most Important Thing' ('Rasskaz o samom glavnom', 1923) the imagery is full of bridges, symbols of the crossing over from one life into another; the caterpillar enters the chrysalis in order to be reborn into a butterfly. Nothing ever comes to an end, and the story culminates in an unfinished sentence that is simultaneously a picture of death and of birth, widening the perspective from the local catastrophic scenes of the Civil War to the vast cosmic expanses of an infinite future:

> Out of the huts, as clumsy as bears, and now erect, come galloping the men of Kel'buy and Orel; they're all running somewhere, dropping into the hot gullies. The earth opens her belly wider – and wider – the whole of herself, – to conceive, so that in a crimson blaze – new fiery creatures, and then in a white warm mist – still newer creatures, like flowers, attached to the new Earth by a single fragile stem, and when these human flowers open . . .[5]

In *The Scourge of God* (*Bich bozhiy*, 1928–35), his last and unfinished novel, Zamyatin seems to return to Blok's analogy (as expressed in the essay 'Catiline') with the destruction of Roman culture by the barbarians. Attila's Huns (*khuny* here rather than Bryusov's *gunny*) are young and healthy, and they bring the promise of new life through the destruction of a sick and dying civilization. The tenor of the story recalls the message of Blok in 1918, that the West is doomed and that some new order, or at least epoch, is advancing from the East. This was no doubt partly due to Zamyatin's disillusionment with the West, where he had emigrated in 1931, but it is none the less striking that the position

from which Blok gradually withdrew in the years 1918–21 was to be Zamyatin's last word on the subject.

For the most part Zamyatin's stories and ideas are oriented firmly to the future. The only one of his works which presents matters in a different light is his novel *We* (*My*, 1919–20). Although the action is set 1200 years in the future, the past plays a crucially important part in it; it is the 'ancient house' that forms the centre of the opposition to the state. The engineer D. 503 who sets out to describe the virtues of the Single State is constantly reminded, every time he takes up his pen, of his indecently hairy hands that link him with the barbarian past. Yet it is just this atavistic throwback that turns D. 503 from a conformist engineer into a creative, heretical, and revolutionary artist. (Many years before the event Zamyatin foresaw the totalitarian persecution of genetics.) Instead of the future coming to the dubious salvation of the past, as the narrator at first naively supposes, it is eventually the past in the form of the poetry of Pushkin, the music of Skryabin, and the timeless values of love and nature that come to the rescue of the totalitarian future.

No doubt this remarkable assertion represents Zamyatin's deepest thoughts and feelings on the subject, but it is difficult to reconcile with his dialectic of human progress. It would seem that though art is heresy, and yesterday's heresies become tomorrow's dogmas, despite the rules of the syllogism, yesterday's art is after all still alive and heretical. Although he seems to have questioned everything else, Zamyatin took over this central contradiction in Marxist aesthetics unquestioningly.

Pil'nyak

Pil'nyak's attitude to the past is no less contradictory than Zamyatin's, but in a different way. For Zamyatin the difficulty arises from his view of history as a dialectical progression; for Pil'nyak, at least in his early works, it springs from his sense of history as circular. The cycle of the seasons and of life provides him with all the plot he needs. His early story 'Above the Ravine' ('Nad ovragom', later renamed 'A Whole Life', 'Tselaya zhizn'', 1915) tells of the life of owls, 'Snow flurries' ('Pozemka', 1917) of that of wolves, 'A Year of their Life' ('God ikh zhizni', 1915) of bears and men. His allegorical story 'The Bridegroom in the Night' ('Zhenikh vo polunochi', 1925) depicts the rise and fall of

empires – whether of ants or of men – as proceeding according to cyclic patterns. The same law holds true of the revolution too:

> Man works twenty-nine days in the month, and on the thirtieth he goes out and gets drunk: when he's drunk he'll stop at nothing; his actual work, the making of his life, of his right to life, is done on the working days. The state too has its working days and its drinking days – they are the revolutions. Drunkenness breeds work, work breeds drunkenness. Russia has been drunk for five years, five glorious years. Now she is returning to work again.[6]

Just because of this cyclicism Pil'nyak saw all change as leading backwards as well as forwards. He welcomed the revolution not because he was a Marxist, or indeed for any social or political reasons, but because he saw it as restoring Russian culture to its true origins, from which it had been fatally diverted by the Western flirtations of Peter the Great, and the whole of subsequent Russian cultural development down to 1917.

Pil'nyak's stories and heroes may visit the Westernized capitals, but only temporarily; they soon withdraw from them to the East and the North, where they rediscover the true nature of their country and themselves. Like Blok's Scythians and Zamyatin's Huns, Pil'nyak's Russians present a barbaric challenge to the overcivilized and enfeebled West. As far as Pil'nyak was concerned, Marxism too was a Western importation, and in time the revolution would shake off these trappings and reveal its essentially Russian face, taking up the thread where it had been broken off in the seventeenth century:

> Russia with its Time of Troubles, with its Razin and Pugachev and 1918, with its ancient churches, its ikons, heroic lays, rituals, with her steppes and forests, her marshes and rivers, water-spirits and wood-demons.[7]

For Pil'nyak all this belongs together inseparably: Russian nature, Russian culture, and the Russian tradition of anarchic uprisings; only the Western influence is alien. The primeval Russian village has re-emerged as a force in the land, and the once haughty city-dwellers are forced to beg food and sustenance from it (see the story 'Forest Paths', 'Proselki', 1919). Old Believers, reminders of the Russia destroyed by Peter the Great,

become the anarchist heroes of today. Pil'nyak often juxtaposes medieval documents and contemporary posters to suggest the rediscovery of historical continuity. Archaeologists in their excavations of the pre-Slavic past discover traces of beliefs and rituals still current in the twentieth century. The wind moaning over the steppes utters sounds that prove to be identical with the acronyms of Soviet institutions, 'gviu', 'glavbum', 'nachevak'. The destruction that reveals the true continuity of Russian development is the main theme of Pil'nyak's early fiction.

The one exception to this pattern appears to be 'The Belokonsky Estate' ('Imeniye Belokonskoye', October 1918), Pil'nyak's first story about the revolution. Here the Communist peasants take over a wealthy house and expel its aristocratic owner. At the end of the story they destroy a priceless eighteenth-century clock and finally throw the pieces down the lavatory. Later Pil'nyak would have treated this episode as a symbolic rejection of the St Petersburg period; in this story, however, it is clearly regarded with horror. The blame rests not so much with the peasantry, however, as with the Communist Party which has turned the active and industrious peasant Koloturov into a pen-pushing bureaucrat. In a brief detail, Pil'nyak anticipates the problem of *Night Search*:

> [Koloturov] was worried all the time about cleanliness: there were lumps of mud off the peasants' boots lying around the floor; he couldn't make out why the gentlemen's boots didn't leave dirt behind them. He knelt down to pick up the lumps of mud off the floor and threw them out of the window; then he fetched a broom and swept up.[8]

Like Khlebnikov Pil'nyak here touches on the sense that somehow the 'gentlemen' had possessed some mysterious secret which had eluded those who had come to inherit their material belongings.

But this attitude is unique in early Pil'nyak. At the end of *The Naked Year* (*Golyy god*, 1922), he tried to see even the new industrialization of Russia as essentially different from its Western model:

> And then what? will our Cathay switch to a bowler-hat and a brief-case! isn't it rather a third type that is coming

instead, one who 'can fuction enegretically' [*enegrichno fuktsirovat'*]?[9]

The peasant may master the machine, but he must preserve his healthy illiteracy as well.

This paradoxical attitude to industrialization – as a Western importation that may yet take a quintessentially Russian direction – is explored in Pil'nyak's most ambitious work *Machines and Wolves* (*Mashiny i volki*, 1923). The two images of the title are complex; apparently they represent polarities, the two faces of Russia, the future and the past, though both may seem inimical to the Russian culture that Pil'nyak admires. But at the same time, the wolf is an image of natural, instinctive life, as in 'Snow-flurries' (for Pil'nyak, as for many other writers of the period, the wolf rather than the bear is the Russian national animal), while the image of the machines is naturally linked with the proletariat and the new industrial culture:

> . . . the black hand of the worker – five feverishly clenched fingers, black as soot, hewn out of steel, like muscles – this hand, like a machine, had seized Russia and the Russian blizzard by the short hairs; no one in Russia understood the romanticism of this hand.[10]

As the book unfolds the two images interweave until they finally come together in the scene at the zoo:

> . . . the wolf was running round its cage; the wolf had studied its cage; it circled round in it, stepping in the same footprints, mirroring the same movements each time, not like a living creature, but like a *machine* – disappearing into the shadows of the cage, and re-emerging into the light; then it stopped, lowered its head, and looked at the people from under its eyebrows, tired and miserable – and quietly howled, yawned – the wolf, the terrible Russian wolf, was helpless . . .[11]

Two men look at it, the Russian peasant Andrey Kozaurov, totally uneducated, but a mechanical genius, who understands machines as if they were alive, and the Russian intellectual and aristocrat, the engineer Andrey Roschislavsky, who has joined the Communists; but their attitudes are poles apart. Kozaurov:

> Ugh! When I look at a wolf all our savagery, Russian savagery, I mean, seems to come oozing out of it. All the bastards should be put in the zoo.

And Andrey:

> And when I look at him, I feel sorry for him, I feel like an orphan. In that wolf I see all our romanticism, the whole revolution, the whole of Razin. I'm sorry that he's locked up! He should be released – set free – like 1918.[12]

In these two attitudes to the wolf Pil'nyak presents two irreconcilable positions, the romanticism of the machine, and the romanticism of the wolf. Each is represented by an Andrey (the name of the Apostle, who according to legend, brought Christianity to Russia); but, ironically, it is the Russian peasant who wants to impose Western discipline on the wolf; it is the Western-trained intellectual who identifies with it as a protest against the demoralizing and dehumanizing effects of industrialization:

> ... behind civilization, behind the five-kopeck newspaper, behind the starch collar, is being reborn a savage, who knows nothing, and who has neither time nor strength to discover what the machines have contrived ... And now our factory's come, and the old songs are forgotten, there are hundreds of vodka-shops, and no children are being born to the workers, they're dying out, every worker in the first generation has three mistresses, and every girl is a prostitute, and in the evenings the crossroads echo with filthy songs.[13]

But the industrialized future is now inevitable, and it seems to possess in the peasant Kozaurov a secret that Andrey cannot acquire – here the myth of *Night Search* is reversed: 'So you want to find out about his "sensometry", do you? But he won't tell you. Everybody would like to know how to animate a machine.'[14] Resistance to this new order seems hopeless, and Andrey is finally sucked in and destroyed by a gigantic fly-wheel.

Although Pil'nyak tries to balance Andrey's complaints with the usual Marxist arguments that under socialism industrialization will avoid the miseries associated with it under capitalism, he

identifies himself with the tragedy of Andrey, for his theme is not just the pros and cons of industrialization, but the loss of the organic culture of the past, which, like Andrey's mistress, the illiterate peasant-girl Mariya, is being sacrificed to the new Moloch. Pil'nyak's earlier cyclic view of history has given way to a linear conception which seems to leave no place for the past.

Pil'nyak, however, did not leave the issue with this pessimistic conclusion, and when he visited Japan in 1925 he was fascinated by the continuity of its culture:

> I am thinking about old and new Japan; I know that what is created over centuries cannot disappear in a decade. How have the old and the new come together in Japan? what brought them together? It is said that Japan's heart is in the old, her head in the new. Perhaps the head and heart of the Japanese people go hand in hand together. But anyway, what are those forces in Japanese antiquity which have given the people their ability to accept the new? [15]

One of Pil'nyak's most ambiguous treatments of the theme is 'Ivan Moskva' (1927). The hero comes from the backward Finno-Ugrian tribe of the *zyryane*, and suffers from hereditary syphilis ('I have no right to have any posterity'[16]); the image, a common one in Pil'nyak's works (indeed he sometimes puns on the words 'syphilis' and 'civilization'), is derived from the old theme of the past as a brothel. In the revolution Ivan joins the Communists and later becomes a radium physicist. The radium offers him the hope of a cure and a new life, as Communism does for the benighted *zyryane*. He thus becomes the battleground where the past and the future meet in an almost Mayakovskian confrontation.

The story ends tragically. Returning from a visit to a Moscow specialist Ivan is killed in a plane-crash, and the story ends with its major issues still unresolved. Which aspect of Ivan Moskva has been killed – the contagion of the past or the prospect of a cure in the future? Pil'nyak, as so often in his work, leaves these questions unanswered.

The most complex presentation of this problem in his work is to be found in his famous story 'Mahogany' ('Krasnoye derevo', 1929; the title hints at a pun on old mahogany and the new world

of 'red' Communism). The story is set in Uglich, where the last
child of Ivan the Terrible, Dmitry, had died in mysterious circum-
stances. Still alive in the town are the last descendants of the
Tuchkovs who had been playing with Prince Dmitry on the fatal
day; now, having been evicted from their historic home to make
way for a dairy factory, they are living in a single basement room.
The whole town is a symbol of the continuity of Russian history
and culture. Boris Godunov had had the church-bells of Uglich
exiled to Siberia for their complicity in the crime; so too in 1928
the Communists took the bells down again and destroyed them as
part of their anti-religious campaign. As one of the characters
says:

> What in your opinion moves the world – civilization,
> science, steamers? . . . Labour? Knowledge? Hunger?
> Love? No! civilization is moved by memory! Just
> imagine that tomorrow morning people lost their memo-
> ries, while their instincts and their reason remained –
> without memory.[17]

But this past is now the subject of cynical exploitation. Two
antique-dealers, the brothers Bezdetov (Pil'nyak indicates his atti-
tude to them by the surname 'Childless', while their eyes are said
to be 'dead' and 'empty') arrive in search of bargains, which they
can sell off profitably to museums and private collections, both
Russian and foreign. The long tradition of continuity seems to be
crumbling at last under the assaults of official vandalism and
private greed; or is this also a Russian tradition? The story ends
unexpectedly with another historical parallel, at first sight totally
unrelated. Pil'nyak suddenly switches to the history of Russian
porcelain, and the moral and commercial unscrupulousness of the
first Russian craftsmen; but despite all this, 'these craftsmen and
eccentrics created objects of beauty. Russian porcelain is one of
the most wonderful arts to have adorned our planet'.[18] On this
note of tentative hope that perhaps a new, but still recognizably
Russian culture will take root amidst the robbery and cynicism of
his own times, Pil'nyak ends his work.

Pil'nyak's attitudes to the past are not remotely Marxist.
Although it may seem at first that his alternation of reverence
and contempt for culture resembles the confusions of Communist
policy, in fact he distinguishes almost without exception between

native Russian culture and the Western imported variety. Pil'nyak's dilemma is rooted in his deep sense of the Russian tradition. Senseless vandalism, whether of the Mongols, of rioting peasants, or of government officials has been a recurrent feature of Russian history since times immemorial. Pil'nyak wants to know if the latest manifestations can still be fitted within that tradition, or if they have finally shattered it. His stories tend to fall, therefore, into two categories – the circular and the linear. The former, for all their brutality and their sickening depictions of destruction, murder and rape, are fundamentally optimistic: events can be contained within the framework of the past. The linear stories, such as *Machines and Wolves*, on the other hand, are despairing, because the breaks in the tradition are then irreparable.

In the nature of things, the final answer must be hidden from contemporaries; Pil'nyak at least made no pretence that he knew the answer.

'Red Cavalry'

Isaak Babel''s service in the Cheka (about which he planned to write a book) and later in the Red Cavalry (which provided the basic material for the stories collected in *Red Cavalry, Konarmiya*, 1926) presented him with the theme of the culture of the past in its most acute form – in the sphere of morality. The problems are given a further intensity by the fact that Babel' was not merely an observer but a participant in the events and dilemmas that he describes; the name of his protagonist, Lyutov, was Babel''s own pseudonym in the Red Army. Emotionally and even intellectually he longs to accept the new morality and to be accepted by it (see 'My First Goose', 'Moy pervyy gus'' and 'The Death of Dolgushov', 'Smert' Dolgushova') but something within him always resists and protests (see the last words of 'My First Goose'), and he never quite succeeds in making the break. At times he finds the cynicism and brutality intolerable: 'The chronicle of daily horrors oppresses me relentlessly like a sickness of the heart',[19] though, significantly, this comment is inspired not by human suffering, but by the destruction of an apiary.

The images of rape and murder that dominate these stories are not just naturalistic or sensational details, as they are so often in such literature; they are paradoxical and provocative, even blas-

phemous, extensions, of the basic themes of birth and death, as observed by two conflicting moralities, the old and the new. Prishchepa takes his gruesome revenge on his native village, which had connived at the murder of his family by the Whites and had then looted all his possessions. After the slaughter he destroys his former home, shoots his cow and sets fire to the remains: 'The fire glowed like a resurrection. Prishchepa untied his horse, leapt into the saddle, threw a lock of his hair into the flames, and vanished.'[20] The more devastating the break with the old life, the more brilliant the resurrection into the new.

The mingled horror and fascination that such episodes inspire is Babel''s own; he is torn between two moralities. One of the commonest words in *Red Cavalry* is 'old' (*staryy*). It is frequently associated with Babel' himself; as a bespectacled intellectual, he is naturally identified by the soldiers with the old world of bourgeois culture. He is a Jew, and despite his renunciation of his faith he cannot help betraying his familiarity with the minutest details of Jewish life and culture, for all this is still part of himself. Often Babel' uses Jews as doubles for himself, rebels from within against the tradition, but still irremediably tainted by it. In the story 'Sandy Christ' ('Sashka Khristos') he seems to identify himself with his hero, who has inherited syphilis at birth (the *old*ness of the beggar-woman who infected his father is particularly emphasized), and who yet humbly assists at the birth of the new.

But Babel' cannot accept even this consolation for long. How can he justify his role as an artist? What right does the humanistic artist have to comment at all on the inhumanities perpetrated in the name of a better life. As one of his fellow-officers says:

> You are a milksop and it's our job to put up with you milksops . . . It's we who scrape the shell off the nut for you people. Quite soon now you'll see this kernel all ready and clean, and then you'll take your finger out of your noses and hymn the new life in marvellous prose. Till then, just sit still, you milksops, and don't whine under our feet . . .[21]

But although Babel' may at times see himself as compromised by his origins and his artistry he also contends that true art stands outside the historical flux, reflecting its grandeur and misery, but

ultimately independent of it. In the opening lines of 'Pan Apolek'
he writes:

> The enchanting and wise life of Pan Apolek went to my
> head like old wine. Among the twisted ruins of Novo-
> grad-Volynsk, a town that had been hastily rolled up,
> fate threw under my feet a Gospel long hidden from the
> world. Surrounded by the innocent radiance of those
> haloes, I vowed to follow the example of Pan Apolek.
> And all the sweetness of my dreams of revenge, all the
> bitterness of my contempt for the swine and curs of
> humanity, all the fire of my silent intoxication with
> vengeance – all of these I sacrificed to my new vow.[22]

The word 'old' refers here ultimately to art, but, by applying
it first to wine, Babel' at once clears it of the suspicion that
attaches to it elsewhere in the book. By his contrast between the
sordid reality of life and the timeless beauty of art and, particu-
larly, by his use of the word 'sacrifice' he recalls Pushkin's poem
'The Poet'. Art is an expression of continuity and permanence,
which sanctifies and immortalizes all that it touches, however
ignoble. The Polish spy Pan Romual'd is transformed by Apolek
into John the Baptist, the priest's 'housekeeper' Eliza into the
Virgin Mary. The Catholic Church struggles in vain against the
carefree and heretical painter, but this art is just as problematical
for the Communists too.

In the first story of Red Cavalry Babel' establishes one of his
central images: 'the orange sun rolls across the skies like a
lopped-off head'.[23] The image is aesthetically and morally shock-
ing, but it is a properly functional one; the sun of the new life is
for many people indistinguishable from death. Again in the story
'The Sun of Italy' (Solntse Italii) the lure of the sunshine of the
Mediterranean and the urge to assassinate the king of Italy are
inextricably interwoven. If the sun stands for the 'terrible beauty'
of the revolution, then the moon, which palely reflects its unbear-
able glare, stands for Babel' himself. Thus the first story, after
beginning with the sun, ends at night when 'the moon, holding
its round, shiny, carefree head in its blue hands, plays the vaga-
bond outside the window'.[24]

The complexities of Babel's attitudes emerge in a group of
three related stories, 'Gedali', 'The Rabbi', and 'The Rabbi's

Son'. In the opening paragraphs of 'Gedali' the theme of age is brought out in various ways: Gedali himself and his mouldering antique-shop, the old Jews and the ancient synagogues of Zhitomir. The narrator too is still attached by his upbringing and childhood memories to this world, so that at first his sympathies seem to be on the side of of Gedali, but before long he finds himself forced to defend the revolution against the traditional but irrelevant morality of Judaism and Christianity. His responses become increasingly intolerant and even brutal, as, for example, when he says to the blinded Gedali: 'The sun cannot penetrate eyes that are closed, but we are going to force those closed eyes open.'[25]

The logic, morality and culture of the old world simply have no place or meaning in the revolution. But the division within the narrator is clear, and his apparent identification with Gedali in the first part of the story perhaps serves to muffle the harshness of the story. For the logic of the story is harsh – that in times of revolution there can be no compromise between conflicting values. Gedali's antique-shop is not just quaint, it is doomed, with its dead butterflies, dead flowers and skulls. Much as one's mind and heart may yearn for a compromise between the old and the new, there is, and apparently can be, none. And the story ends with the recurrent image of the 'timid evening-star'. It stands for an ideal that is remote and fragile, perhaps even inaccessible, but able to guide and inspire. Both Gedali and the narrator are drawn by the same star – is the star of David irreconcilable with the star of the Red Army?

In the sequel, 'The Rabbi', Babel' makes the conflict still harsher. At dinner with the Rabbis, Lyutov learns that Gedali's son, Il'ya, has betrayed his calling and joined the Communists. Throughout the story various details have suggested parallels and even a certain sympathy between the boy and the narrator, and finally Lyutov echoes his act of betrayal too; he insults his hosts by leaving the table early and returning to his unit:

> There at the station, in the propaganda train of the First Cavalry Army, the radiance of hundreds of lights awaited me, the fantastic glare of the radio-station, the persistent throb of machines in the printing-room, and an unfinished article for *The Red Cavalryman*.[26]

The 'timid star' of Babel''s idealist hopes has turned into the
blinding light of activity here and now. The 'terrible beauty' of
sunlight has been extended by electricity, and the moonlight has
disappeared. Fiction and art end and are replaced by reality-
journalism. But the story still doesn't end there.

In the final story of the cycle 'The Rabbi's Son' ('Syn Rabbi'),
the story with which Babel' originally ended the book, Il'ya has
joined the Red Army, and has been mortally wounded in battle.
The narrator surveys his few remains and brings out all the
contrasts between the old culture and the new:

> Here everything was jumbled together – the documents
> of a Party-propagandist and the jottings of a Jewish poet.
> Portraits of Lenin and Maimonides were lying side by
> side. The angular metal of Lenin's skull and the sombre
> silk of the portraits of Maimonides. A lock of woman's
> hair was stuck in a pamphlet of the resolutions of the
> Sixth Congress of the Party, and in the margins of Com-
> munist posters were crammed the crooked lines of ancient
> Hebrew poetry. In a sad and slow drizzle they fell on me
> – pages from *The Song of Songs* and revolver cartridges.[27]

Religion, love and art – the supreme values of the old culture
are each in turn juxtaposed with the single all-embracing morality
of the revolution. In the final sentence Lyutov seems to make the
identification of himself with Il'ya complete:

> And I, hardly containing within my ancient body all the
> tempests of my imagination, – I received the last breath
> of my brother.[28]

Or does the emphasis on 'antiquity' and 'imagination' finally
distinguish Lyutov from his 'brother'? Is he still unable to take
the final step of abandoning the values of art and continuity, and
ultimately life itself, for total dedication to the revolution?

Unfortunately, the later addition of 'Argamak' to the cycle, a
story which provides a happy ending to the more superficial
theme of Lyutov's alienation among the Cossacks, seriously
weakens the effect of 'The Rabbi's Son', turning its provocative
ambiguity into a mere loose end.

Yuriy Olesha

One of the most celebrated examples of the clash between the
new and the old is Yuriy Olesha's short novel *Envy* (*Zavist'*,
1927). With almost diagrammatic neatness the various characters
fall into one or the other camp. The central figures are only
slightly more complex: Andrey Babichev is an elderly man who
has come over to the new; while Nikolay Kavalerov is a man of
the twentieth century (exactly the same age, as he tells us),
though by temperament he belongs to the past.

Babichev has a scar on his body from a wound incurred in
escaping from a Tsarist labour-camp, 'as though there had been
a branch growing there, and it had been cut off'.[29] Babichev has
no links with the past at all, no branches or roots. He has no
culture: he is ignorant of who Jocasta was (at least he does not
suffer from any Oedipus complex about the past); his values are
thoroughly materialistic; he lives simply for his projected cafeteria
and his improved types of sausage. To Kavalerov he seems
'inhuman', and his eyes 'metallic reflectors'.

But Babichev's qualities are the virtues of the new age, and
have already brought him fame. Kavalerov's envy is caused by
the sense that if he had been born in the nineteenth century or
in contemporary Europe his individual talents would surely have
been appreciated. In a remarkable episode the age-old bells of
the churches of Moscow seem to be summoning him like Dick
Whittington, the archetype of the Western self-made man; the
door opens and 'Dick Whittington' appears in the guise, not of
Kavalerov, but of Volodya Makarov, the most extreme repre-
sentative of the new materialist past-less world: 'I am a machine-
man. You won't recognize me. I have turned into a machine. Or
if I haven't yet, I want to.'[30]

The prospect of this new and perfected humanity inspires in
Kavalerov and his ally Ivan a sense of love–hatred like that which
the past had once aroused in Gershenzon:

> How beautiful is the world rising before our eyes. How
> splendid will be that festival to which we shall not be
> admitted! Everything comes from it, the new age, and
> everything is drawn to it, it will receive the finest gifts
> and ecstasies. I love it more than life, this world that is

moving towards me, I bow before it, and I hate it with everything I have. I choke, the tears stream in torrents from my eyes, but I want to sink my fingers in its clothes and tear them. Don't steal my limelight. Don't steal what might have belonged to me.[31]

The culture of the past, its irrationality, its fantasy and escapism are seen nostalgically but unflatteringly:

The centuries are now a rubbish-dump. Machines, bits of iron and tin, screws and springs are scattered across it . . . It's a dark and gloomy dump. And within it mould and fungi glow phosphorescently. That's our feelings – that's all that's left of our feelings, the spring flowering of our souls. The new man comes up, pokes around, climbs down into it and takes what he needs – here a bit of a machine, there a bolt will come in useful – and the phosphorescent mould he stamps out and quenches.[32]

This striking image is an ironic metaphor for Soviet attitudes to the past. What is preserved is valued for its utilitarian value; the unhealthy but fascinating iridescence, 'this famous bottle-glass, the famous fragments immortalized by writers for their ability to shine out from the rubbish and desolation, and create all sorts of mirages for lonely travellers'[33] – in a word, what one thinks of as the art in art – will be thrown out.

Yet as the novel unfolds Volodya and Andrey prove to have retained most of the human qualities (the ability to love and doubt) that being a machine would seem to have precluded. As Ivan finally admits:

I thought that all feelings had perished: love, devotion, tenderness – but it's all survived, Valya . . . But not for us, we're left with nothing but envy, envy . . . Poke out my eyes, Valya, I want to be blind.[34]

In an unexpected reversal the new world proves to be a worthy heir, while the old world, in a fit of despairing pique, prefers to blind itself rather than look any more on the values which it had claimed to protect and defend. At the end of the book it is Ivan and Kavalerov, who have lost their ability to feel; they have nothing left to live for, or drink to, but 'indifference'. In Olesha's version of the myth, it is not the new world that feels

envy for the elusive secrets of the past, but the past at the triumph of the new.

To some extent one can identify Olesha himself with Ivan and Kavalerov. He too shared their distaste for the new world in which he had to live. Like them he found in its brutal rejection of his kind of sentiment an alibi for his own disappointed ambitions. Olesha needed the revolution for his own illusions, and so there is a note of gratitude for its barbarian onslaught. But despite this dangerously gooey centre, *Envy* remains an infinitely fascinating book; its wit, and its melancholy, its pathetic defiance and its final abject surrender are combined in a way that transcends the 'autobiographical confession' which it might easily have been, and which Olesha elsewhere succumbed to all too easily, for example in 'Human Material' ('Chelovecheskiy material', 1928) and the later *Not a Day Without a Line* (*Ni dnya bez strochki*, 1940–60).

In the story 'The Cherry-Stone' ('Vishnevaya kostochka', 1929) Olesha offers a parable of the place of art in a materialist society. To commemorate the occasion of his rejection by Natasha, the hero plants a cherry-stone, a clear metaphor for a work of art. But he discovers that his friend Abel, a Communist engineer, plans to build a vast concrete factory on the very spot where he had planted his cherry-tree. The story has a happy ending, however: the building will take the form of a semi-circle, with space for a little garden inside, and so the hero's cherry-tree will survive after all; and so, presumably, there will be a place for art in socialism too.

I used to think that this ending was ironic at the expense of a state which thought it could allot the arts a little garden-plot in the modern Utopia. But now I feel that Olesha was really quite happy with this arrangement. In the Bible story Abel was the practical meat-eating brother, and Cain – could he be the unnamed narrator? – the peace-loving, vegetarian dreamer. Mock these modest aspirations and he could turn into a fratricide; but satisfy them, and perhaps he will turn into your obedient servant. Abel and Cain seem to have learnt their lessons all too well.

Andrey Platonov

In Richard Aldington's novel *Very Heaven* (1937) the hero is shown at one point contemplating suicide; he finally rejects the

idea, however, as he comes to recognize that he has a moral duty not to break a single thread in the huge skein of evolution, which links him to the amoeba in the past and to unimaginable forms in the future.

When he came to review the Russian translation of the novel in the following year Platonov quoted this passage, but reinterpreted it to refer not just to the morality of suicide, but to the preservation of the cultural heritage as a whole. Applying Aldington's words to the West in general, he went on to assert rather sententiously:

> Only those will be forgotten, who have tried to break or throw away into the darkness of the labyrinth the thread of Ariadne, who have tried to leave us as amoebas. . . . To break the thread of Ariadne–History, or not to break it, – that is the question for the West today. True, you must be absolutely sure who has the right . . . to break the thread and who does not have the right. This thread is not given ready-made; it is spun by the hands of all the workers of mankind, and to break or to continue the thread of one's fate is given only to those who make and spin the thread with their hands, and not to those whose hands try to fasten on to the hands of the workers.[35]

Of course, Platonov's critical articles are the least interesting part of his work, and this one was written at a time of personal disgrace, when he was trying not to say anything that could possibly offend anyone. As happens in such situations, by the logic of whatever may be the Marxist equivalent of a Freudian slip, he ended up by saying the exact opposite of what he intended. For Ariadne's thread is not a synonym for the 'skein of life'; it is not an image of continuity at all. It was a lifeline enabling Theseus to find his way back out of the labyrinth after killing the Minotaur. Once it had done its job it could be discarded: there was no reason for Theseus to remember either the labyrinth or the Minotaur; in fact soon afterwards he had forgotten Ariadne too.

Ironically enough, this stricter version of the Theseus legend is closer to the logic of Marxist theory (Mayakovsky could have subscribed to it) and of Platonov's own fiction. For few of his heroes ever carry any traces of the past with them into the

future. Often enough they have no memories of their parents
and no families of their own. Their existence is so minimal, so
peripheral, that even their deaths are hardly noticed: all one
can do is mark their graves in the hope of sustaining some traces
of them a little bit longer before they are finally lost for ever in
oblivion. In the face of such a view of human existence to speak
of continuity and permanent values seems something of an
insult.

Even in Platonov's wartime stories where one might expect
some concessions to the natural pressures for a more optimistic
attitude to death, one finds the same conviction that nothing but
total oblivion awaits man both as an individual and as a species.
Seen in this vast perspective the destruction and slaughter brought
by the war, for all their horror, are only an acceleration of
natural processes. Memory may be a palliative, but it is only a
temporary and, in the light of history, insignificant, prolongation
of existence. Thus a mother reflects as she gazes at the graves
of her son and fellow-soldiers:

> A little time will pass, and the place where men once
> lived will grow over with untrodden grass, the winds will
> blow over it, the torrents of rain will level it, and then
> there will be no trace of man left, and there will be no
> one to understand or inherit all the agony of man's
> existence on the earth for the benefit and instruction of
> the future, because there will be no one left alive. And
> the mother sighed at this last thought and also at the pain
> in her heart for the wastage of unremembered life. But
> her heart was kind, and because of her love of the dead
> it wanted to live on behalf of all the dead, and to fulfil
> the wishes that they had taken away with them into the
> grave.[36]

In most of Platonov's stories, there is an unbridgeable gulf
between the past and the future; the past is so remote and
wretched that there is no need or reason to look back at it. Thus
in the early story 'The Schoolteacher and the Desert' ('Peschanaya
uchitel'nitsa', 1927) we are told of the heroine's upbringing:

> Her father the teacher did not explain these events [the
> revolution and Civil War] to his little girl, taking pity on

her childhood, and fearing to inflict deep, unhealing scars on her as yet weak and growing heart.[37]

In a later story 'At the Hazy Dawn of Youth' ('Na zare tumannoy yunosti', 1938) Platonov tells of a young girl who loses her parents during the Civil War. However, she soon finds a new family in the Soviet state, and a new father in Lenin; and so there is no need for her to look back or search for any continuity.[38]

At the end of 'A Wattle House in a Provincial Garden' ('Glinyanyy dom v uyezdnom sadu', 1937) the hero returns to look for the scene of his childhood but canot find it:

> He never found or recognized the precise location of his childhood universe; all around him in the country of the former orphans were tall clean cities, the rustle of leaves on the new trees; the roads gleamed into the distance, and so many unfamiliar handsome people had been born and were walking around everywhere.[39]

The emphasis on the newness and unfamiliarity of everything (even the trees) is not intended to alarm or alienate; it is a guarantee of security against any attempt at subversion by the old world.

In general in Platonov's works the past is ignored or forgotten. Where it does survive into the present it threatens to destroy or corrupt it with an almost Mayakovskian intensity. In the short novel *The Foundation-Pit* (*Kotlovan,* early 1930s) he presents two allegorical figures: the innocent ten-year-old orphan Nastya (the name means 'resurrection'), an image of the fragile and vulnerable new world, shorn of all its attachments to the old; and the legless war-invalid Zhachev, the incarnation of the hideous past of physical and psychological mutilation. In a clearly symbolic scene Voshchev, the central figure, and Zhachev are watching a parade of young girls. Recalling the unpropitious circumstances of their birth and early years, the killings, the famines, the epidemics, Voshchev reflects that these children are now a picture of health, innocence and joy; but Zhachev's feelings are a different matter:

> Voshchev looked at the cripple: his face was swollen with frustrated blood, he groaned aloud, and worked

with his hand in the depths of his pocket. Voshchev observed the mood of the mighty cripple, but was glad that socialist children would never fall into the hands of the amputee of imperialism. Nevertheless the cripple stayed until the end of the procession, and Voshchev began to fear for the innocence and safety of the children.[40]

In fact Zhachev develops a touching but still slightly alarming affection for Nastya. For all that, the story ends with the death and burial of the girl and the continuing survival of Zhachev.[41]

Like Zamyatin Platonov seems to leave no place for the past except as a nightmare in the new age; if anything, then, it is even more surprising that he should make the same exception for art, since his world is generally utterly unaware of its existence. In his long and apparently uncompleted novel *Chevengur* (1929; the title is the name of a town) he depicts with bitter irony a group of naive and idealistic Marxists who try to establish a Communist Utopia in the steppes. Old ideas of order and cultivation are rejected as mere class prejudices. The houses of the former bourgeoisie, symbols of the strength and solidity of the old culture, are removed bodily from their sites and dumped higgledy-piggledy in the main square. By analogy with the doctrine of the class struggle the aristocrats of the fields, the crops and the flowers, are now deposed, and favour is shown instead to the down-trodden and despised proletarian flora, the weeds. By these and other such absurd extensions of the logic of Marxism, Platonov shows how his heroes cannot move around their own town or find anything to eat.

The same principles are applied to the creation of a new culture. Literacy becomes suspect as an instrument of class oppression, while the central hero, Dvanov, is confident that if only all traces of the culture of the past could be eradicated, then a new and healthier crop would appear spontaneously:

> In his heart of hearts Dvanov preferred ignorance to culture: ignorance is a virgin field, and culture an over-grown one, where the salts of the earth have been plundered by the plants so that nothing else can grow there. And so Dvanov was happy that the Russian revolution had ruthlessly weeded out the few plantations

where culture had been, and that the people remained
the same virgin soil that they had always been – not
cultivated, but fallow and fertile. And so Dvanov was in
no hurry to sow anything; he guessed that the rich soil
wouldn't hold out long and would then produce lavishly
and abundantly a priceless and unprecedented crop,
provided only that the wind of war from Western Europe
did not bring the spores of capitalist weeds.[42]

When Dvanov can apply his policies, needless to say, nothing
does grow but weeds. With the expulsion of the last traces of
the old world the town suddenly looks uninviting and deserted;
something vital seems to have been lost, and an aching void, a
sterile desert confronts the revolutionaries. One of the heroes is
reminded of the day of his mother's funeral. Having at last
cleared the way for the glorious future, he can only look back
with a terrible sense of bereavement, which seems to threaten
the future too:

> Chepurnyy sat on the ground by the fence and took an
> overgrown thistle gently between his fingers; it too was
> alive, and now would live to see Communism. For some
> reason the dawn was taking a long time, the new day
> should have started some time ago. Chepurnyy sat still
> and began to worry whether the sun would ever rise this
> morning, whether the morning would ever dawn – the
> old world was dead, wasn't it?[43]

But Platonov gives the theme one more twist; for there *is* an
image of continuity in the novel, Sonya (her name means
'wisdom'), the first and only true love of the proletarian Dvanov.
It is now the rootless Party-official Serbinov who hopes to
'possess' and 'master' her, seeing in her all those qualities that
the new world seems to have lost:

> Serbinov sensed in his new-found acquaintance a certain
> firm structure, an independence, as if this woman were
> quite invulnerable to people, or were the final product
> of some unknown extinct social class, whose energies
> were no longer effective in the world. Serbinov pictured
> her as the last of some aristocratic tribe; if all aristocrats
> had been like her then history would not have produced

anything afterwards – on the contrary these people would have made their own destiny out of history.[44]

But even in these impressions Serbinov is succumbing to the Soviet myth of culture. For Sonya is not an aristocrat, but the daughter of a worker. The attraction of culture lies, as we have seen in Khlebnikov and Bagritsky, in just these links with a condemned class; the bitter corollary for Platonov is that even when the proletariat does produce its own culture, it is not recognized or appreciated as such. Despite the love for Sonya that both the Communist idealist Dvanov and the Party pragmatist Serbinov feel, neither of them wishes to stay with her for any length of time.

In these five brief studies I have tried to bring out the sense of a need for the past, whether or not it can be justified in Marxist terms. The arts of the past provide not just moral and social lessons, not even a mere standard or model; they actually, for some inexplicable reason, matter in their own right. The contradictions that we find in these writers spring from an instinctive recognition of the difference of art and a natural desire to find a positive function for it, even if this would seem, as argued in chapter 3, to lead ultimately to its negation. Perhaps, instead of looking for functions, we should proceed from the fact of art.

6

The fact of art:
Leonard Leonov

It would be healthier not to look back, but that's why I've chosen
you, just because you don't worry too much over your health.
Leonid Leonov, *The Thief*

In the various cases discussed so far the problem of the past has
generally been a subsidiary theme in the author's work taken as
a whole. With Leonov it has been a central preoccupation
throughout almost all his fiction (though, surprisingly, it appears
hardly at all in his plays); from the time of his first story *Buryga*,
in which a Spanish Count appears in defiance of Mayakovsky's
strictures: 'I watch in amazement as *Aidas* and *Traviatas* with
their Counts and Spaniards play from the boards of the theatres
which we have only just captured',[1] Leonov has clearly been
aware of the various other treatments of this theme. He often
makes use of scientists to carry his argument, but the professions
of his heroes, palaeontology, archaeology, forestry, are chosen to
suggest antiquity and continuity rather than progress or utility
(the use of physics in *Skutarevsky* is an exception to this
generalization). His fondness too for flashbacks, and in particular
for juxtaposing the pre-revolutionary and post-revolutionary
periods is more than a technical trick; it takes us at once into
the heart of Leonov's conviction of the continuing presence of
the past in the present.

In Leonov's mature treatments of the theme two other
apparently unrelated elements in his earlier thinking are com-
bined: a strong sense of dualism, as reflected in the binary
oppositions that characterize nearly all his works; and second, a
conviction of the interconnectedness of all phenomena, sym-
bolized by the central images of the 'ocean' and the 'forest' in his
last two novels.

The dualistic trend is something of a heresy, at least in the Soviet Union, where the revolution tends to be treated as the synthesis to end all syntheses; it therefore seldom appears overtly in Leonov's works, but it can be traced right back to one of his first short stories. 'Ham's Departure' ('Ukhod Khama', 1922) is a stylization of the story of the Flood, an image which was frequently used at the time for the revolution (notably in the works of Mayakovsky, as in his *Mystery-Bouffe*). At the climax Ham tells the Gnostic version of the Creation story:

> And the void and the deep were full of the waters of darkness. And the Father was reflected in them. The one in His reflection came silently. When he was close he snatched the Earth out of the hand of the Father and leapt into the deeps and the void. There he became the second Father of the Earth and the Earth gave him Life . . .[2]

Noah is indignant at this story and accuses Ham of suggesting that he worships the Usurper and not God; as a result Ham is cast out of the family. There are various features of this story which recur in Leonov's later work: the theme of the inseparability of good from evil, even after the deluge that had been intended to separate them once and for all; second, the belief that the artist cannot help being a witness to this dualism; and third, the unpopularity of the artist for the witness he bears.

The second idea appears slightly later in Leonov's work. He was travelling in a car with Gor'ky in Italy when he suddenly became aware of the infinite number of concepts and interactions involved in such an apparently simple statement as 'We are travelling'. These ideas naturally expanded into an awareness of the indivisibility of the entire natural world, an idea which can be detected in *The Thief* (*Vor*, 1927), but which does not become fully explicit until *The Road to Ocean* (*Doroga na Okean,* 1935), where he recalls Dostoyevsky's words in *The Brothers Karamazov:*

> For everything is like the ocean: everything is connected and in a state of flux: if you touch it in one place, it will have its effect at the far shore of the world.[3]

In the infinite chain of interactions that can be observed in the movements of the sea Leonov perceives a parallel to the inexhaustible complexity of causality.

In the temporal scheme of the novel the past and the future are depicted in a dialectical relationship, which can be conveniently illustrated by the following diagram:

where the diagonal line represents the present. The past and the future intersect at each moment of the present, and the shifting balance of their forces creates the movement of history. This view of the past is totally unselective; it is rather an application of the theory of the conservation of matter to the temporal dimension. Nothing can be lost or discarded, though the importance of each past event will naturally diminish with time. This idea is clearly seen in Polya's thoughts in *The Russian Forest* (*Russkiy les,* 1953), as she sets out on her wartime mission to the partisans behind the German lines:

> A blazing intensity came over Polya at these words and she saw clearly how with the years the as yet unwritten book of her Loshkarev expedition would inevitably shrink, first to a page, to a paragraph, and then to a single line.[4]

Only at the point of infinity will the past disappear, and infinity is outside the historical process.

The first of Leoniv's stories in which the theme of the cultural heritage is raised explicitly is *The End of a Petty Man* (*Konets melkogo cheloveka,* 1922). Here the palaeontologist hero, Likharev, is prevented by the revolution from completing his life's work on the climate of the Mesozoic age. He is guiltily aware of the irrelevance of his work to the present (though, ironically, the imagery suggests that humanity has reverted to the Mesozoic level of life), and he has no confidence in the ability of the

Russian people to create a new culture; either way culture, as he understands it, seems doomed. Finally, he goes mad and burns his manuscript. In this first approach to the theme there are clearly some limitations: it is seen primarily as an intellectual's problem, and it is treated in terms of individual psychology, rather than as a matter for universal concern. But it is topical enough in that it is an intellectual who deliberately snaps the continuity.

The theme acquires real significance in Leonov's work only with his second novel *The Thief*. It has often escaped notice there, however, because of other more obvious problems raised in the novel, though it was pointed out by Leonov himself in an interview of 1930.[5] Here he stated that *The Thief*, like its successor *The River Sot'* (*Sot'*, 1930), was concerned with the theme of the cultural heritage, and the difficulties encountered by the new generation in their attempts to acquire it.

The novel is dominated by an enigmatic scene, in which the hero Dmitry Vekshin, a commissar in the Red Army, kills a White officer, whom he has taken prisoner, 'not out of anger, but envy, at being unable to acquire (*ovladet'*) his last and highest treasure which has neither weight nor measure'.[6] This treasure is the cultural heritage, and it is symbolized by the 'glint in the eye' (*blestinka v zrachke*) which still stares defiantly and mockingly into Vekshin, as he slashes at it unavailingly. The image of the 'eye' of the White officer, already seen in *Night Search* and *February*, reappears with the same connotations of envy and admiration, of hatred and desire; cultural superiority is inseparable from class superiority, and the 'new man' thus seems doomed to remain an outsider. Despite all his frustrated and violent gestures the culture of the past proves to be both indestructible and elusive.

There is thus a deliberate ambiguity in Leonov's treatment, just as there was in *Night Search* and *February*. Is Vekshin really trying to acquire the cultural heritage by a single stroke of his sword, or simply to destroy it? The point is summed up in Firsov's notebook:

> The two principles of envy. A. Why haven't I got what you have? B. Why have you got what I haven't?
> And hence three solutions to the problem of acquiring

the treasure. 1. Putting out the glint in the enemy's eye, so that there should be no difference between us. 2. Removing the conditions under which it can appear in anyone's eye. 3. Acquiring it oneself. Which will Vekshin choose?[7]

There is no shortcut, however, to possessing the cultural heritage; Vekshin's attempts to seize it by force lead nowhere. The only way of acquiring it that Leonov leaves open to his hero at the end of the book lies through hard work and education. The point is echoed by the fictional character Firsov, who is writing on the same events and themes as Leonov:

> The virgin soil of post-revolutionary Russia must absorb the old culture: otherwise collapse. We, the people, are the direct heirs of the great achievements of the past, and we, in the person of our grandfathers, ploughed its mighty fields.[8]

This idea takes on a metaphysical aspect, characteristic of Leonov, when Vekshin comes across a photograph of himself as a child before the revolution:

> All these years he had been smiling . . . the Vekshin in the photograph . . . triumphing over death itself in that smile. And yet he, the real Vekshin, had lived all these years without a smile.[9]

The past is no less present and alive for having been forgotten or abandoned. But for Leonov the process works both ways; the present is a tenuous membrane, through which the past and the future interpenetrate one another. Thus Vekshin, when invited to sit down, falls into an Einsteinian version of the dilemma of Buridan's ass:

> I can sit on this one or that one . . . and if you imagine that this is now all in the past, then I have already sat on one of them . . . So, I must sit on the right one, the only one. I must not make a mistake.[10]

This interdependence of past and future makes a mockery of conventional causality:

> Everything is interlinked and interconnected with the

strength of an inextricable knot. If the leaves did not
fall from the trees, then this cutting wind would not
blow – for what could it do alone in the open field?[11]

In Leonov's universe time and logic work both ways.

Such relativism is closely akin to dualism, and for Leonov the
equilibrium of the Universe is only sustained by the continuous
interplay of opposites, where 'the light plays with the darkness,
and the darkness is its equal and rival'.[12] But such dualism
raises a dilemma for the Soviet artist. He is campaigning, at least
in theory, to upset this equilibrium, to strengthen the good and
progressive elements, and to silence and suppress the negative
and reactionary ones. If, as Leonov seems to be suggesting in this
novel, life is wiser than any human agency: 'Life rushed in and
upset all Firsov's ingenious combinations',[13] then man's inter-
vention, far from providing life with its meaning, is actually
rendered meaningless since it has no effect on life at all.

On the other hand, if culture can influence life for the better,
it can by the same token also influence it for the worse. The
continuity of the cultural tradition may, as Mayakovsky feared,
simply be a pretext for the restoration of bourgeois values and
ideals. This realization protects Leonov against any facile
acceptance of the past. There are two figures in the novel that
straddle the historical divide of 1917, the cynical bureaucrat
Chikilev, who is the very negation of culture, and the old
aristocratic landowner Manyukin, now reduced to beggary.
Manyukin keeps a diary which he addresses to his long-lost son
Nikolasha, whom Leonov invites us to look for among his
characters. At times it appears to be Dmitry Vekshin, at others
his repulsive half-brother Leontiy, while the only Nikolay in the
novel is Zavarikhin, one of the new NEP (New Economic Policy
1921–8) profiteers, a man with no links to the past at all. Which
of them is to be the heir to the cultural heritage? The value of
the past will clearly be affected by the uses it is put to.

There is thus an unresolved tension in *The Thief* between two
attitudes to the culture of the past – a metaphysical acceptance of
it, because the whole of time and space is a seamless unity, and
one can't do anything but accept it. At the same time the
recognition of the unsavoury aspects of the past and of the
dangers of its misuse inclines Leonov to rebel against its whole-

sale retention in the name of some kind of selectivity, or even of a total break. At the end of the 1920s Leonov was as appalled as Mayakovsky by the apparent resurgence of the past. Perhaps the ugly aspects that it had acquired outweighed the values that it had created? In that case was there any point in trying to separate one from the other?

In his works of the next three years, Leonov almost succumbed to these fears. Post-revolutionary life, particularly in the play *Untilovsk* (1927) and the novella *A Provincial Story* (*Provintsial'naya istoriya*, 1928), is shown as completely stagnant. The problem now is not so much one of acquiring the culture of the past as of breaking its stranglehold; it has become a mask for all that is anti-Soviet.

This phase in Leonov's development culminates in his next novel *The River Sot'* (*Sot'*, 1930). The book is devoted to the construction of a paper-mill in Northern Russia. The age-old Russian forests and the ancient monastery alike have to be torn down to make way for the new factories of the technological age. The past is equated with every kind of squalor. One of the *kulaks* boasts:

> Want, my dear comrade! . . . In beggary we live, in bed-bugs and ruptures – and I've no complaint. I even rather like it, my beggary . . . Make me the boss of all Russia, and I'd spend it on drink, yes I would, the whole lot.[14]

With the past depicted in such repulsive terms, it is not surprising that Leonov's Communist hero, Uvad'yev, has no trace of the past within him. He is a 'second Adam', and Leonov wrote of him, in a clear echo of Gershenzon:

> This beginning all over again, this question of the birth of the new man, for whom the world has only just been discovered, a man who has to find out new names for everything, all this marks out *The River Sot'* from my previous works . . . We carry on our shoulders the weight of centuries. We know the history of Syria, Babylon and Egypt, the histories of vanished cultures and civilizations – we know too much. We can never quite liberate ourselves from it, and this oppresses us. And so it is with affection that I write of a man like Uvad'yev, who knows

> nothing, and accepts the world in a new way, in its
> materialistic essence.[15]

And so Leonov is careful not to suggest that the paper produced
by this factory might be used at all for art or literature.

Like Andrey Babichev, Uvad'yev has been completely un-
touched by culture; he has never heard of Lermontov's Pechorin,
and when he is invited to listen to some Grieg, he misunder-
stands this as the German word *krieg*. He is uninterested in all
non-materialistic concepts:

> Beauty – that's a strange sort of word . . . the soul – that's
> another odd one. I know what cotton is and bread and
> paper and soap. I've made them, or eaten them, or
> touched them . . . But I don't know what the soul is.
> What's it made of? Where can you buy it?[16]

He lives only for his work: 'He saw everything but the project
in a grossly oversimplified light; even love was only a fuel which
would treble his strength for tomorrow's journey.'[17]

It may seem surprising that Leonov should give his Com-
munist hero sentiments very similar to those which Mayakovsky
had only just been forced to disown, but perhaps they were more
acceptable on the lips of Uvad'yev since he was not an artist. The
opinions themselves were widespread and all too understandable
in the climate of the first Five-year plan, but it was alarming
when artists started saying these things: for how could one have
a culture if even the artists didn't believe in it?

The representative of the culture of the past is the elderly
engineer Burago. Though his outlook is naturally different from
Uvad'yev's he expresses views very close to those of Leonov:

> A new Adam is coming to distribute names to creatures
> that existed long before him . . . I am an old man: I can
> remember the French Revolution, and the death of
> Icarus, and the tower of Babel.[18]

His roots are entirely in the culture of the pre-revolutionary
past: he plays chess and appreciates classical music; he even has
many friends in the West. Though his training sometimes makes
him sceptical of the grandiose ambitions of his Soviet masters he
is always ready to be convinced and to applaud their achieve-
ments, and at the end of the novel he is ready to join the Party.

But there is no suggestion that the Party has acquired the wisdom of the past in this way. It is Burago who is thought to be the gainer: a likeable camel has passed through the needle's eye.

The most interesting ideas are given to the wrecker Vissarion Bulanin, formerly an officer in the White Army. Vissarion is driven by a hatred of all modern civilizations, both socialist and capitalist. Modern man, in his view, has developed his intellect at the expense of the other elements of his nature, so that he is now a weakling by comparison with the animals and even his own ancestors. He has been enslaved by his own ingenuity in both art and science: 'All these Homers and Shakespeares control us more powerfully than any tyrants. We must put an end to this elephantiasis of the brain.'[19] Man has taken a wrong turning; and so he must go back to the beginning and start again. Accordingly, Vissarion dreams of a new Attila, who will destroy everything, and prepare the way for a new and richer humanity; the vandalism of the revolution is thus perfectly justifiable:

> Men clothed in wrath raised their hands against the museums and the Midas-like riches within them, these portraits and statues of the world's leading scoundrels, hypocritical saints, half-crazed conquerors, madonnas, cardsharpers, tricksters and idiots. These men valued their freedom above Pythagoras's theorem or the cathedral of Notre Dame. They said: 'Let the dead rot in the ground and not tyrannize the living, even if they were geniuses'. Man took his revenge on the beauty which he had created, and which had made him a slave.[20]

Unfortunately, in Vissarion's view, the revolution, which had begun so promisingly, had stopped half-way, but he remained confident that a more ruthless and thorough-going upheaval was still inevitable.

Vissarion's views are not, of course, to be taken too seriously (Leonov later claimed that the figure was a prophecy of Hitler; certainly in Soviet literature about this time the image of the Huns became a cliché for the Nazis), and he is finally exposed as a wrecker by the simple question: 'Does that mean that it's obligatory to blow up Soviet factories or not?'[21] But the fact

remains that his views are only a logical extension of Uvad'yev's, and Leonov is, I think, tempted by them: the whole tirade is written with great verve and ingenuity. By contrast, the Soviet values are rather pallid in their selectivity: 'Technology, yes: art, no'.

In *The River Sot'* the break with the cultural heritage seems complete; neither Vissarion nor Uvad'yev sees any need for it; Burago is apparently able to dispense with it quite painlessly. To some extent this renunciation may be related to the years of RAPP (Russian Association of Proletarian Writers)[22] domination. It was a period of strident anti-intellectualism, with the takeover of the Academy of Sciences by the Party, the trials of engineers for sabotage, and the campaign against Pil'nyak and Zamyatin in literature. Whether in *The River Sot'* Leonov was genuinely swept away by this tide, or whether he was yielding opportunistically to ideas that he found alien, is not easy to determine. In his following works, however, he increasingly withdrew from the extreme position he had adopted here.

At first, admittedly, only timidly. His next novel, *Skutaresky* (1932), which appeared soon after the dissolution of RAPP, is the story of a physicist working on the wireless transmission of electricity. Where Leonov's earlier scientist hero, Likharev in *The End of a Petty Man,* had studied palaeontology, a discipline of no apparent relevance to the revolution, Skutarevsky's work is an important contribution to the Five-year plan. The problem of the cultural heritage thus hardly arises; it has been replaced by utilitarianism. In most respects the novel is as uncompromising as *The River Sot'* had been. The representative of the new socialist culture, Cherimov, has no ties with the past; his loyalty to Skutarevsky takes the form of extracting the immediate practical possibilities from his master's work and writing papers on them in his own name.

It is really only in the post-Stalin period that Leonov returns seriously to this theme. In these new works, however, the question is no longer one of accepting or rejecting the past, but of recognizing the fact of its continuing presence. An illustration of this idea can be found in the temporal structure of *The Russian Forest (Russkiy les,* 1953) in which the story of the first year of the Russo-German war, 1941–2, alternates with the biography of the hero, stretching back to the 1890s. The past

and the future are shown to be intimately related, and each set of events casts light on the other.

Of course no one in the Soviet Union in the 1950s would have attempted to dispute the necessity of the cultural heritage any more, and to that extent Leonov is flogging a dead horse; but then Leonov's interest in the question had always been a personal one; he had never joined in the public discussions and controversies of the 1920s.

In these new works Leonov portrays figures from the younger generation, for whom the revolution and Civil War have receded into the general historical background. To some extent this makes Leonov's point about the indivisibility of the past for him; but it also reflects a growing concern, which crept into Soviet literature about the middle of the 1930s, that the younger generation might fail to appreciate the sacrifices made by its parents – would the children be worthy of inheriting the benefits that had been achieved for them? The question is a ticklish one, since it implies that the young may not be quite the men their fathers (and mothers) were, and although Soviet authors invariably answer it affirmatively, the appearance of the question at all is significant.

For Leonov this is not a matter of physical or military flabbiness – on the battlefield his young heroes and heroines cover themselves with glory easily enough – but of culture. The debate culminates in an argument between the hero, Vikhrov, and his adopted son, Serezha (significantly, he is an orphan), at the foot of the copy of the Venus of Milo in the Pushkin Museum. Vikhrov has tried to arouse the boy to an awareness of non-utilitarian values: he reads the Bible to him, discusses the significance of love, and takes him round art-galleries. Serezha, however, remains unimpressed, displaying a truculent materialism, reminiscent of Uvad'yev: 'Beauty, father? That's a pretty obscure word; it has served all too often as a cover for crime and injustice. Ruins always look attractive at sunset, but just look at the ancient reptiles still lurking in the crannies. No, this won't do for *my* Hellas.'[23] The less truck one had with such a past the better, and so Serezha, 'remembering the lamentable fate of Lot's wife, would never have allowed the young to look back at the old world or to overload themselves with its seductive antiques'.[24]

Vikhrov replies rather lamely: 'Possibly you have got a point there, but I can't deny that I shall be sorry if you are right.

Usually people come to question the good things of life only when they've drained them to the last drop.'[25] The defence is a lame one because it concedes the possibility that the culture of the past may yet be superseded by the march of progress, while its appeal to sentiment and regret is unlikely to cut much ice with the hard-boiled Serezha.

Fortunately, Leonov has another card up his sleeve, and at this moment, a stranger, Morshchikhin, intervenes. He begins by over-whelming Serezha with his erudition and then proceeds to support Vikhrov with suitable quotations from Marx and Lenin. Having provided Vikhrov and himself with this Scriptural authority, Leonov can now go on to re-assert the continuity of culture and the necessity of preserving it. Morshchikhin reminds Serezha that Heine and Gleb Uspensky had 'considered themselves to be the legitimate heirs of all the best that had been produced by the titanic endeavours of their predecessors . . . How then can you give all this away, this well-loved home to the cavemen of our time – and the cavemen were probably more merciful than our present-day monopolists.'[26] The 'monopolistic cavemen of the present day' are clearly meant to suggest Western capitalists in general, and the Nazis in particular, so that Serezha is virtually identified with the saboteur Vissarion in *The River Sot'*; as Leonov, however, was well aware, it is only in the socialist countries that a monopoly of culture can be said to exist.

Morshchikhin's words are strictly Leninist in their selectivity; if it were simply a matter of 'all the best' there would be less of a problem. The truth is that the 'best' and the 'worst' are insepar-able. In conversation with his daughter Polya, Vikhrov relates the myth of the Medusa: 'it is unknown how, whether by horror, by enchantment, or by sorrow, but the fact remained that it turned to stone everyone who dared to look into its eyes'.[27] Even Perseus had to avoid looking into the poisonous beauty of those fateful eyes. Once he had killed it, however,

> there emerged from its blood poetry and a storm-cloud, which in hot climates is associated with fertility. As you see, not such a bad reward for victory. But even Perseus turned away as he raised his scimitar over the Gorgon, though he had prudently equipped himself with a magic mirror.[28]

Perseus's refusal to look the Medusa in the eye is the equivalent of the selectivity of which Vikhrov, despite his good intentions, is still guilty. His guarded hints to Serezha about the limitations of Soviet introductions to editions of the classics, 'specifically designed to weaken the harm contained in them',[29] suggest that he, like the rest of the 'older generation, which had personally experienced the misfortunes of social disorder, was trying to inoculate its successors against the humiliations of poverty and to insure it against all possible diseases of the spirit'.[30] Vikhrov is making the same mistake as Serezha and Soviet critics; he has forgotten that 'it was the very hardships and the sheer protractedness of his search for a philosophy, the constant collisions with alien ideas that had helped the truth to mature in his own brain'.[31] The cultural heritage is indivisible.

It is in the revised edition of *The Thief* that Leonov comes closest to combining all the strands of his views on the cultural heritage. It is fitting that this should happen in connection with the book in which he first raised one of his most characteristic themes in all its complexity. The novelist Firsov now declares:

> Each generation imagines that it is the rightful heir to life, whereas it is really no more than a link in a long chain of logic. It is not only we who create our habits, our brains and our hands – and in this sense the Christian myth of original sin doesn't seem to me such utter nonsense. The past treads on our heels inexorably; it is harder to escape from it than to fly off the face of the earth or to break out of the power of the matter that forms us . . . Only pretty and tasty fish and various colourful butterflies are exempt from the agonizing sense of the past, and it is better, far better, that mankind should never attain that ideal state.[32]

With the comparison of culture to 'original sin' the wheel has come full circle, for here Leonov deliberately harks back to the image used by Ivanov and Gershenzon in their correspondence of 1920. Culture is both enslavement and liberation, the distinguishing and limiting characteristic of mankind.

As in the earlier edition this complex of ideas is associated with the 'glint in the eye' of the murdered White officer, but the image

now receives a much deeper examination. Firsov, who is now identified with the young Leonov, tells Vekshin:

> According to my plan, you are destined to possess the whole world [*ovladet' vsem mirom*; here Leonov recalls the 'Vladimir' pun of *Night Search*] . . . I will furnish you with all the blessings of the world, so far as your tastes and understanding allow . . . and most important of all this round cerebellum of yours will be completely sterilized against any dirt or contamination. Some authorities consider this the prime condition of happiness in the world . . . And finally when the long-awaited day comes for humanity to quit the slums of Blagusha for a better equipped habitation everyone will leave the world of yesterday without a qualm . . . and then, suddenly, an inexplicable nostalgia will grip your whole being, it won't touch anyone else, but to you it will seem to tie your very legs. And the further you go, the more agonizing will become the need to look back at the grey wilderness you are leaving, where your unenlightened ancestors languished and wandered for so many centuries . . . and there you will see an utterly deserted wilderness, as though nothing at all had ever happened there . . . Only, propped against a tree, with the last apologetic sunset behind it, there will gaze into your eyes the soul of yesterday. Not even the most practical or proprietorial scrutiny will find in it anything of any value worth nationalizing – except for the naggingly-knowing sorcerer's glint in its darkening eye. Nobody will pay any attention to it, but you will notice it unfailingly. And at the same moment you will be fired with the realization that this tiny something, this spark, hardly even a dot . . ,. is perhaps the most priceless treasure of existence, because it is the distillation of everything that is behind us, the entire experience of history . . . the memory of the whole human race of the past . . . On the one hand you will be attracted to this glint, as if it contained the most demonic of passions, and on the other you will hesitate, because all the gallantry of youth is founded on nothing else but its magnificent ignorance . . . And just when you are

wondering how to acquire it, the soul of yesterday will itself stretch out its glint to you: 'Don't torment yourself . . . take my treasure, remarkable for the fact that nothing can take it away, put it out, or kill it . . .' It would be healthier not to look back, but that's why I've chosen you, just because you don't worry too much over your health.[33]

Culture cannot be handled selectively; it is all or nothing. It is not a luxury, and still less a tranquillizer; it is an overwhelming burden, an intoxicating draft, a distillation of countless earlier distillations. The majority will always prefer to shun it; but equally there will always be someone to take up its challenge.

In fact Vekshin turns out to be unworthy of this confidence. In the new edition of the novel he proves to be more concerned with trying to destroy the culture of the past than with acquiring it: 'I slashed at him, but it still shone, his eye, it wouldn't go out.'[34] This re-interpretation of his role is partly to be explained by the consistent devaluation of Vekshin that is a feature of the new edition. But it is also forced on Leonov by the logic of his case; if the cultural heritage is a fact then its survival does not depend on the whim of a single character, however symbolic he may be. The chief justification of Vekshin's existence has thus been removed.

On the other hand the beauty of Leonov's answer is that it finds a special place for the artist: in the new *The Thief* it is not the Red commissar, not economists or Party-officials, not even the progressive scientists that Leonov depicted from *Skutarevsky* to *The Russian Forest*, but the old traditional artist, the novelist Firsov, that is the real hero. Without necessarily being a 'judge' of the present, it is the artist who ultimately decides the character that his age will have for future generations. The responsibility for distilling history in all its complexity, and conveying it in the actual process of evolution is his alone. This is explained by the archaeologist Pickering in Leonov's latest story to date, *Evgenia Ivanovna*:

the mission of art . . . consists not in the reflection of life in the mirror of a limited technique . . . nor in mimesis. The aim of art consists in the mastering of the logic of an event through the study of its vascular system, in the

search for the shortest possible formula of its inception and existence, and so in the revelation of the original conception . . . Once upon a time the Universe itself was only an idea, the first stroke in a rough draft, and possibly expressed on a scrap of paper no larger than a man's hand. What if this formula is still a bit clumsy – as man matures it will contract to the dimensions of a line of poetry, a hieroglyph, and finally to the magic sign with which the act of creation once began. And the task of the artist is to pack each event into the space of a seed, so that, once flung into a living human soul, it will blossom out into the miracle that had originally captivated him.[35]

Of course it may be objected that such a view of the cultural heritage is a purely metaphysical one, springing as it does from an unlikely mixture of dualism and a belief in the interconnectedness of all phenomena in space and time. It has no practical application and can hardly cut much ice with ministers or commissars of culture. But at least Leonov is talking of real works of art, of the cultural heritage that disconcerts as well as delighting us, and not of the comfortable, generalized, passive 'culture' that demands our admiration for no very clear reason other than a desire for intellectual respectability.

7
Some properties of art

The Venus of Milo, that's more incontestable than Roman law or
the principles of 1789.

Turgenev[1]

This book has been concerned with the strange amalgam of rever-
ence and hostility that has characterized modern Russian attitudes
to the culture of the past, a relationship that has been further com-
plicated by the attempt to impose Marxism as a state ideology.
However, it has been only a secondary purpose of this book to
demonstrate the impossibility of fitting art into a Marxist frame-
work, or to question the validity of Marxism as a system. (As far
as I am concerned any theory of man that treats art merely as an
afterthought stands self-condemned.) The real point is that Western
theorists too find it embarrassingly difficult to account for the
appeal of the arts of the past, or for that matter, of those of the
present. Marxism is, after all, only an extension of certain tend-
encies in Western thought.

The West too has the same faith in science, progress and utility;
our critics too suppose that the arts must serve some kind of prac-
tical function. Art, therefore, is regularly treated as one half of
some such combination as 'art and society', 'art and morality' or
'art and life', with the implicit assumption that art is not important
for what it is, but for what it can tell us about something else; art
is simply another way of saying something that has been, or could
be, said differently. At best, the special quality of art amounts to
devising a form adequate to the content.

The principle of modern criticism is that art is artificial; one
should trust the facts of the tale, not the fallible teller. Critics,
therefore, tend to treat art as a kind of code that has to be cracked,

like the dreams of a patient undergoing psycho-analysis, or as some kind of fancy packaging, dressing up the useful matter inside. Some critics (e.g. the Formalists) see the packaging as designed to illustrate or reinforce the actual content; others (e.g. the Freudians and the Marxists) treat it as a deformation or a distortion. But both these approaches view a work of art as *containing* something, which it is the critic's duty to unearth, much as a scientist identifies a promising ore, or an engineer extracts the precious mineral from it. Presumably, once the code has been cracked and the packaging removed the work of art can be 'mastered', assimilated, and – eventually dispensed with.

This attitude has been intensified by the growing insecurity of the arts faculties in our universities. The Humanities that once formed the heart of our education now find themselves pushed further and further to one side. They have tried to defend their position by pretending that they can be as scientific as the scientists, or at least, that they can apply scientific techniques as rigorously.[2] Undoubtedly scientific techniques can help in establishing matters of historical fact and in collecting statistical data about the frequency of certain images, devices or metres. Analyses of the theories and obsessions of artists, their tricks of technique and their stylistic preferences have a certain value in helping us to identify dubious works one way or the other and to relate an artist to his circle or generation. But they have as much to tell us about the essence of an artist and his works as his fingerprints or his handwriting.

There is, however, great satisfaction for the academic critic in this kind of work. His training has given him some techniques to apply to art and it is only natural for him to wish to demonstrate his skill in handling them; it is almost inevitable that he should look for and prize just those qualities of complexity and subtlety that are valued in his profession; but he should not confuse the qualities which he brings to a work of art with those of art itself. The academic who attaches himself to a great artist is almost certainly more learned than the object of his study, and this enables him to say things that the unfortunate artist could never have thought of, or perhaps even have understood. This sense of superiority often leads to that uneasy blend of reverence and hostility, of deference and arrogance that is audible in the tone of so much critical writing, in the West as in the Soviet Union. But where are our priorities? Isn't the gift of creativity infinitely more precious than the

ability to criticize? Wouldn't any critic worth his salt leap at the chance to become an artist, however minor, even if it meant abandoning a comfortable academic career for starvation in a garret? I can put no faith in any critic who is not constantly mindful of this basic scale of values.

The fact is that in the arts the intellectual (or scientific) approach has only a limited applicability; the goals of exhaustive, definitive analysis are quite unattainable; the search for aesthetic laws and a system of measurement by which artists and their works can be ranked is founded on a misconception. The follies of even the most learned critics have made them laughing-stocks down the centuries. By a cruel irony those who are most steeped in the culture of the past are those who have most difficulty in appreciating the arts of their own times. Artists themselves are seldom experts or authorities on art; they are often sadly deficient in 'good taste'; they are no better than the rest of us at judging their fellow-artists and probably even worse when it comes to their own works. The new arts are introduced and propagated often enough by seeming barbarians.

Art is not science, and any attempt to treat it as such can only emphasize its inadequacies in this respect. Even the most ingenious and complex works of art are, by intellectual standards, child's play beside the marvels of modern science (let alone those of nature). Scientific works possess objective value: they are true or false. The arts, however, are notoriously vulnerable to the swings of fashion, and no artists have received the same honour from all critics at all periods (compare nineteenth- and twentieth-century interpretations of Shakespeare). On the other hand a single reading should suffice for the understanding of most scientific works; they can be studied at second-hand – indeed it is often better to do so, for the original writing may well contain errors and misconceptions which have been corrected by later research. A scientist is remembered by posterity as an act of piety, for his actual work is destined to be 'mastered' and superseded. But the great artist whose discoveries are taken up and developed by later generations is not superseded by them; *his* followers are known as mere epigones. He cannot be read in paraphrase or summary; there is no substitute for, or improved model of, the *Odyssey*, however many times it is read. The artist is remembered not out of piety, but because he is unforgettable. In art, then, we are looking for qualities utterly different from those of science.

The scientific method is ill-equipped to deal with art for one simple reason: the sciences deal in generalizations and universals; they are helpless when it comes to special cases. Where science is concerned with relating the individual to the general, with the classification of varieties and the elimination of exceptions, art glories in the particular, the unclassifiable, the unique. Whatever scientific methods can tell us about the arts, it is, almost by definition, only secondary. The basic axiom of science is that 'there is nothing new under the sun'; everything can be accounted for in terms of existing elements. If that were true artists might well curse their predecessors: 'Pereant qui ante nostra dixerunt'; their work, however, is a standing refutation of this pusillanimous complaint.

In other words art is not simple one-way communication. If it were really telling us something that could be 'mastered' or summarized or were simply the result of applying artistic technique to individual feelings and imaginings then the aesthetic experience would indeed be a vicarious one, justifying all the strictures of LEF. But it is not: the extraordinary thing about art is that it seems to provide us with experience at first-hand. It does not *contain* something, it *is* something. Its deepest revelations are to be found not only in the great climaxes and culminations, but also in moments of relaxation and transition. It is nowhere near as artificial and self-conscious as modern critics would have us believe (if art were primarily a matter of technique then Bryusov and Richard Strauss would be unsurpassed), but natural and almost accidental. It is self-expression in the full sense of that much-abused word, with the corollary that the quality of the self is more fully exposed than many of its practitioners bargain for. Of all human activities art is closest to conversation. If it is as natural as speech it is also as mysterious. Its powers and its limitations alike spring from here.

In everyday conversation the surface meaning of our words is constantly being modified and shaded by word-order, gesture and intonation, the more revealing for being largely unrehearsed; we do not hear even the sound of our own voices as others do. Yet it is these unconscious elements which are perceived as the real substance of what we say, even though they cannot be analysed and deciphered in any intellectual sense (indeed they are notoriously liable to misinterpretation). Art works in the same way: the actual feelings and intentions of the artist play only one part in the overall effect which he produces. If artists are often unaware of those

thematic relationships and recurrent images in their work, which to the critic appear as obvious 'devices', how much more so of the subtler implications of the innumerable minute details to which they attach even less importance? If even the artist's view of his work is not definitive, how can anyone else's be?

Our own perceptions are even more fallible, for we discover in a work of art not only what the artist has put there but what we ourselves bring to it (as can be seen in any piece of criticism). Poets have often compared themselves to echoes spontaneously and faithfully reflecting the outside world; but in Vyacheslav Ivanov's poem 'The Alpine Horn' ('Al'piysky rog') the truer analogy is drawn that the echo distorts and yet at the same time mysteriously enriches the original sound. The image holds true for both artists and their readers. No two people will understand a poem or a symphony in exactly the same way, nor will any of these ways correspond to the feelings and intentions of its creator. In this paradox of creative misconception lies the whole fascination of art.

Thus it is that we can often recognize a masterpiece without necessarily 'understanding' it or even always being able to say what it is 'about'. Even in our favourite works there is much that we do not understand and never will. If I had a native knowledge of Russian and perfect pitch my love of Russian literature and music would be immeasurably richer than it is (not that the blessed souls in the first sphere of Paradise feel any resentment or even any deprivation at their comparatively lowly station); but it would even then be incomplete and distorted.

It is perhaps easier to accept this principle of imperfect understanding with the language of music and to recognize its extension by poets to nonsense-verse and *zaum'*, but it operates just as inexorably in conventional poetry and prose too. As children we often comically misinterpret the poems that appeal to us; but when later we come to see our mistakes we realize that our first impressions none the less caught something that still seems to us of the essence. It was our attempt to rationalize this perception by means of words rather than the actual perception that was at fault. There is no reason to suppose that our adult interpretations and rationalizations come any closer to the heart of the matter. The moral of art, for all the claims of academic critics, is: 'Trust the teller, not the tale.'

If the overwhelming sense of a human presence in art distin-

guishes it from mere formal abstractions, then the comparative unimportance of the message distinguishes it from information-systems. For this reason there is, to my mind, no clear dividing line between artifacts that are intended and recognized as works of art and other everyday activities such as sport or motor-cycle maintenance, or, if it comes to that, cooking (indeed I would rather justify even the pursuit of literary criticism as a minor art than as a minor science). Thus it is not an irrelevant compliment to say that a work of scholarship reads like a novel, or to compare gifted sportsmen and chess-players to artists. What one means is that they have succeeded in expressing something of themselves through the rules and forms of a discipline that might seem to preclude the intrusion of any individuality. Perhaps too the fascination of *objets trouvés* is that we look at them as though they were works of art, bearing the stamp of a creator, even while we know that there was none. Art is not a standard to which the various arts and skills aspire, as though they were athletes hoping to qualify for the Olympic Games; it is a quality that is present, at least in potential, in anything that anyone does. It is not the special property of some exotic breed remote from the rest of humanity.

Most of us, of course, do not trust our individuality enough to dare lay claim to the title of art for our actions. But everyone is surely aware of sides of his character which are unknown even to close friends; everyone has surely experienced moments of thought and feeling which seem at least for a few moments to transcend one's normal level of existence. This awareness and these 'fugitive visions' are the things that artists capture and recreate, the infinite variety and uniqueness of their own selves – indeed they are perhaps the reason why so many people keep diaries. In this sense it is easy to accept the idea that everyone has it within him to create at least one decent work of art.

The popular interest in the biographies of artists is an expression of this instinctive feeling. The sense of personality that comes from a work of art is so strong – indeed it is the chief factor in our evaluation of it – that it is natural to identify it with the character of its creator and to look for biographical clues or parallels. They may be there, but eventually we come to realize that artists, just like anyone else, could write many different autobiographies. Unlike the rest of us, however, artists do.

In the arts that I understand best, literature and music, each

work of any significance is distinguished from all others by the same artist or by anyone else by what I can best describe as a unique 'voice'. I mean by this word a mixture of rhythm and timbre and their magical interaction with subject-matter and tone. These different elements fuse into a distinct and pervasive character (Blok said: 'Don't listen to the words, listen to the voice,[3]); in the same way I visualize 'form' not as a shape or a mould but rather as the unique intonational curve, a sort of 'continuous melody', by which each work of art expresses and defines itself. (Although this image may seem to exclude the visual arts and indeed other ways of apprehending even the aural arts I feel sure that similar analogies could be found to hold good there too.) I cannot conceive of a work which would be 'voiceless' or 'formless'; monotony, repetitiveness and inarticulacy all play their part in the total effect; even computer poetry and aleatory music have their voices to my ear, though I happen to find them utterly uninteresting.

By 'voice', then, I mean something different from 'tone', at least as it is usually understood. 'Tone' I hear as a local effect, a deviation from the overall unifying 'voice'. None of us has a single tone or intonation; we vary them more or less unconsciously according to mood and context, while still remaining instantly recognizable and uniquely ourselves. Our voices can be 'falsified' by embarrassment, insincerity or pretentiousness, or they can be extended to encompass and express new aspects of ourselves; but in both cases they tell the 'truth'. In the same way dramatists use a variety of characters, novelists often employ stooge narrators; there are artists who affect deliberately artificial or flamboyant styles; others engage in mystification, parody or caricature. But these are all aspects of 'tone' and do not alter the fact of 'voice'. When we meet a new artist, for example, the young Mayakovsky, we may at first be puzzled by the unfamiliar gestures and rhetoric (the 'tone'), but with practice we learn to hear the voice behind it – could Brünnhilde really have failed to recognize Siegfried's voice beneath the mask of Gunther?

This unique voice of a work of art is for me its primary unifying elements. There is a unity in all great works of art which goes far beyond any conscious desire or intention (in either creator or critic) to establish unity by such extrinsic devices as recurrent themes, images or whatever. Even the smallest details of such works (and their number is much greater than might at first be thought) prove

to be utterly distinct and characteristic. One recognizes a line of poetry not so much as by Shakespeare as from, say, *Macbeth*, a fragment of apparently conventional recitative not so much as Mozart as *Don Giovanni*,[4] a snatch of dialogue not so much as Dostoyevsky as *The Devils*, and so on. One identifies them not by means of the obvious indicators or through any intellectual process, but by a flash of intuition, as one recognizes a friend's voice down the telephone. In a famous debate over the authenticity of Pushkin's poem 'To Chaadayev' ('K Chaadayevu') the issue was finally resolved by the scholar Vengerov reading the poem aloud: 'But, gentlemen, that's Pushkin!'[5]

Nowhere are the peculiarities of art more striking than in the ancient and fundamental form of 'theme and variations', common in one way or another to all the arts. On any utilitarian view such a procedure must seem most uneconomical and shamelessly repetitive. Nor can we really pretend that the form involves the 'exploration', still less the 'revelation' of the theme's possibilities, for in what sense can Diabelli's waltz be said to have contained the fantastic potential that Beethoven discovered in it? The richness is all in the artist, not in the theme. On the face of it, nothing could be easier to demonstrate than the unity of a set of variations (though, truth to tell, most criticism is quite content to aspire no further); but here the inadequacies of critical terminology are particularly cruelly exposed, for the real unity lies not in the theme behind the different variations but in the unique voice that binds them all together in a single whole. Brahms, Rachmaninov and Boris Blacher all wrote variations on the same Paganini theme, yet one could not insert a single variation from one set into either of the others; the formal unity might remain unimpaired, but the artistic unity, the 'voice', would be shattered.

This strange inner unity of the work of art is its only 'message'. People often think of the arts as long-winded and ornamental. They are not: they are compact and functional even in their apparent longueurs; they are falsified by being summed up; they are resistant to quotation. They do not contain a message; they are one. When Tolstoy was asked to sum up his ideas in *War and Peace* he replied that if he had been able to shorten the novel any further he would have done so. Hence works of art defy translation; they may sometimes be transformed into new works of art, but they can never be recreations of the original. The attempt of another person, however

selfless and sympathetic, to convey its essence in alien intonations is bound to coarsen and distort it.

Of course works of art do not exist in complete isolation from one another. They form galaxies in which constellations and other local systems can be discerned. But when one work of art yields, however briefly, to the gravitational pull of an already existing intonation or cadence, whether created by the same artist or not (for artists are threatened as much by their own works as by those of others), this destroys, at least temporarily, the sense of unity and uniqueness that is its most precious quality. When Mozart uses the same phrase at the same structural point in both his fortieth symphony and his last piano concerto one is disconcerted as the later work passes briefly under the shadow of the earlier one.

In the same way young artists who fall under the influence of a great predecessor or contemporary are not 'modelling themselves' on him or 'mastering his lessons' as critical jargon would have us believe. Rather they imagine in their innocence that they are already writing maturely and professionally, much as a child apes the words and gestures of its parents, thinking that this is the way these things ought to be done. The sound of a famous work becomes so familiar that it is easy to mistake it for the voice that comes from within oneself. It sounds so masterful, so desirable, so right – except in the new context. One cannot create according to one's likings or wishes any more than one can choose one's own voice.

It is for this reason that didacticism and sentimentality can be artistic weaknesses. There is nothing wrong with them as such; many works of art aim to teach us something, and all of them manipulate their material for expressive purposes. The danger lies in the vulnerability of certain types of scene or authorial comment to standardized intonational patterns which effectively destroy the work's own 'voice'.

The unique world that each true work of art evokes is often hailed as though it were a generous bonus which the artist has thrown in out of his superabundant creativity; but it seems to me to be central to the whole artistic process. Everyone knows the experience of remembering a passage of music or poetry imperfectly and the strange feeling of compulsion to complete and place it correctly; approximations or 'the gist of it' for some reason simply will not do. We know just what we are looking for even though we cannot describe or express it until we have found it. When the right

words and notes finally come in the right order and rhythm we feel an immense satisfaction, which is enough of itself to assure us that we have got it right. This process seems to me essentially similar, though far less intense, to the experience of inspiration.

Artists have often described this state as the awareness of a persistent throb within which more significant rhythmical patterns seem to be lurking. The artist cannot rest until he has succeeded in releasing and articulating these elusive rhythms and intonations (though of course the point at which the artist is willing to settle for 'success' varies widely from one to another). Beethoven's famous sketch-books would seem to have served primarily as records of these half-apprehended impulses, which would enable him later to return and listen in to them more carefully. Critics often speak of the composer 'hammering out' the raw material provided by his inspiration into something serviceable (in that case 'inspiration' would seem to be a pretty poor thing); surely his work lay rather in the opposite process of going back to the original vision and finally uncovering it, like the statue that Michelangelo saw latent within a lump of marble.

The finished work may still be superficially classifiable in terms of standard formal patterns, but its essential property is its uniqueness. As Mayakovsky, that least mystical of poets, put it:

> But where this basic throb-rhythm comes from is unknown
> . . . A rhythm can be one and the same in many poems,
> or even in the entire work of a poet, without making his
> work monotonous, since a rhythm can be complex and so
> difficult to realize that you don't get to the bottom of it
> even in several long poems.[6]

He was probably thinking here of the Pushkinian iambic tetrameter, but his words could equally well be applied to the classical four-in-a-bar allegro, and indeed to any standard art-form. It is in this sense that the word 'creation' is justified for a work of art, for the emergence of each new voice with each new work is a miracle beside which even the differentiation of the world's languages begins to pale. It is this that accounts for the sense of achievement in every work of art, even tragedy. Art does not need to resolve the questions that it seems to raise because its own existence is sufficient answer.

The difficulties then that artists experience in beginning each new work (unlike the rest of us, for whom the beginning presents few problems; it is the continuation that is so hard) spring largely from the urgency of establishing this rhythm and character, of finding 'one's own voice' unmistakably from the start, but in a way that has never been done before. Once this has been achieved the work develops its own momentum and evolves its own unity. It takes over as it were from the artist: events in a novel turn out contrary to his original intentions; poems that grow out of a certain combination of words sometimes end up with no surviving trace of them.

For the listener it may seem that the artist has merely uncovered another aspect of his inner self, but the artist feels that he has discovered something from outside himself, something whose existence he had not previously suspected. If we find it hard to imagine a world without *Hamlet* it was even harder to conceive the work in a world without it. Not even the most passionate admirer of an artist is as astonished by his works as the artist himself – and by the same token the artist's sense of disappointment at failing to recapture the full mystery of the original inspiration in what appear to be his greatest works often seems incomprehensible to us. We know only the finished product. The artist knows both the inspiration and the void without it.

Pasternak's words in *Safe Conduct* (*Okhrannaya gramota*, 1930) seems to go to the heart of the matter:

> The most vivid, memorable and important thing in art is its emergence, and the finest creations of the world, while talking about the most wildly different things, are in fact speaking of their own birth.[7]

It is a process which is re-enacted in us whenever we give our attention to a work of art. To divide culture then into active and passive elements, as so many Russians tried to do in the 1920s and as our cultural well-wishers do today, is to distort its whole nature. Culture, as Ivanov declared in *Correspondence from Two Corners*, is not just a museum containing the relics of past generations, but rather the memory of the experiences and processes by which they had been created; it is not a burden but a liberation. The 'timelessness' of art is a recognition not just of the uniqueness of the

individual within the continuity of the human family (though this is one of its chief pleasures) but also of the paradoxical fact that art can actually provide experience at first hand.

It is the intensity of this experience, the extent to which it evokes in us a sense of individuality, not only the artist's but our own, that determines our valuation of a given work; but even here our subjective likes and dislikes predispose us to certain types rather than others. When the phone rings and we recognize a friend's voice we do not ask him what his latest ideas are; we are simply pleased. So too our relationship to works of art is first and foremost one of pleasure, a pleasure in which familiarity plays a major part. We do not invariably find something new on each encounter with a well-loved work of art, as some would claim, except in the sense that the unique is always new. We adore our favourite works, not for the marvels of technique and intellect that may (or may not) have gone into them, but for what they uniquely are, at least to us. In the words of Thomas Mann in *Death in Venice*:

> Men do not know why they bestow fame on one work of art rather than another . . . They think to justify the warmth of their commendations by discovering in it a hundred virtues, whereas the true ground of their admiration is imponderable; it is sympathy.[8]

We may recognize the intellectual and formal mastery of a given work, admit its unmistakable individuality, and yet still dislike it. We all have our blind spots and our inconsistencies; indeed a total and equal receptivity to all art, however ideally desirable, is impossible. We may find even our favourite works sometimes unresponsive. We shut our eyes and ears to limitations in our favourite artists, as I do with Bruckner, while others, equally admirable by all accounts, such as Carl Nielsen, leave us cold. We may dislike our friends' friends intensely, despite all attempts to bring us together and make us see one another's undoubted virtues. I do not like thee, Doctor Fell, and there's an end of it.

To respond to art in these subjective terms does not mean that we are uninterested in the ideas and social concerns of artists, or in the forms which they have devised for them, rather that our interest is a consequence, not a cause, of our interest in *them*. We may indeed disagree passionately with them over certain matters

(as we often do with Dostoyevsky, Wagner or Ezra Pound) without rejecting them as artists. On the other hand, the modern obsession with uncovering the original significance and impact of a given work often results in a reversal of artistic priorities, for it tries to confine us to the limited horizons of the first audiences, while ignoring the experience of intervening generations which have found quite different qualities in it.

The urge to find some greater significance for art springs from a recognition of its extraordinary power. Some think to find in it a substitute for religion or an intellectual steeplechase; others an agent of social change or a discourse on matters of life and death; others again an 'alternative government' or a revelation of ultimate truths. But art has a different set of values, beside which, in the words of *Doctor Zhivago*, 'such grandiose projects as reshaping the world come to seem mere trivia'.[9] Some of the greatest and most irresistible works of art are frivolous comedies: only a professional critic could pretend that *Cosi Fan Tutte* is really a vehicle for more serious ideas, as though lesser mortals could not digest such things without dilution and fancy packaging. It is minor artists who take art so seriously; it is in their work that all the qualities of form, intellect, and moral and social concern that critics look for in art are to be found, and much less problematically too.

Thus when we say that *Hamlet* is 'inexhaustible' we are not thinking so much of its intellectual profundity, which is finite, but rather that the fascination of its 'voice' is unfathomable. Each age and each reader will hear and respond to its dilemmas differently, and in each generation the critics, while regarding their own rationalizations as objective, will be careful to place works of art in the relativities of time and space. Of course the truth is just the reverse; and our century's academic conceit will surely seem as aberrant to our successors as the Grundys and the Bowdlers do to us. The works of art themselves will remain unchanged, tantalizing hints at the existence of absolutes, not in the guise of Voronsky's generalized Platonic abstractions, but particular, materialized and unique.

For the extraordinary fact is that despite the impossibility of establishing any objective criteria, and despite the wild swings in public taste and critical fashion, certain artists and their works have remained at the core of the canon over the centuries. If we feel the need for a hierarchy among artists, then the greatest figures would seem to be those who display the widest range of 'voice', not neces-

sarily between one work and another, as do such Protean figures as Shakespeare and Beethoven, but even within a single work, such as *The Divine Comedy*. One can imagine people (Tolstoy for a start) who dislike much or even most of such artists and their works, but one cannot imagine someone who, given a fair chance, would be incapable of responding to any of it; other artists with a more limited range, such as Franz Schmidt or Sluchevsky, can win just as passionate devotion, though from a smaller circle.

There will never be any conclusive agreement as to their respective 'merits', but there is no reason to look for any, for each artist is unique; how can someone else's friends mean more to us than our own do? We may feel that Bach is 'deeper' than any athlete can ever hope to be, but it can hardly be proved, and even if it could be, would it actually persuade any dissenter to change his mind?

It is then peculiarly horrifying that the sense of taste, once a byword for the infinite variety and unpredictability of human character (*chacun à son goût*) should instead have been appropriated by aesthetic and intellectual snobs for their own narrow purposes. Art is a living affirmation of this variety and of our right to choose our company among it; Bryusov and Richard Strauss have their admirers too; we are not clones. The business of making judgements about art is not a matter for experts but for ordinary mortals like ourselves. The only lesson that we can justifiably learn from art is to trust and follow our own better selves, as did Zamyatin's D.503. It is just this that works of art, without necessarily being egotistical or subversive, achieve triumphantly time and time again.

This apology for subjectivity and individualism will doubtless seem intolerable after all the earlier fine talk about 'taking art seriously'. The idea that artists and their works should achieve immortality through qualities that amount to little more than irresistible personal 'charm' (though the term was good for Marx) affronts not only decent citizens and tidy-minded governments, but also many lovers of art. But if the arts are indeed the 'humanities' how else are we to take them seriously?

In the 'social childhood' of our civilization Plato argued that the truly courageous man was the one who felt fear but managed to overcome it. Yes, logically, this should be so; but don't we instinctively admire even more the courage of the man who does not feel fear at all? In the same way we revere the great artists not for what they have made of themselves, but for what they are. Our ambiguous

attitude to art is a reflection of our confusion between these two moralities. As Pushkin's painstaking and deserving Salieri observed of the irresponsible but inspired Mozart: 'There is no justice in earth or in heaven above.' We critics and academics feel that somewhere there must be a justice: perhaps artists are philosophers or prophets or revolutionaries? or perhaps they just work terribly hard? We betray our impatience with the capriciousness of aesthetic values by extolling some new work as 'more than art' but, just like the concept of the superhuman, there is no such thing; time passes and the work in question proves to be either a genuine work of art, neither more nor less, or, all too often, very much less.

The human (antihuman?) impulse to systematize and regularize has defeated religions and revolutions, but the arts have somehow contrived to escape each time. However, the attempts by our universities and governments to convey social and intellectual respectability upon them through institutionalized patronage may well constitute the most serious threat so far. If they have not yet succeeded in stifling the creation of new art – the great art of any generation has often been ignored in its own time, particularly in such fashion-conscious periods as our own – they have come perilously close to discrediting all culture, both present and past. As Ivanov foresaw, culture becomes oppressive only when it is imposed. Governments and societies cannot buy the sort of culture they would like to commemorate them. Art is nothing if it is not human; this is both its strength and its weakness.

We should not overvalue art then. Puritans are right to distrust it; good causes find it a tricky ally; its charms are as available to SS-men as to children. Art is not an authority and any attempt to treat is as one can only backfire. We may agree that the enrichment and liberation that art offers should be open to all, but we should also be mindful of the myth of Candaules and Gyges, recalled for us so appositely in *Temporary Kings*; it is only a minority, and not necessarily of the best or the wisest or the healthiest either, that has ever responded to it. If we treat art as medicine, we shall find that it can also be a poison; if it can reveal Heaven to us, it finds it even easier to reveal Hell. Art that creates an extraordinary bond of communion across the centuries and the frontiers often alienates its devotees from their own times, even if it does not actually turn them to stone. Art, that has the salutory ability to show that progress and science are largely illusory, can also make us forget that

our duty still lies with the living not the dead. We should remember that the fiercest attacks on art have been mounted not by the Philistines but by the artists.

It is said that somewhere in South America there lives a tribe whose language associates the future with 'behind' and the past with 'in front'; after all we can see something of the past but nothing of the future. Some traces of this logical but utterly unWestern way of thinking still survive in European languages: the word 'before' has two contradictory meanings, depending on whether it refers to time or place. Compare 'this happened before that' and 'the future lies before us'. This small linguistic detail sums up the paradoxes of art in Western culture.

Did Lot's wife then look back, or was she really looking straight before her, at the past which is all we have? At any rate for all her anonymity, her single rash gesture has long out-lived the memory of her godfearing but prosaic husband. She can be seen to this day, looking out over the desolation of Sodom and the Dead Sea beyond, the other Venus at the heart of our culture.

NOTES

Chapter 1

1 Leonid Leonov, *Sobraniye sochineniy*, 9 vols (Moscow–Leningrad, 1960–2), vol. IX, p. 434.

2 Thus Blok called St Petersburg, the Westernized capital of Imperial Russia, 'a gigantic brothel' (*Sobraniye sochineniy*, 8 vols, Moscow–Leningrad, 1960–3, vol. VIII, p. 131); see also the cycle of poems 'The City' in the second volume of his poetry, and his comments on Florence during his visit there in 1909. Pil'nyak called European culture 'a five-hundred-year-old brothel' in the story 'Coltsfoot' ('Mat'-machekha': see *Sobraniye sochineniy*, 8 vols, Moscow, 1929–30, vol. IV, p. 149). See also Bagritsky's poem *February* (*Fevral'*) discussed later in this book.

3 P. S. Kogan, *Literatura etikh let 1917–23* (Ivanovo–Voznesensk, 1924), p. 9.

4 *A Handbook of Marxism*, ed. Emile Burns (London, 1935), p. 119.

5 It may of course be argued that bourgeois critics deliberately played down the elements of social discontent implicit in the masterpieces that passed through their hands. In that case one may ask: If they saw this revolutionary potential why did they praise the works at all and recommend people of all classes to read them? on the other hand, if they did not see it, then presumably few of their readers would either. Either way a Marxist can hardly regard the situation as very satisfactory.

6 A. V. Lunacharsky, *Stat'i o sovetskoy literature* (Moscow, 1958), pp. 26–7.

7 C. V. James, *Soviet Socialist Realism: Origins and Theory* (London, 1973), p. 11.

8 Karl Marx, Friedrich Engels, *Literature and Art: Selections from their writings* (New York, 1947), p. 19.

9 *Ibid.*, pp. 19–20.

10 *Ibid.*, p. 142.
11 Lev Trotsky, *Literatura i revolyutsiya* (Moscow, 1924), p. 140.
12 Mayakovsky gives an amusing example of the ability of the ruling class to assimilate uncommitted and even subversive art and use it for its own ends. When he was on one of his reading-tours in pre-revolutionary Russia he was given an official warning: 'Kindly remember that I will not permit you to speak disrespectfully of the activities of the authorities, you know, Pushkin and the rest of them.' (*Polnoye sobraniye sochineniy*, 13 vols, Moscow–Leningrad, 1955–61, vol. I, p. 296). The process has repeated itself in the Soviet Union. Mayakovsky himself has become just such a figurehead in his turn. Art does seem to have a way of ending up as a weapon in the hands of the ruling class.
13 Vyacheslav Polonsky, *Ocherki literaturnogo dvizheniya revolyutsionnoy epokhi* (Moscow, 1929), pp. 82–3.
14 Sheila Fitzpatrick, *The Commissariat of Enlightenment: Soviet Organization of Education and the Arts under Lunacharsky* (Cambridge, 1970), p. 141.
15 Quoted from Mayakovsky, *Polnoye sobraniye sochineniy*, vol. XII, p. 621.
16 V. Ya. Bryusov, *Sobraniye sochineniy*, 7 vols (Moscow–Leningrad, 1973–5), vol. I, p. 433.
17 V. Ya. Bryusov, *Rasskazy i povesti* (Munich, 1970), p. 96.
18 *Ibid.*, pp. 96–7.
19 The article was published in *Vesy*, 1905, no. XI. Rather surprisingly, it was reprinted in the Soviet period; see Viss. Sayanov, *Ocherki po istorii russkoy poezii XX veka* (Leningrad, 1929).
20 There is a certain irony in the fact that the poet who first raised the theme of the 'coming Huns' in Russian literature should have disowned its implications within a year. There is an even greater irony in the fact that, when the Bolsheviks seized power in 1917, Bryusov dropped his earlier criticisms and joined the Party almost immediately. In this new role he proceeded to defend the culture of the past energetically, and, in the opinion of some, displayed equal determination in resisting the emergence of new talent.
21 Quoted from John Elsworth, 'Andrey Bely's Theory of Symbolism', *Forum for Modern Language Studies*, October 1975, vol. XI, no. 4, p. 327.
22 It is not clear whether this phrase was the invention of Mayakovsky or Khlebnikov. Mayakovsky's speech with this title was delivered on 24 March 1913. Khlebnikov's first use of the expression occurs in 'Neizdannava stat'ya' (V. V. Khlebnikov, *Sobraniye proizvedeniy*, 5 vols, Leningrad, 1928–33, vol. V, p. 187) which can be dated only approximately to 1913–14; he used the phrase again in 'Razgovor Olega i Kazimira' (*ibid.*, p. 194), an article based on the same material. Presumably it was a current joke among the Futurists at the time, but we know that at the end of his life Khlebnikov accused many of his former colleagues, notably

Mayakovsky and Aseyev of having plagiarized his ideas (see 'Kruchenykh' *ibid.*, p. 400). So it is possible that this may have been one of the cases that he was thinking of.

23 Khlebnikov, *Sobraniye proizvedeniy*, vol. v, p. 207.

24 It is amusing to note that Soviet republications of this manifesto usually omit Gor'ky's name from the Futurists' list of great writers to be jettisoned in this way – a rather backhanded compliment, one might have thought.

25 Vyacheslav Ivanov, *Prozrachnost'* (Moscow, 1908), p. 91. The first line of the final stanza was taken by Bryusov as the epigraph to his 'Coming Huns'.

26 Ye. Zamyatin, *Litsa* (New York, 1955), p. 139.

27. Mayakovsky, *Polnoye sobraniye sochineniy*, vol. I, p. 183.

28 *Ibid.*, p. 309.

29 *Ibid.*, p. 304. A few years later Bryusov was to echo these sentiments when he declared that possibly the whole Russian revolution had been justified by the creation of Blok's *Dvenadtsat'*.

30 Vyacheslav Ivanov and M. O. Gershenzon, *Perepiska iz dvukh uglov* (St Petersburg, 1921), pp. 11–12.

31 *Ibid.*, p. 18.

32 *Ibid.*, p. 19.

33 *Ibid.*, p. 25.

34 *Ibid.*, p. 27.

35 *Ibid.*, p. 23.

36 *Ibid.*, pp. 44–5.

37 See Renato Poggioli, *The Phoenix and the Spider* (Cambridge, Massachusetts, 1957).

Chapter 2

1 A. A. Blok, *Sobraniye sochineniy*, vol. v, p. 248. This edition will be referred to as *SS* followed by the volume in roman numerals and the page-number.

2 Anna Akhmatova, *Sochineniya*, 2 vols (Munich, 1967–8), vol. I, p. 222.

3 Blok, *SS*, IV, 134–5.

4 Blok, *SS*, VII, 360. If in his works of 1908 Blok identified the source of inspiration with the Russian people, his later view was that it came from quite outside this world. The significance of the common people was now seen as their ability to respond to these influences more spontaneously than the introverted and self-conscious intellectuals.

5 Blok, *SS*, VI, 110.

6 Blok, *SS*, v, 319.

7 A. A. Blok, *Zapisnyye knizhki* (Moscow, 1965), p. 320. This volume will be referred to as *ZK* followed by page-number.

8 Blok, *ZK*, 316.

9 Blok, *SS*, VII, 265.

10 E.g. Blok, *SS*, VIII, 504, 505.

11 Blok, *SS*, VII, 279.
12 *Ibid.*, p. 297.
13 Blok, *SS*, VIII, 484–5.
14 *Ibid*, p. 487. See also the similar views expressed in his diary for 4 March 1918 (*SS*, VII, 329).
15 Blok, *ZK*, 346.
16 *Ibid.*, p. 384.
17 Blok, *SS*, VII, 314.
18 Blok, *SS*, V, 35.
19 Blok, *SS*, VI, 16.
20 *Ibid.*, p. 12.
21 Blok, *SS*, VI, 55–6.
22 *Ibid.*, p. 56. There are some interesting differences between the finished article and Blok's original notes on the conversation in *SS*, VII, 323–4. Stenich actually said: 'We asked for bread, and you gave us ambrosia', which makes better sense.
23 Anatoliy Yakobson, *Konets tragedii* (New York, 1973), p. 89.
24 For a detailed analysis of the iconography of the poem, see Sergei Hackel, *Aleksandr Blok's 'The Twelve'* (Oxford, 1975).
25 Blok, *SS*, VII, 330.
26 It may be noted that Blok attributed to Wagner the same ambivalent attitude to Christ: 'In one place [Wagner] calls Christ with hatred "the wretched son of a Galilean carpenter" while in another he invites us to erect an altar to Him . . . It is just this poison of love-hatred . . . which saved Wagner from ruin and mockery. This poison, spread through all his works is the "new" which shall inherit the future' (*SS*, VI, 26).
27 Blok, *ZK*, 390.
28 Blok, *SS*, VI, 73.
29 The same idea is expressed in different terms in the famous, but probably never sent, letter to Mayakovsky of 30 December 1918: 'I hate the Winter Palace and the museums just as much as you do. But destruction is just as old as construction, and just as traditional too. We are just as bored and uninvolved in the destruction of the state as we were when we watched it going up. The fang of history is more poisonous than you realize, the curse of history not so easily turned aside. . . . When we destroy we still remain slaves of the old world; the breaking of traditions is itself a tradition. And a greater curse still hangs over us; we cannot stop sleeping, we cannot stop eating. Some will build, and others will destroy, because "there is a time for all things under the sun", but we shall all remain slaves until a third element appears, as different from mere construction as it is from mere destruction.' (*SS*, vol. VII, p. 350). In *The Premature Revolution* (London, 1972) I took this to refer to some higher synthesis. I now think that Blok did not mean anything of the sort, but rather a totally new moral order, like Christianity, miraculously unpredictable before or after the event.

30 Blok, *SS*, vi, 98.
31 *Ibid.*, p. 110.
32 *Ibid.*, p. 99.
33 *Ibid*, p. 112.
34 Blok, *ZK*, 441.
35 *Ibid.*, p. 234.
36 See Gor'ky's correspondence with him in *M. Gor'ky i sovetskaya pechat'. Arkhiv A. M. Gor'kogo*, vol. x (Moscow, 1964).
37 Blok, *SS*, vii, 351.
38 *Ibid.*, pp. 352–4.
39 Blok, *SS*, vi, 292–3.
40 *Ibid.*, p. 294.
41 *Ibid.*, p. 465. Blok was referring in particular to his own company's production of Schiller's *Don Carlos*.
42 Blok, *SS*, vi, 391.
43 *Ibid.*, pp. 298–9.
44 *Ibid.*, p. 125.
45 Blok, *SS*, vii, 366–7.
46 Blok, *ZK*, 484.
47 Blok, *SS*, vi, 352.
48 *Ibid.*, p. 354. For other examples of this tendency see Blok's introductions to Benelli's *The Ragged Cloak* on 21 July 1919 (*ibid.*, p. 357), Schiller's *Don Carlos* in December 1919 (*ibid.*, p. 377), Büchner's *Danton's Death* in January 1920 (*ibid.*, p. 360) and even Maeterlinck's *The Blue Bird*, November 1920 (*ibid.*, p. 418).
49 *Ibid.*, pp. 425–6.
50 Blok, *SS*, iii, 298.
51 Blok, *SS*, vi, 366–7.
52 *Ibid.*, p. 367.
53 *Ibid.*, pp. 391–2.
54 *Ibid.*, p. 440. The references in the last sentence are to Pushkin's poem 'The Poet and the Mob' ('Poet i tolpa').
55 *Ibid.*, p. 161.
56 Blok, *SS*, vii, 404.
57 Blok, *SS*, vii, 415–6.

Chapter 3

1 Mayakovsky, *Polnoye sobraniye sochineniy*, vol. viii, p. 115. In this chapter this edition will be referred to as *PSS*, followed by the volume in roman numerals and the page-number.
2 Blok, *SS*, vii, 356–7.
3 Trotsky, *Literatura i revolyutsiya*, p. 7.
4 Quoted from Sheila Fitzpatrick, *The Commissariat of Enlightenment*, p. 93.
5 A. V. Lunacharsky, *Vospominaniya i vpechatleniya* (Moscow 1968), p. 167.
6 Mayakovsky, *PSS*, ii, 20.

7 See 'Ode to the Revolution' ('Oda revolyutsii', 1918, *PSS,* vol. II, p. 12). It must be admitted, however, that Mayakovsky waxed extremely indignant over the rumour (a false one, as it turned out) that the cathedral of St Vladimir in Kiev had been blown up by the Poles. He saw this as clear evidence of the lack of culture of the Bolsheviks' enemies. See *PSS,* III, 94.

8 Vladimir Kirillov, *Stikhotvoreniya i poemy* (Moscow, 1970), p. 35.

9 *Voprosy istorii KPSS,* 1968, no. V, p. 91.

10 Mayakovsky, *PSS,* XII, 251.

11 V. I. Lenin, *Polnoye sobraniye sochineniy,* 55 vols (Moscow, 1959–65), vol. XLI, p. 337.

12 A. K. Voronsky, *Iskusstvo videt' mir* (Moscow, 1928), p. 88. For a detailed discussion of the evolution of Voronsky's aesthetic views see R. A. Maguire, *Red Virgin Soil: Soviet Literature in the 1920s* (Princeton, 1968).

13 The same time-lag can be seen at work in the recent rehabilitation in the Soviet Union of modernist artists of the beginning of the century, while the same intolerance is still extended to contemporary modernists.

14 Trotsky, *Literatura i revolyutsiya,* p. 179.

15 Marina Tsvetayeva, *Proza* (New York, 1953), p. 312.

16 M. Gor'ky, *Sobraniye sochineniy,* 30 vols (Moscow, 1949–55), vol. XVII, pp. 39–40.

17 *A Handbook of Marxism,* pp. 116–17.

18 See O. Brik, 'Razgrom Fadeyeva' and V. Trenin, 'Intelligentnyye partizany' in *Literatura fakta* (Moscow, 1929), pp. 88–93 and 94–7.

19 Mayakovsky, *PSS,* XII, 454.

20 *Ibid.,* pp. 150–1.

21 *Ibid.,* p. 327.

22 See *ibid.,* p. 45.

23 *Ibid.,* p. 160.

24 *Ibid.,* p. 46.

25 *Ibid.,* p. 46.

26 *Ibid.,* p. 98.

27 *Ibid.,* p. 482.

28 See V. O. Pertsov, 'Ob'yem khudozhestvennogo proizvedeniya i byudzhet vremeni russkogo rabochego' in *Na putyakh iskusstva* (Moscow, 1926).

29 *Literatura fakta,* p. 28.

30 Mayakovsky, *PSS,* VII, 94.

31 It is interesting to note that this position anticipated the views adopted by LEF's arch-enemy Gor'ky (the hostility was reciprocated) in the early 1930s. In reviewing the book *Donbass the Heroic* (*Donbass geroicheskiy,* 1931) Gor'ky wrote: 'This book by the industrial correspondent Yeremeyev is not literature, but something greater, more important and more dynamic . . . This is the raw material out of which beautiful plays and novels will one day be fashioned: this is a true historical document, created by

the masses alone' (M. Gor'ky, *Sobraniye sochineniy*, vol. xxv, p. 400), and he refused to correct even the grammatical mistakes in the text. Yeremeyev was offered a place at a writers' training college, but logically enough, he turned it down on the grounds that he had a more important job to do in the mines.

32 A single example may illustrate this point. In *Good!* Mayakovsky had imagined the dead Lenin asking whether his precepts were still being followed, and had felt himself fully entitled to answer such questions. In the work of later generations, however, down to and including Yevtushenko and Voznesensky, the artist asks the dead Lenin, or rather the current image of him. The past has completely overshadowed the present and the future.

33 *Literatura fakta*, pp. 268–9.

34 *Ibid.*, pp. 246–7.

35 Mayakovsky, *PSS*, xii, 327.

36 *Literatura fakta*, p. 16.

37 Trotsky, *Literatura i revolyutsiya*, p. 137.

38 *Ibid.*, p. 12.

39 Mayakovsky, *PSS*, xii, 510.

40 *Ibid.*, p. 408. Another example of the sudden collapse of Mayakovsky's previous standards comes in his changing appraisals of Bezymensky's play *The Shot* (*Vystrel*, 1929). On January 16 1930 he wrote: 'in its political aims and its basic desire to take part in socialist construction this play is ours; but in its technique of using the worn-out devices of Griboyedov it is totally opposed to us, utterly impossible' (*PSS*, xii, 402). Yet only a few weeks later he completely abandoned these criticisms and joined in the general acclaim: 'it was one of the very few plays to set against the sea of rubbish in the contemporary theatre' (*ibid.*, p. 514).

41 *Ibid.*, p. 423.

Chapter 4

1 Leonid Leonov, *Sobraniye sochineniy*, vol. ix, p. 147.

2 I am grateful to Slavic Publishers, Inc. for permission to use here some material from my paper 'Khlebnikov and $3^6 + 3^6$' which was published in *Russian and Slavic Literature* edited by Richard Freeborn, R. R. Milner-Gulland, Charles A. Ward, Slavica Publishers Inc., Columbus, Ohio, 1976, pp. 297–312.

3 Khlebnikov, *Sobraniye proizvedeniy*, vol. i, p. 95. In this chapter, this edition will be abbreviated as *SP*.

4 *Ibid.*, p. 101.

5 The immediate inspiration for *The End of Atlantis* probably came from the sinking of the Titanic in April 1912; by a strange coincidence the ship that bears the lifeless body of the Gentleman from San-Francisco in Bunin's story of 1915, clearly influenced by the same event, also bears the name Atlantis.

6 V. V. Khlebnikov, *Sobraniye sochineniy*, ed. Vladimir Markov, 4 books (Munich, 1968–72), book iii, p. 476. Despite Khlebnikov's

dating this action was taken by the Soviet government at the end of October 1921. (See *Izvestiya*, 29 October 1921.) The purpose was to secure recognition of the Bolshevik government by the Western powers. It may be noted that once this recognition had been granted, the Communists repudiated their undertaking at the Genoa Conference of April 1922.

7 Khlebnikov, *SP*, vol. I, p. 260.
8 *Ibid.*, p. 255.
9 *Ibid.*, p. 256.
10 *Ibid.*, p. 257.
11 *Ibid.*, pp. 269–71.
12 *Ibid.*, p. 273.
13 Vladimir Markov, *The Longer Poems of Velimir Khlebnikov* (Berkeley, 1962), p. 181.
14 This expression is, admittedly, used only in a variant of the final lines (see *SP*, vol. I, p. 325); but there is nothing to indicate that the mother of the White youth is an 'old woman' either, except insofar as her hair has been turned prematurely white by the shock of her son's death. Compare too the short poem 'Asia' ('Aziya', 1921), where the continent is described as the 'old mid-wife of revolts' (see *SP*, vol. III, p. 122).
15 Khlebnikov, *SP*, vol I, p. 261.
16 *Ibid.*, p. 272. In Khlebnikov's works the Lorelei/*rusalka* image is almost always associated with positive values and contrasted with the materialism and cruelty of the phenomenal world.
17 *Ibid.*, p. 262.
18 Eduard Bagritsky, *Stikhotvoreniya i poemy* (Moscow–Leningrad, 1965), p. 104.
19 *Ibid.*, p. 105.
20 *Eduard Bagritsky. Al'manakh,* ed. Vlad. Narbut (Moscow, 1936), pp. 375–6.
21 Bagritsky, *Stikhotvoreniya i poemy,* p. 205. Yuriy Olesha recorded that when Bagritsky was dying his last words, addressed to the nurse, were: 'What a good face you have! I can see you had a good childhood; when I think of my childhood, I can't recall a single good day from it' (Yu. Olesha, *Izbrannyye sochineniya,* Moscow, 1956, p. 366).
22 Bagritsky, *Stikhotvoreniya i poemy,* p. 205.
23 *Ibid.*, p. 204.
24 *Ibid.*, p. 204.
25 *Ibid.*, p. 209.
26 *Ibid.*, p. 210.
27 *Ibid.*, p. 211.
28 *Ibid.*, pp. 211–12.
29 *Ibid.*, p. 212.
30 *Ibid.*, p. 213.
31 *Ibid.*, pp. 215–16.
32 *Ibid.*, p. 217.

33 *Ibid.*, p. 219.
34 *Ibid.*, p. 220.
35 *Ibid.*, p. 221.
36 *Ibid.*, p. 222.

Chapter 5

1 Marina Tsvetayeva, *Stikhotvoreniya i poemy* (Moscow–Leningrad, 1965), p. 295.
2 Konst. Fedin, *Sobraniye sochineniy*, 10 vols (Moscow, 1969–73), vol. I, 418–9.
3 Zamyatin, *Litsa*, p. 173.
4 *Ibid.*, p. 185–6.
5 Ye. Zamyatin, *Povesti i rasskazy* (Munich, 1963), p. 197.
6 Boris Pil'nyak, *Mashiny i volki* (Leningrad, 1925), p. 87.
7 Boris Pil'nyak, *Byl'ye* (Revel, 1922), p. 32.
8 *Ibid.*, pp. 80–1.
9 Boris Pil'nyak, *Sobraniye sochineniy*, vol. I, p. 206.
10 Boris Pil'nyak, *Mashiny i volki*, p. 44.
11 *Ibid.*, p. 82.
12 *Ibid.*, p. 83.
13 *Ibid.*, pp. 92–3.
14 *Ibid.*, p. 94.
15 Boris Pil'nyak, *Sobraniye sochineniy*, vol. VII, p. 25.
16 *Ibid.*, vol. III, p. 193.
17 Boris Pil'nyak, *Krasnoye derevo* (Berlin, 1929), p. 39.
18 Ibid., p. 77.
19 I. Babel', *Izbrannoye* (Moscow, 1966), p. 60.
20 *Ibid.*, p. 83.
21 *Ibid.*, p. 99.
22 *Ibid.*, p. 39.
23 *Ibid.*, p. 27.
24 *Ibid.*, p. 28. See also the stories 'Pan Apolek' and 'Di Grasso'. Pil'nyak made the same use of the image in his 'Tale of the Unextinguished Moon' ('Povest' nepogashennoy luny, 1926).
25 Babel', *Izbrannoye*, p. 51.
26 *Ibid.*, p. 59.
27 *Ibid.*, p. 150.
28 *Ibid.*, p. 151.
29 Yu. Olesha, *Povesti i rasskazy* (Moscow, 1965), p. 26.
30 *Ibid.*, p. 59.
31 *Ibid.*, p. 86.
32 *Ibid.*, p. 83.
33 *Ibid.*, p. 93. The image of the broken bottle comes from Chekhov's *The Seagull*.
34 Olesha, *Povesti i rasskazy*, p. 106.
35 Andrey Platonov, *Razmyshleniya chitatelya* (Moscow, 1970), p. 177.
36 Andrey Platonov, *Smerti net!* (Moscow, 1970), p. 140. This idea is

common in Platonov's war stories; see in particular 'Afrodita'. So too the story 'The Light of Life' ('Svet zhizni'), which begins by affirming that memory bestows immortality, ends up by demonstrating the exact opposite.

37 Andrey Platonov, *Rasskazy* (Moscow, 1962), p. 36.

38 A similar pattern is found in Platonov's stories of Central Asia, 'Takyr' and 'Dzhan'; the family, the natural image of continuity, is replaced by the State, and so the past is completely detached from the present.

39 Andrey Platonov, *Techeniye vremeni* (Moscow, 1971), p. 272.

40 *Grani*, 1969, no. 70, p. 8.

41 A similar pattern is found in the 'Origins of a Craftsman' *Proiskhozhdeniye mastera* (1928) and its sequel *Chevengur* (1929), where the lecherous hunchback Kondayev outlives all the Communist heroes.

42 Andrey Platonov, *Chevengur* (Paris, 1972), p. 89.

43 *Ibid.*, p. 211.

44 *Ibid.*, p. 319.

Chapter 6

1 Mayakovsky, *PSS*, XII, 8.

2 Leonid Leonov, *Gibel' Yegorushki* (Riga, 1927), p. 81.

3 F. M. Dostoyevsky, *Sobraniye sochineniy*, 10 vols (Moscow, 1956-8), vol. IX, p. 400.

4 Leonid Leonov, *Sobraniye sochineniy*, vol. IX, p. 680. This edition will be abbreviated in this chapter as *SS*, followed by the volume in roman numerals and the page numbers.

5 See S. Romov, 'Vstrecha s Leonidom Leonovym', *Literaturnaya gazeta*, 24 September 1930.

6 Leonid Leonov, *Vor* (Moscow–Leningrad, 1928), p. 420. These words are addressed to Vekshin by the fictional novelist, Firsov, but they are later confirmed by Leonov himself. See *ibid.*, p. 467.

7 Leonov, *SS*, III, 561–2. This quotation is taken from the revised version of the novel, first published in 1959. In the original version it was attached to the time-serving bureaucrat, Chikilev: 'Interesting formulation of Chikilev's envy – it didn't amount to the usual: 'Why don't I have what they have? but the specific: 'Why do they have what I don't?' (*Vor*, p. 503.) In Chikilev's lips the sentiment is merely of psychological interest; given to Vekshin, it contributes to the debate.

8 *Vor*, p. 48.

9 *Ibid.*, p. 59.

10 *Ibid.*, p. 422.

11 *Ibid.*, p. 8.

12 *Ibid.*, pp. 69–70.

13 Ibid., p. 202.

14 Leonov, *SS*, IV, 129.

15 Romov, 'Vstecha s Leonidom Leonovym'. Compare Gershenzon's

words: 'I know too much, and this burden oppresses me' (*Perepiska iz dvukh uglov*, p. 19). In view of the abundant evidence that Leonov has read *Correspondence from Two Corners* with close attention, it is tempting to wonder if the opening scene of *The River Sot'* depicting an elk drinking peacefully from a stream on the eve of the Communists' arrival, is not a reminiscence of Gershenzon's stag with its overgrown antlers.

16 Leonov, *SS*, IV, 47.

17 *Ibid.*, p. 96.

18 *Ibid.*, p. 292.

19 *Ibid.*, p. 210.

20 *Ibid.*, p. 212. One wonders whether Leonov was deliberately alluding to Marx's '. . . the revolution . . . must leave the dead to bury their dead'.

21 *Ibid.*, p. 213. There is a probable link here with Zamyatin, for Vissarion's views are a distorted version of those often expressed by Zamyatin, notably in his article 'The Scythians' (1919) and, in particular, in his play *Atilla* (1928) then scheduled for production in Leningrad: the distrust of both Western progress and the socialist ideal of equality is a factor in much of Zamyatin's work. Zamyatin was disgraced in the autumn of 1929, and his play *Atilla* banned. By this time Leonov's work on *The River Sot'* was fairly far advanced: the novel is dated December 1928 – November 1929, and the first instalment was published in January 1930 (in *Novyy mir*). I suspect that the Vissarion episode was a late addition, designed to take advantage of the situation, for his tirade is contained within a single section of a single chapter (the fourth) and is only weakly tied in with the rest of the novel.

22 For a full discussion of RAPP see Edward J. Brown, *The Proletarian Episode in Russian Literature 1928–32*, Columbia University Press, 1953 and Herman Ermolaev, *Soviet Literary Theories 1917–34*, University of California Press, 1963.

23 Leonov, *SS*, IX, 439.

24 *Ibid.*, p. 434.

25 *Ibid.*, p. 439.

26 *Ibid.*, p. 442.

27 *Ibid.*, p. 513.

28 *Ibid.*, p. 514. Vyacheslav Ivanov had also applied the myth of Perseus and the Medusa to culture. See his *Sobraniye sochineniy*, vol. II (Brussels, 1975), pp. 599, 648.

29 Leonov, *SS*, IX, 434.

30 *Ibid.*, pp. 433–4.

31 *Ibid.*, p. 433.

32 Leonov, *SS*, III, 147.

33 *Ibid.*, pp. 146–9. I have slightly rearranged one or two passages in this long quotation in order to shorten it as far as possible. These ideas are expressed again in the epilogue to the novel, where they

are presented ironically, as seen by a hostile critic. See *Ibid.*, pp. 673–4.
34 *Ibid.*, p. 559.
35 Znamya, 1963, vol. XI, 162–3.

Chapter 7

1 I. S. Turgenev, *Polnoye sobraniye sochineniy i pisem v dvadtsati vos'mi tomakh* (Moscow–Leningrad, 1961–8), vol. IX, p. 119.
2 In my own university each department in the faculty of arts was once invited to submit a justification of its work, whether in teaching or research, in terms of new technical equipment, amounts of computer time, new methodologies, etc. etc. Few departments felt strong enough to remind the authorities that the proper study of the humanities is man.
3 Blok, *SS*, vol. IV, p. 135.
4 This is a question that particularly interested Schoenberg. In his 'Composition for Twelve Tones' the great theorist and analyst expressed his conviction of the inner unity and distinctiveness of Mozart's great comic operas: 'We may not be able to discover it, but certainly it exists'. Any ear can hear it, even if the intellect cannot demonstrate it.
5 L. Slonimsky, *Masterstvo Pushkina* (Moscow, 1963), p. 39. There is, admittedly, a problem here with certain works of art, such as Renaissance paintings or Mozart's *Requiem*, to which disciples and pupils have contributed significantly. If I may leave the paintings to others more qualified than I am, I would say that the *Requiem* does not, to my ear, possess the unity' that the great comic operas do. But I am well aware that this is to take an easy way out.
6 Mayakovsy, *PSS*, *vol.* XII, p. 101.
7 B. L. Pasternak, *Proza, 1915–58* (Ann Arbor, 1961), p. 241.
8 Thomas Mann, *Death in Venice* (Harmondsworth, 1971), p. 11.
9 Boris Pasternak, *Doktor Zhivago* (Milan, 1957), p. 514.

SELECT BIBLIOGRAPHY

Bloom, Harold, *The Anxiety of Influence* (New York, 1973)

Bowra, C. M., *Poetry and Politics* (Cambridge, 1966)

Brooks, Cleanth, *The Well-Wrought Urn* (New York, 1947)

Chuzhak, N. F., ed., *Literatura fakta* (Moscow, 1929)

Cooke, Deryck, *The Language of Music* (London, 1959)

Demetz, Peter, *Marx, Engels and the Poets: Origins of Marxist Literary Criticism* (Chicago, 1967)

Eagleton, Terry, *Marxism and Literary Criticism* (London, 1976)

Ellis, John M., *The Theory of Literary Criticism: A Logical Analysis* (California, 1974)

Ermolaev, Herman, *Soviet Literary Theories 1917–34* (Berkeley, 1963)

Fischer, Ernst, *The Necessity of Art: A Marxist Approach* (London, 1963)

Fitzpatrick, Sheila, *The Commissariat of Enlightenment: Soviet Organization of Education and the Arts under Lunacharsky* (Cambridge, 1970)

Frye, Northop, *Anatomy of Criticism* (Princeton, 1957)

Gablik, Suzi, *Progress in Art* (London, 1976)

Hawthorn, Jeremy, *Identity and Relationship* (London, 1973)

Hirsch, E. D., *Validity in Interpretation* (Yale, 1967)

Hough, Graham, *An Essay on Criticism* (London, 1966)

James, C. V., *Soviet Socialist Realism: Origins and Theory* (London, 1973)

Jameson, Fredric, *Marxism and Form* (Princeton, 1971)

– *The Prison-House of Language* (Princeton, 1972)

Langer, Susanne, *Feeling and Form* (London, 1953)

LEF (Moscow, 1923–5)

Levin, Harry, *Grounds for Comparison* (Harvard, 1972)

Maguire, Robert, *Red Virgin Soil: Soviet Literature in the 1920s* (Princeton, 1968)

Marx, Karl, Friedrich Engels, *Literature and Art: Selections from their Writings* (New York, 1947)
Peacock, Ronald, *Criticism and Personal Taste* (Oxford, 1972)
D. G. B. Piper, *V. A. Kaverin: A Soviet Writer's Response to the Problem of Commitment* (Duquesne University, 1970)
Prawer, S. S., *Karl Marx and World Literature* (Oxford, 1976)
Richards, I. A., *Principles of Literary Criticism* (London 1926)
Spector, Jack J., *The Aesthetics of Freud* (New York, 1973)
Trotsky, Lev, *Literatura i revolyutsiya* (Moscow, 1924)
Wollheim, Richard, *Art and its Objects* (New York, 1968)
– *On Art and the Mind* (London, 1974)
Yakobson, Anatoliy, *Konets tragedii* (New York, 1973)

INDEX

Substantive references are in italics